LOTTE JACOBI

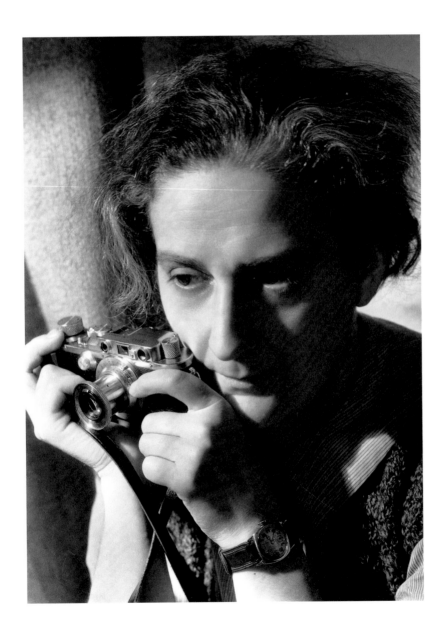

Lotte Jacobi
New York, 1935
Photographed by
her sister, Ruth

MARION BECKERS
ELISABETH MOORTGAT

ATELIER
LOTTE JACOBI
BERLIN
NEW YORK

DAS VERBORGENE MUSEUM

NICOLAI

BERLIN 1998

The original German version
of this book
Atelier Lotte Jacobi • Berlin – New York
was published in conjunction with the exhibition
of the same name, shown at:

Das Verborgene Museum, Berlin
January 23 – March 23, 1997

Suermondt Ludwig Museum Aachen
April 5 – May 25, 1997

Museum Ostdeutsche Galerie Regensburg
June 8 – July 13, 1997

The German edition and exhibitions were funded by:
Stiftung Deutsche Klassenlotterie Berlin, Senats-
verwaltung für Wissenschaft, Forschung und Kul-
tur Berlin — Beirat des Künstlerinnenprogramms
und Senatsverwaltung für Arbeit, berufliche
Bildung und Frauen — Förderprogramm Frauen-
forschung (Berlin Senate Department for the
Sciences, Research and Culture — Council Pro-
gram for Women Artists and Senate Department
for Employment, Professional Training and
Women — Womens' Research Funding Program)

We are grateful to the following people and organiza-
tions for their help and support for the exhibition:
Janos Frecot, Berlinische Galerie, Berlin
Ingrid Streckbein, Berlinische Galerie, Berlin
Ute Eskildsen, Museum Folkwang, Essen
Robert Knodt, Museum Folkwang, Essen
Eckhart Gillen, Berlin
Galerie Bodo Niemann, Berlin
Anja Hellhammer, Theaterwissenschaftliche
Sammlung, Universität zu Köln
Gary Samson, Lotte Jacobi Archives, UNH, USA
Ulrike Ottinger, Berlin

Cover photo
Lotte Jacobi:
Lotte Lenya (detail)
Berlin 1928

Editor
Das Verborgene Museum e.V.
Translation
Karen Margolis, Kevin Michael Madden,
Taryn Toro
Cover
Dorén + Köster
Design
Jürgen Freter
Typesetting
Mega-Satz-Service, Berlin
Lithos
Bildpunkt, Druckvorstufen GmbH, Berlin
Printing
H. Heenemann GmbH & Co., Berlin

© Photographs
Lotte Jacobi Archives, Photographic Services,
University of New Hampshire, USA
© Text
Das Verborgene Museum e.V.

© Nicolaische Verlagsbuchhandlung,
Beuermann GmbH, Berlin
Printed in Germany
Berlin 1998

ISBN 3-87584-636-2

Unless otherwise stated, all photographs are from
Lotte Jacobi Archives, Photographic Services and
Special Collections, University of New Hampshire,
USA.
The lithographs for this book were specially produced
from original negatives, vintages prints and mod-
ern prints from the Lotte Jacobi Archives, Photo-
graphic Services. We would like to thank Gary
Samson, Dan Pouliat, Judy Eisenberg and every-
one else for their patient assistance.
Other reproductions by:
Bernd Kuhnert: p. 41
Markus Hawlik: pp. 40, 49, 83, 93, 103, 106
Dietmar Katz: pp. 47, 53, 81, 104
AFD, Atelier für Fotografie und Druckvorlagen
GmbH, Cologne: pp. 84, 96, 97
Deutsches Tanzarchiv, Cologne: pp. 106, 115
Museum Folkwang, Essen: pp. 56, 109, 186, 187,
188, 189

Contents

The Wonderful Laugh of a Headstrong Woman

When I first met Lotte Jacobi she was 76-years-old. I was instantly captivated by the vivacity of this extraordinary woman. She had an enormous lust for life, and that's the way I remember her. For years, her portrait laughed on my desk while I went about my daily work. I met Lotte Jacobi during an exhibition Otto Steinert had organized for her in the Museum Folkwang in 1973. Her personal account of her life in Berlin around 1930, and her encounters with personalities such as Egon Erwin Kisch, Max Hoelz, Joachim Ringelnatz, Lotte Lenya and Albert Einstein greatly inspired my own work.

Of all the numerous celebrities Lotte Jacobi sought to capture on film as a modern 'court photographer' of the finest kind, her portraits of Einstein reveal a special aspect of her work. She first met him in Berlin in 1927 and later photographed him several times in the USA with a 35mm camera and a plate-backed camera. These are two diametrically opposed techniques: one producing a statically comprehensible, precise reproduction of details; the other offering the opportunity to work improvisationally with movement and under extreme lighting conditions. There are no logical explanations for Jacobi's choice of cameras. The tool she used depended upon the individual conditions presented by the shot at hand. This method of working in two different ways at once is indicative both of her personal career and the rapid changes in photography at that time.

Lotte Jacobi not only had professional training as a photographer but grew up in her father's traditional photographic studio. Her great-grandfather had started the business as a daguerrotypist. Unlike the relatively large number of other young women who became photographers in Germany after the First World War, her choice of career was hardly surprising. What was indeed remarkable was her consistent and instinctive urge to break out of the tradition of portraiture which she had 'inherited'.

Throughout her life Lotte Jacobi wavered between two photographic conceptions that actually merge continually in her pictures. In 1923, influenced by the contemporary practices of the illustrated press, which promoted and created serial photography and photo-reportage, Lotte Jacobi decided to buy an Ermanox 9 x 12 cm camera. Only nine examples of these cameras as are known to have existed. Though fascinated by new photographic techniques, she hesitated to commit herself to this really modern camera. Accordingly, her 1929 self-portrait seems rather traditional. Here the ambiance of self-portrayal is not shaped by the

new Ermanox, but that monstrosity, the familiar old plate-backed camera. The old studio-camera, a large black box with a long cable release and a black cloth, has a far more drama-tic effect — the portrait transforms the studio into a stage set. (pl. 2)

Made after her unsuccessful attempt to become an actress, this self-portrait allows at least a glimpse into Lotte Jacobi's desire to play different roles. This predilection, along with her innate curiosity, a considerable degree of charm and more than a touch of dauntlessness, helped her gain access to the famous personalities of the Weimar era and later to public fig-ures in the United states. It was there, in her chosen country of exile, that she found refuge from the Nazi persecution of the Jews.

A self-portrait of 1937, taken in New York (pl. 84), shows a marked contrast to the one previously mentioned: she had become a woman with the attributes of the "new era" — with her Leica camera, complete with a cigarette and saucy hat with her short hair peeping out. Was this new image only possible for her in the "New World"?

In terms of photography, both self-portraits strikingly display, though with a time gap, the complete reduction in size and simultaneous increase in speed of photographic equip-ment. The Leica with which Lotte Jacobi portrayed herself in 1937 was something special. In the USA, it was a symbol of the advanced technology that helped the magazine industry achieve international dominance aided by a great many European immigrants. But it was not easy to start a new professional life, and in terms of commissions for the illustrated press she was never to regain the success she had achieved in Berlin. Lotte Jacobi was not a photojour-nalist, but in the early years of emigration she was forced to take on any and every commis-sion simply to survive. Nevertheless, it did not take her long to get famous people in front of her camera again. her ability to communicate and the fact that her work was not dependent on the knowledge of a foreign language made it easier for her to get back on her feet. By the end of the 1930s, through her old contacts with German emigrants and the new acquain-tances she deliberately sought with people like Alfred Stieglitz, Theodore Dreiser and even Eleanor Roosevelt, she had already resumed her practice of photographing the great person-alities of the time.

Lotte Jacobi never developed a characteristic formal style. Her approach to her subject is diverse; she rarely produced completely composed pictures. Her portraits reveal the kind of encounters she had with people, and the nature and intensity of the communication between herself and her subject. They also show the outcome of coincidences, impatience and a practice of photography that moves between traditionalism and Modernism. This con-tradiction is what gives Jacobi's work its special status, a reputation developed primarily dur-ing the Weimar Republic in Munich and Berlin. Most current assessment of this era has gen-erally been viewed culturally in terms of the avant-garde movement. In this book, Elisabeth Moortgat and Marion Beckers provide an alternative analysis of Jacobi's biographical and professional development and influences. They also take into account the tremendous pres-sures involved in building a new life in the US.

In have seldom seen an old woman who laughs in such a wonderful way. She lived in a remote part of New Hampshire, where I often visited her at the end of the 70s, but she never lacked visitors. She not only answered almost the same questions repeatedly, but thoroughly enjoyed discussing the piles of photos young photographers brought to show her. People made the trip to the rural oasis of Deering because they wanted to see this headstrong, active old lady with her acute self-awareness, lifelong experience and sense of humor. Maybe they also wanted to find out now specific events can be brought to life by an eye-witness of the times.

Ute Eskildsen

Introduction

Lotte Jacobi had her own special way of being interviewed. Her answers were usually shorter than the questions posed — not because she didn't enjoy talking about herself, but because she only reflected — to a limited extent — what she did intuitively. Like so many people of her generation, she was not in the habit of theorizing, and thought it rather pointless to question the motives behind her actions. The continuity of a middle-class family tradition established over generations gave her the self-confidence to lead her life the way she wanted and do what she enjoyed as much as possible. Without being consciously aware of it, she derived her criteria for action from the traditional 19th century humanistic world view. She hated any kinds of rules and regulations, whether photographic and artistic formulas or traditional role models, yet she remained caught within the net of dominant social consensus. This contradiction was a driving force behind her actions in every respect. Nothing shows this more clearly than 29-year-old Lotte Jacobi's decision to become a professional photographer even though she met all the criteria for embarking on a path of free photographic experimentation. She sought formal instruction but rebelled against normative direction, and nevertheless finally chose the métier of the portrait — the photographic genre most bound to tradition at that time, but still tried to go beyond the set rules and canons to express her personal viewpoint in every single picture.

Lotte Jacobi's photographic legacy is eloquent in many respects, even if it is no longer possible for us to form a complete picture of her photographic oeuvre today. The only remaining evidence of the Berlin period of Atelier Jacobi (see note 52), which was also the most intensive phase of Lotte Jacobi's career (1927–1935), was what she took with her into exile in 1935. She said this was only tiny part of the archive she had built up by that time. But the surviving collection also testifies to what Lotte Jacobi herself regarded as valuable and found especially interesting. Along with around 6,000 subjects she had photographed during her trip to the Soviet Union between 1932 and 1933, the surviving works were mostly portraits. They reveal various aspects of photographic history, biography and history which still arouse in today's viewer the same type of curiosity that motivated Lotte Jacobi to take photographs. The countless photographs published in the press give us information about the importance and widespread impact of the studio, and particularly about the way the media used individual journalistic pictures. Lotte Jacobi rarely took on any contractual assignments, but she had extensive contact with magazines in and beyond Berlin, if only because of the difficulty of tracking down all the pictures published at that time. Even today, photographs of unknown subjects preserved by private owners or in partially assembled archives still turn up at auctions and antique markets. However, the collection of negatives in Lotte Jacobi's archives, which she bequeathed in 1981 to the University of New Hampshire,

Durham, USA, give a complete overview of her photographic work in the USA from 1935 onwards. From the rich variety of material available, we have compiled a selection of photographs that present Lotte Jacobi first and foremost as a photographer of her contemporaries. In the accompanying text we examine exemplary individual works in the context of photographic and media history and trace the circumstances under which they were created, as well as the motives of, and constellations between, the photographer and her models. Though she worked mainly in portrait photography, Lotte Jacobi defended herself vehemently against being labeled a portrait specialist: "I am an artist, not a commercial photographer", she declared. She would envisage her meeting with her subject and how to convey it visually before setting a date for the photo session. The richness of her portraits is the result of a photography guided by interest in, and enthusiasm for, her models.

The publication of this book is the result of our research on the life and work of Lotte Jacobi. It would not have been possible without inspiration and information from many different quarters. The art historian Eckhart Gillen set us on the track in 1983 by introducing us to Lotte Jacobi in Berlin. We visited her for discussions several times in Deering, N.H. in the following years. Not only the artist, but also her son John F. Hunter and his wife Bernadette Hunter responded to our frequently demanding inquiries and requests with enthusiasm and support.

We had the good fortune to meet the photographer Elisabeth Röttgers, Lotte Jacobi's assistant between 1929 and 1931 and an eye-witness who recalled for us in great detail the work and atmosphere in the Atelier Jacobi. Arnold Kirchheimer, who studied with Lotte Jacobi at the Munich Photo School in 1926 and later worked for her in New York, still had vivid memories of the period after her arrival as an emigrant to the USA. Her friends Maryanna and John Hatch in Durham, N.H. offered us warm hospitality during our research in the Lotte Jacobi Archives. Beatrice Trum Hunter, John F. Hunter's first wife, never tired of our discussions. Her personal experience with Lotte Jacobi gave us insight into some aspects extending beyond the published works, and she offered us generous hospitality and welcome relaxation at her house after our daily research in the Lotte Jacobi Archives. Her help was invaluable.

Gary Samson, photographer and Director of the Lotte Jacobi Negative Archives at the University of New Hampshire, Durham, USA, took on the difficult, complicated task of producing fresh prints; we were lucky to have been able to entrust this work to a true lover of Lotte Jacobi's oeuvre. Ute Eskildsen, Director of the Fotografische Sammlung im Museum Folkwang, Essen, let us listen to tape recordings she and Sally Stein made of conversations with Lotte Jacobi in 1977. Along with her comments on the manuscript, the tapes corrected some of our own assumptions. Jürgen Freter took on the design of the pictures and text with expertise and great sensitivity. We would like to extend special thanks to all of them.

We would like to thank the following people for help of all kinds: Charles Buckley, Manchester, N.H.; Grace Casey, Portsmouth, N.H.; Janos Frecot, Berlin; Thomas Friedrich, Kleinmachnow; Manfred Gebhardt, Berlin; Monica and Walter Heilig, Berlin; Dieter Hinrichs, Munich; Anne Hoy, New York, N.Y.; Enno Kaufhold, Berlin; Michael Krysa, Berlin; Rudi Lesser †, Berlin; Kurt Lesser, Copenhagen; Antonia Meiners, Berlin; Richard Merrit, Durham, N.H.; Margaretta Mitchell, Berkeley, Ca.; Magdalena Mrugalska, Poznan; Bodo Niemann, Berlin; Frank-Manuel Peter, Cologne; Naomi Rosenblum, Long Island, N.Y.; May Sarton †, York, Maine; Beate Sauerlaender, New York, N.Y.; Ilse Siebert, Berlin; Anneliese Somogyi, Berlin; Steffi Spira †, Berlin; Ilse Wassermann, Oakland, Ca.; Geoff and Dorothy White, Inverness, Ca.; Tadeusz Zakrzewski, Toruń.

Alexander Jacobi:
Portrait of Samuel Jacobi
Toruń, around 1870

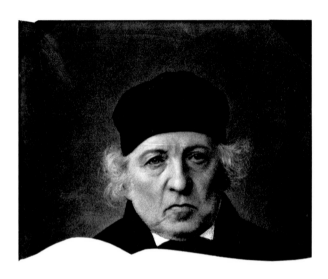

Anonymous:
Portrait of Alexander Jacobi
Toruń, around 1890

Four Generations of the Atelier Jacobi

Four pictures illustrate the story of the Jacobi dynasty of photographers. The first two are the 19th century portraits of Lotte Jacobi's great-grandfather, Samuel, and Alexander Jacobi, her grandfather. The close-up half-length portraits without trimmings reveal two affluent, self-confident, middle-class men — the elder gazing sternly into the camera; the younger's face slightly averted. Without any additional clues as to property or profession, they are depicted, in tune with the middle-class ideal of the times, against a neutral background as independent private persons.

At the end of the 1920s, Lotte Jacobi photographed her father Sigismund Jacobi (pl. 1) in a private, candlelit atmosphere, absorbed in reading a book — a frequent pose used in male portraiture around the turn of the century to indicate good education and prudence. She emphasized the darkness of the background — the traditional setting for enhancing the significance of the subject — by highlighting the head and hands. This achieved a naturalistic, exact reproduction that captured even the fine details of wrinkles and mustache hairs. The stance of the reading man, still holding the matches he has just used to light his pipe, is not an empty pose, it convinces us that he was really reading — his favorite occupation. This was Lotte Jacobi's view of her father, how she saw him at home.

In contrast to her forefathers, who present themselves as confident and complacent, Lotte Jacobi appears mobile and very restless in her self-portrait (pl. 2). Emerging into focus from the darkness, she surveys herself skeptically in the mirror with an air of fugitive inquiry — but she is the only family member to give us a glimpse behind the scenes of the photographic trade. Lotte Jacobi was always aware of the importance of this long-established family tradition and nurtured it faithfully. Especially in difficult times, notably in exile, it gave her a sense of personal security. "I was to be a photographer", was the way she voiced it in old age. She felt her destiny was linked to photography — the statement expresses both identity and detachment.

The written records of the Jacobi family go back to the 18th century. Further back in time they are lost a list of names that cannot be identified more closely. The family tree starts with the founding father Jakob in the mid-18th century. He was a leading figure in the Jewish community of Majdan, an island in the Vistula River on the outskirts of Toruń. Jakob's son Samuel was the first to adopt the name Jacobi and to become a resident in the town of Toruń[1]. His grandson of the same name, Lotte's great-grandfather, is reputed to have bought a camera and license to photograph from Daguerre in Paris in the early 1840s. Family legend holds that after his return to Toruń he ran a photography business.

"Before he became a photographer, my great-grandfather was a glazier and belonged to the guild in Toruń," we read in Lotte Jacobi's biographical notes. She goes on: "I come from

Plate 1
Sigismund Jacobi
Berlin, around 1930

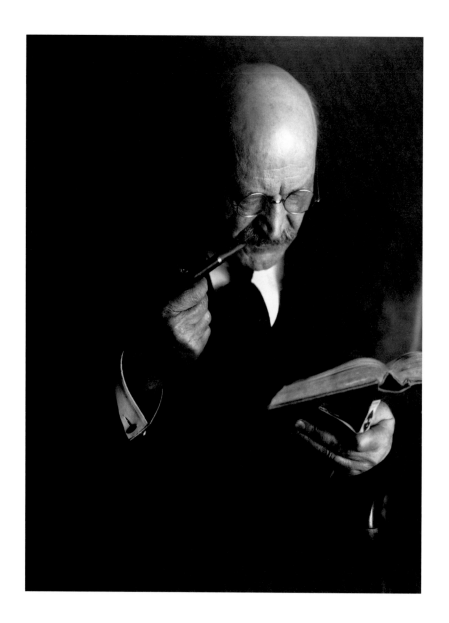

Plate 2
Self Portrait of Lotte Jacobi
Berlin, 1929

one of the oldest families of photographers in eastern Germany[2]." But no evidence remains in the city archives to confirm that Samuel Jacobi worked as a photographer.

The great-grandfather whom Lotte Jacobi never met was thus connected less by facts than by legend to the Jacobi heritage of photography. It was with her grandfather Alexander Jacobi (1829–1894) that the family history entered the realm of the documentable. The Jacobis counted among approximately 400 Jewish residents of the Prussian garrison town of Thorn, later and currently know by its Polish name, Toruń. At the time, they were not counted as a separate minority group within city's the total population of ten thousand Polish and German inhabitants. As a Prussian Jew, Alexander Jacobi did his military service in the Musical Corps. He then went on to train as a photographer.

In the second half of the 1850s, he took over management of the studio started by the photographer Benno Friedländer. His own studio was formally registered for the first time in

Section from the Thorn address book
1876
Toruń City Archive

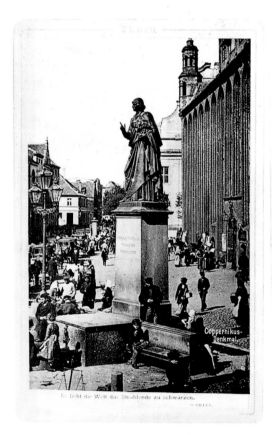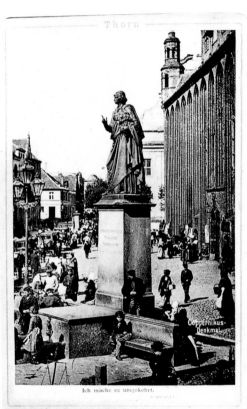

Alexander Jacobi:
Stereoscope of the Copernicus
Monument
Toruń, 1866
Copernicus Museum, Toruń

1866 and in 1869 he opened the studio on Mauerstraße, which was located on the border of Toruń-Neustadt.[3]

He successfully fought off competition from the growing numbers of itinerant photographers in the 1860s to establish a studio second only to that of Julius Liebig.[4] He soon became successful and gained esteem with lucrative commissions for portraits of the town notables, reproductions of paintings and public contracts for architectural photos which, like the portraits, were published in official prestige albums.[5]

As a prosperous businessman he now belonged to the town council, and over the years the family business in Toruń developed into a medium-sized enterprise with branches in Inowrazlaw, Culm, Poznan and the military post of Podgórz on the opposite bank of the Vistula to Toruń.[6] In the Toruń town directory, Jacobi regularly advertised his "photographic-

Atelier S. Jacobi, Poznań, around 1917

artistic atelier" as "producing photographic portraits" and "copying paintings, engravings, lithographs and photographs etc." In addition, he mentioned his specialization in stereoscopy, a photographic fad at that time. The stereoscope was used primarily to show three-dimensional images of the city's tourist attractions and its countryside.

Of Alexander Jacobi's three sons, Franz took over the studio in Inowrazlaw. Julius initially ran the branch in Podgórz and Sigismund managed the main office in Toruń for a few years after his father's death in 1894. All three brothers had learned the craft of photography.

Sigismund, the eldest, born in Toruń in 1860, had previously studied chemistry in Switzerland. In 1898, two years after the birth of his first daughter, Lotte, he moved with his family to Poznan and tried to create a healthy business out of the branch that had been there since 1895. The fortress city of Poznań, known by its German name, Posen, at the time, had been the capital of the South Prussian province of the same name since 1815; at the turn of

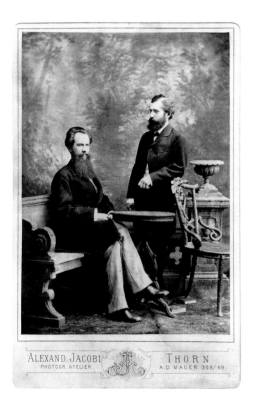

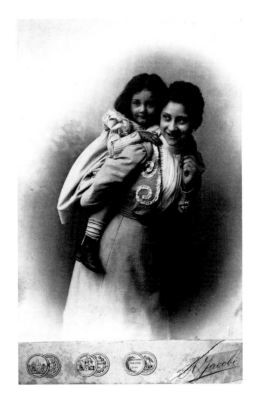

Left
Alexander Jacobi:
Marcin Górski and Leonard Kostrzenski
Toruń, 1881
Historical Museum of the
City of Poznań

Center
Sigismund Jacobi:
Lotte with nanny
Poznań, 1899

Right
Reverse of a photo
by Sigismund Jacobi
around 1900

the century it was elevated to the status of a royal seat of residence. The German Reich made a great drive to encourage state officials and military organizations, lawyers, doctors and teachers to move there; this offered the prospect of a growing clientele of well-to-do people. The lay-out of the city was based on the model of Berlin, the capital of the Reich, with boulevards and apartment houses which were built in the style of the Gründerzeit, the era of expansion in the 1870s. Booming business in Poznań encouraged the growth of photo studios — among them Atelier Jacobi. Located in the city center, the studio had large display windows that characterized its storefront, and insribed in large letters above the entrance was the name of the owner: S. Jacobi.[7]

There are three main reasons why only a few existing photographs can be definitively ascribed to Sigismund Jacobi; first, he retained the seal of his father, Alexander Jacobi, on his carte de visite photographs. Secondly, at that time, it was unusual for landscapes and city views to be provided with the name of the studio. And finally, all private and public collec-

15

tions of photographs were almost completely destroyed during the destruction of Poznań in World War II.

The extent to which Sigismund Jacobi's business concentrated on portraiture is shown on the reverse side of his carte de visite portraits. They bore the typical contemporary designation "Photogr. artist. Ateliers" (photographic and artistic studios). The seals indicate the dates when they were awarded and document Sigismund Jacobi as their originator. The reference to platinotyping emphasizes the use of quality materials in processing and specialization in various kinds of photography including "… children's and group portraits. Snapshots and reproductions. Photos of paintings, interiors, machines, landscapes, animals etc". Commission like these comprised the bulk of the work done by professional photographers like Sigismund Jacobi. Continual competition from within the field and the rise amateur photographers — who took pictures of families, friends and acquaintances — led to diversification in the trade. Technical advancements revolutionized reproduction techniques, made processing cheaper, and rendered mass production and broad distribution of picture postcards possible. But what truly turned the art into an industry, was the invention of autotyping, which make it possible to illustrate newspapers and magazines with photographs. The introduction of this process signaled the age of press photography.

The seals on Jacobi's works indicate participation in exhibitions in Krajowa (Lemberg) in 1894, Poznań in 1895, and Graudenz in 1896, where he received an award for "excellent achievement". The names of the towns on the seals were in either Polish or German, a fact that shows whether Poles or Germans were running the exhibition. Although it is certain that Sigismund Jacobi attained the title of "court photographer," there is no longer any indication of why it was granted. From 1896 on, Kaiser Wilhelm II made repeated visits to the city of Poznań and its eastern provinces. The trips were part of a campaign to raise the level of culture in the area, to make it more attractive to Germans, and to bring the twin seats of residence, Berlin and Poznań, closer together. If nothing else, the imperial certificate of gratitude displayed on the photographs — personally signed by his Majesty, the Emperor and King, Wilhelm II — certainly indicates that Sigismund's business was thriving.[8]

Left
Sigismund Jacobi:
Lotte with dog
Toruń, 1897

Right
Sigismund Jacobi:
Lotte, Mia Jacobi, Ruth
Poznań, 1900

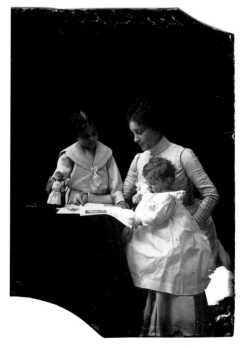

Johanna Alexandra Jacobi — Growing Up

Johanna Alexandra Jacobi, called Lotte for short, was born in 1896 while her parents were still living in Torun. The eldest daughter of Sigismund Jacobi and his wife Mia, Lotte grew up in Poznań in the atmosphere of her father's prospering photography studio. Her younger sister Ruth was born in 1899; brother Alexander followed in 1902.

From the time she was a child, the smells of the darkroom and the concoctions her father prepared for print paper emulsions and developing were as familiar to Lotte Jacobi as the outdoor exposure of heavy glass plates. But what especially impressed her were the extravagant settings for portrait photos, the arrangements of accessories appropriate to the sitter's status and the different colored backdrops. In her later years, she enjoyed reminiscing about the powerful impact of her father's work on her view of the world as a child. Going home with her mother one dark winter evening, she remarked quite naturally that the dear Lord had pulled down the dark backdrop once again.

Sigismund Jacobi's experience with his own children may well have led to him to list the photography of children as one of his specialties. This type of photography was considered particularly difficult "because the young clients didn't like to hold still for the amount of time needed to take the shot".[9] Yet we can see Lotte Jacobi at the age of two, photographed by her father, sitting on the sofa with the obligatory palm as decoration, carried piggy-back by her nanny or with her sister, brother and the maid on an outing in their Sunday best, or proudly showing off a toy. Sigismund Jacobi's pictures of his children show a prosperous family similar to those of his potential clients.

Lotte Jacobi made her first attempts at photography at around the age of eleven with a pinhole camera constructed with her father's help. He insisted that she learn the principles of the photographic camera. At the age of thirteen she was given her first real camera, an Ernemann 9 x 12 cm plate-back camera.

She loved photographing landscapes and — right from the start — people. One of her first experiments with the new camera has survived — a picture of her brother with a friend

Left
Sigismund Jacobi:
Ruth, Lotte and their nanny
Poznań, 1900

Right
Sigismund Jacobi:
Alexander, Ruth and Lotte
Poznań, around 1904

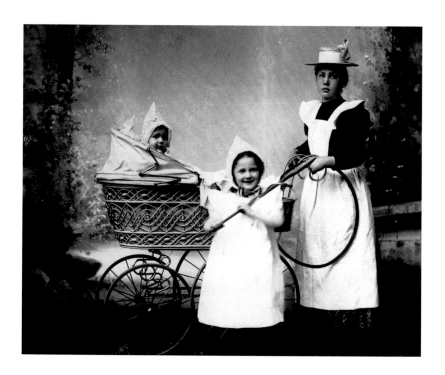

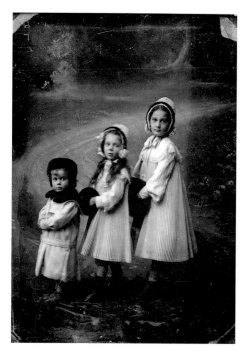

17

in the backyard of the apartment house where they lived. One can see their father in the cellar door, obviously following the impromptu portrait session with interest.

This was the decade before World War I, which saw growing tension between the Polish and German populations. The Polish minority were no longer willing to accept their loss of independence. Under Kaiser Wilhelm II, Germany's policy towards Poland was characterized by intensified efforts to integrate the Prussian province into the Reich. Like all the Jews of Poznań, following what was known as 'the emancipation' of the mid-19th century, the Jacobis had Prussian or German citizenship. They enjoyed good relations with the Polish population and had Polish servants, like most middle class Jewish families at the time.

Although Lotte Jacobi grew up without religious training and in an atmosphere of tolerance and cosmopolitanism, by observing clients at the studio and from her experiences at school she learned at an early age the problems that minorities could experi-

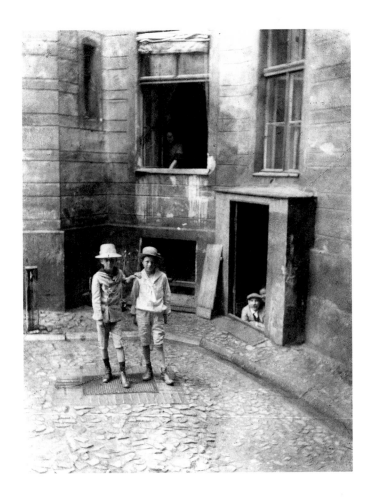

ence in society. As an older woman, she still remembered the hostile climate induced by the forced Germanization of the city. Perhaps this laid the foundation for her outspoken liberal opinions and her acute sensitivity to politically motivated discrimination.

At the age of seventeen, shortly before the outbreak of the First World War, Lotte Jacobi finished the last of the ten grades at the Girls' High School of Poznan-Wilda, but she refused to consider a profession. She firmly rejected the obvious option of taking up photography. She bewildered her parents even more when she announced one day that she had made all the necessary arrangements for training to become an actress at the Poznan Theater — all she needed now was parental agreement.

"If having a job was already degrading enough for a girl in those days, wanting to be an actress put her well beyond the boundaries of what was permitted and traditionally accepted. A young girl might have been allowed to paint, play the piano and sing, but God forbid that she have any artistic aspirations — again, that would look suspiciously like a career. She was supposed to wait for the man she would joyfully follow into marriage whether she loved him or not; the marriage would then result in the birth of another 'waiting maiden', who would in turn … and so on for all eternity."[10] In those days Lotte Jacobi could have hardly foreseen the ring of bitter truth in this autobiographical recollection by one of her contemporaries, Tilla Durieux, the grande dame of acting.

Lotte Jacobi's parents did not immediately try to force their daughter into submission; they realized that the best way to control her theatrical ambitions was for her to take private lessons with a professional actress. In the end, Lotte Jacobi's enthusiasm for a career in the theater, which inspired her to give a daily recitations for the whole family at dinner, remained

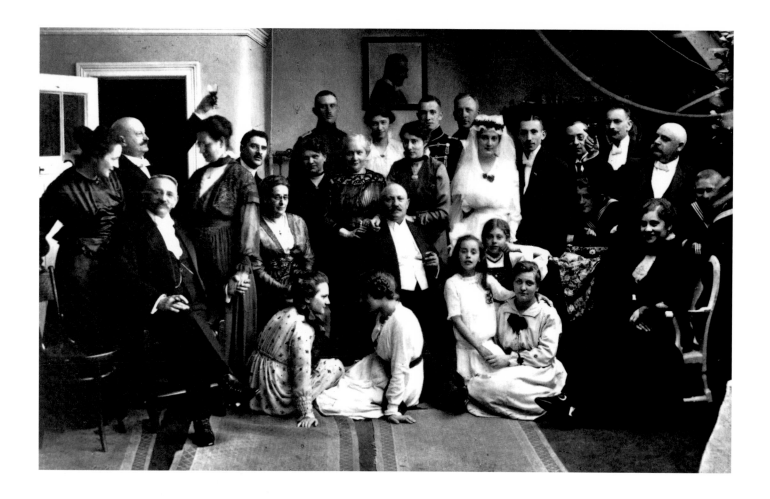

Sigismund Jacobi:
Wedding photo for the marriage of
Lotte Jacobi and Siegbert Fritz Honig
May 21th, 1916, Poznań
Lotte's mother is standing second
to her left next to Sigismund Jacobi.
To Lotte's right is her husband

nothing more than an amusing episode. Her study of acting was only a short interlude in her life. But her fascination for the stage, especially for comedy, was revived in a different way in Berlin in the 1920s.

For a while Lotte continued taking photographs for pleasure, attended history of art courses at the academy and longed for a life in the country. But when she finally made the decision to study photography in England, the First World War put a stop to her plans.[11] For a brief period, the daily routine of the studio turned to monotony with the production of photographs of soldiers.

Then in 1916, she embarked on a different path by marrying Siegbert Fritz Honig, the son of a Poznan wood merchant.[12] After only four month of life together, the couple separated for the first time. In 1917, her son Jochen was born, and in 1920 she tried once again to live with her husband. They left Poznan, which had been returned to Poland in 1919 under the Treaty of Versailles, and moved to Berlin. Her parents followed a short time later. In 1926, Lotte Jacobi's marriage finally ended in divorce. The previous year, at the age of 29, she had decided to go learn her father's trade at the *Staatliche Höhere Fachschule für Phototechnik* (State Higher Academy for Photo-Technology) in Munich.

"Forget the idea you can already do something"

When Lotte Jacobi went to Munich in 1925 to start her studies at the *Staatliche Höhere Fach-schule für Phototechnik*[13], she belonged to a generation of women who did not use the camera primarily as a tool of their chosen trade, but as an "instrument of self-definition". "These women were no longer interested in the photographic image as it was associated with a specific crafted to a specific locality, but more in relation to their own experiences."[14] Lotte Jacobi's motivation for studying was not based on the future prospect of a steady professional job where she would most likely be obliged to accept imposed conditions. She certainly had no intention of transforming female clients into Greta Garbos or being forced to produce portraits in line with current tastes with the aid of the retoucher's paintbrush. Her main inspiration was derived from her curiosity about life, the world of art and increasingly, politics. With her natural spontaneity and strong likes and dislikes, she was hardly ever willing to compromise her inner feelings.

Sigismund Jacobi:
Lotte Jacobi
Poznań, 1920

The key to Lotte's approach was her uncomplicated attitude towards other people, her constant openness to new inspiration and delight in unusual ideas. She frequently used the camera as a pretext for gaining an introduction to people she wanted to meet and whose artistic and political interests she shared. Her portrait sittings often led to life-long relationships and close friendships.

Self-confident and stubbornly persistent, she tried to pursue her personal interests and make her own decisions about how to lead her life. Her family did not oppose this. "During the Weimar period, women like this benefited from the short-lived historical conjunction of traditional bourgeois privileges and the radical expansion of job opportunities, though in subordinate positions — especially in new fields such as journalism, film and architecture... They often came from secure family backgrounds, in which well-bred daughters were not necessarily expected to have profession, but were not prevented from having one either ... That fleeting moment of historical transition gave this highly unusual female minority an extraordinary chance to combine family life, a job and involvement in the affairs of society ..."[15]

Throughout her life, Lotte Jacobi frequently felt compelled by external circumstances to take on commissions and jobs that contra-

Sigismund Jacobi:
Lotte Jacobi and her son, Jochen
Berlin 1923

dicted her basic concept of freedom in action. But she always maintained a deep-seated desire for self-determination. After all, when she was six-years-old her father had made it clear that she could do what she wanted, regardless of social convention. This was a children's edition of the image the Jacobis had nurtured for generations: the self-defined, well-educated bourgeois individual imbued with humanism.

This explains Lotte's decision not to study photography in her home town, and her desire to see more of the world than the perspective her father's studio can offer. In addition, after her divorce from Siegbert Fritz Honig and the break-up of their home, she was faced with the problem of building a new life together with her son, who was seven-years-old at the time. For practical, not to mention financial, reasons it would have been easier for her to study photography at the *Lette-Verein* (Lette Association) in Berlin, which had been set up specially to train and educate women professionals. Her sister, Ruth Jacobi, had completed her photographer's training there in 1922. Lotte's resolve to go and study in Munich was unconventional, as was her decision to entrust the education of her son to the teachers at a nearby boarding school. "We visited each other by turns", she said later, recalling her relationship with her son at that time.

Along with the idea of using her art studies to gain access to artistic and Bohemian circles, while she was in Berlin, Lotte must have already been thinking about attending courses in film studies at the Munich Academy. Her student card shows that in October 1925 she was already enrolled in the department of cinematography. By opting for the *Staatliche Höhere Fachschule für Phototechnik* she had certainly chosen the only institution in Germany with international status. It had been set up in 1900 as the "College of the South German Photographic Society in Munich for Teaching and Experimentation in Photography, with privileged status granted by the Royal Bavarian State Government". Initially open only to male students, "ladies" were first admitted in 1905.[17]

The college had been founded to help stop the decline in craftsmanship that had begun in the Gründerzeit, the era of rapid industrial expansion towards the end of the 19th century. The college placed special emphasis on combating the stylistic decline of portrait photography. The curriculum advocated "teaching based on artistic principles for freelancers who are exploring subjects from their own viewpoint" and the rejection of "soulless technology" in favor of an "individual approach".[18] Its aspirations for reform were underscored even more clearly in the inauguration speech given in 1900 by its first director, Georg Heinrich Emmerich: "The photography we want to teach here is different from what you've already learned; so forget the idea you can already do something; the further you get away from this idea, the more receptive you will be to what we are offering."[19]

We may be right in discerning here the first glimpses of a reform-based education similar to that which led to the radical practices of the Bauhaus period after the First World War. But at the Munich College the development of this modernist educational approach — trusting one's own eyes rather than copying predetermined forms — did not last long. In 1921, the College was taken over by the state and by 1925, the year Lotte Jacobi began her studies there, the aims were still essentially the same as when it was founded: "The College is continuing its aim of giving students wide knowledge and practical skill in purely technical areas,

with the goal of awakening their sense of good taste and visual perception."[20] In this period of general artistic and conceptual stagnation, the College — as an institution responsible for training the next generation of professional photographers — drew its legitimacy primarily from the resurgence of job opportunities after the First World War: "The photographic profession has survived the hard times that set in after the war, which means that new graduates now have the chance of finding a position immediately …".[21]

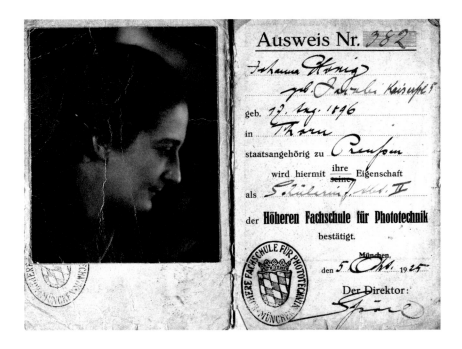

There were 51 new students in the winter semester of 1925; Lotte Jacobi was one of the 26 "ladies". Of the school's total of 97 students, 21 came from German-speaking regions, the remainder from Holland, Scandinavia and the Baltic, Poland, Hungary and Czechoslovakia.[22] The fact that more than half the students in the Photography Department were women was obviously the result of "a trend that had been prominent for some time, to educate girls and women in particular". Meanwhile, mainly because of growing competition, professional photographers were of the opinion that "from an general standpoint … we would be well advised to provide preferred access to apprentice positions to male students."[23]

Until 1927, the College's aspiration to develop new approaches to photography was limited to hiring new staff[24], which had no notable effect on actual instruction. Hanna Seewald graduated from the College in 1925; in the same year, she was one of the first of the younger generation to be appointed by Hans Spörl, the director, primarily to assist him in teaching first semester classes. At least up to 1927, Seewald's teaching was still based entirely on art photography, so that Lotte Jacobi and her fellow students continued using the same German syllabus their teachers had studied. Their models were the art photographers Heinrich Kühn and Hans Watzek, along with Hugo Erfurth, who had begun to liberate portrait photography from the prevailing rigid attitude that favored prepared sets for the picture.

Only after 1928 did the course of study extend beyond portraiture to include architectural, industrial and landscape photography. Photolithography was replaced by direct silver bromide printing. Willy Zielke, who was a student at the college from 1924 to 1926 and was involved in experimental photography, was appointed to the teaching staff in 1927. But the trend known as *Neues Sehen* or "new seeing", was to remain a topic of debate at the College for years to come.[25] Finally, at the end of the 1920s, the influence of Edward Steichen's fashion photography on Hanna Seewald's work marked a turn towards a more objective conception of photographic design.

Consequently, as far as the portraiture courses were concerned, Lotte Jacobi's studies between 1925 and 1927 took place in a period when a conceptional vacuum existed in photography. In 1926, Willi Warstatt, a leading critical observer of the photographic scene of that period, surveyed the doldrums of photographic production in Germany in his article about the state of German portrait photography, "Wo stehen wir?" (Where do we stand?). He attributed the situation to the economic effects of World War I, but even more to the lack of any international exchange. At the end of his résumé, he mentioned the first major photo-

graphic exhibition in 1926 in Frankfurt and concluded that despite a great many "errors of taste", there was no hope for the objective approach of someone like Hugo Erfurth. Erfurth's works were not based on "… a soft, shimmering variety of tone, or on nervously exaggerated expression …, but on working with the possibilities of simple planes and lines and the tranquil but vibrant portrayal of an individual's personality."[26]

In painting, there was already a well-established contemporary concept that saw people as being born of pre-existing relationships, on a constant quest and as victims of circumstance. Artists were continually finding new ways of expressing humanity's lack of orientation.[27] Meanwhile, professional photographers were still clinging to the kind of portraiture created by art photography around the turn of the century.[28] The debate about pictorial photography dragged on for around 25 years. Whether photographs should be "mistily blurred" or "softly out of focus"[29]; whether they should be produced by different printing techniques or more naturally by using soft-focus lenses; how the photograph could be "true to life" without imitating the mode and impact of painting; whether the tendency toward clearer contours revealed the notion of an over-egalitarian society; and finally, whether the portrayal should be modeled on daily life or should be an ideal image; these are debates which intensified in the trade press towards the end of the decade, with the "New Photography" having established itself in the public media from 1925 onwards.[30]

How did Lotte Jacobi experience Hanna Seewald's classes? We can only get an indirect idea from Seewald's photographic works such as *Portrait of a Seated Woman, Dreaming* or *Young Man*, and by looking at the printing techniques employed, which included pigment printing, bromide oil printing and carbon printing[31]. The course still concentrated on portrait photography and photolithography — rubber, bromide oil painting and bromide oil processing. The creativity of the students continued to be assessed on the basis of their ability to imitate painterliness in photography; although this was in line with the contemporary maxims of true-to-life reproduction and naturalness, aided by improved printing techniques, there was now greater scope for individual expression. Subject and execution of the photograph were still both completely bound by the standard of achieving artistic effects by means of painterly qualities. If Hanna Seewald was amenable at all to individual divergence in her student's work, it may have been the result of a third-year course for promoting artistic photography that was introduced during her student days and was open to particularly talented students. The course was intended to inspire "personal feelings in the conception and portrayal of forms of artistic expression". It did not concentrate on the field of "photography for daily use and done on commission" but in the less familiar area of photography for the art market.[32]

Lotte Jacobi declined to abide by the rules of academic portrait photography, which stipulated that it was the pictorial canon, not the personal statement, that should determine the portrait. This is confirmed by a photograph that still exists from 1926: the portrait of Josef Scharl (pl. 4). There is also evidence of a conflict between Lotte Jacobi and Hanna Seewald concerning the correct conception of portraiture in the context of her graduation work.[33] But where did Jacobi find the self-confidence to bypass the ritualized pictorial canon and capture her subjects at the very moment she thought she could recognize the essential nature of the person facing her camera?

Along with the German photographic tradition, another trend had also been part of instruction at the College for a good two decades before Lotte Jacobi took up her studies in Munich. This was the photography of the American pictorialists and "straight photography", the modernist version of art photography, which was pioneered by Paul Strand, Alfred Stieglitz and Gertrude Kaesebier. In 1910, when Alfred Stieglitz visited the school with Georgia

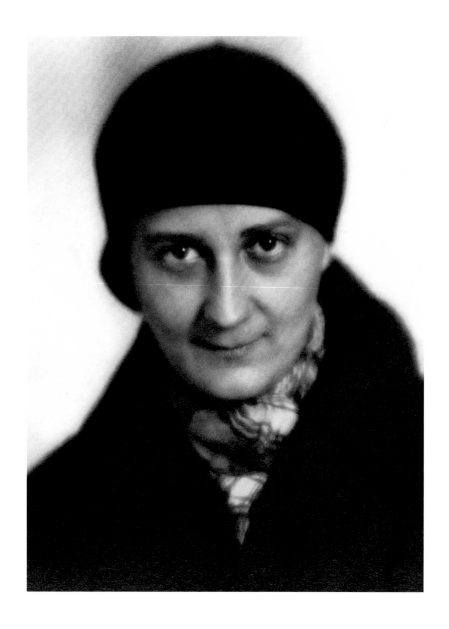

Plate 3
Sigismund Jacobi:
Lotte Jacobi
Berlin, 1928

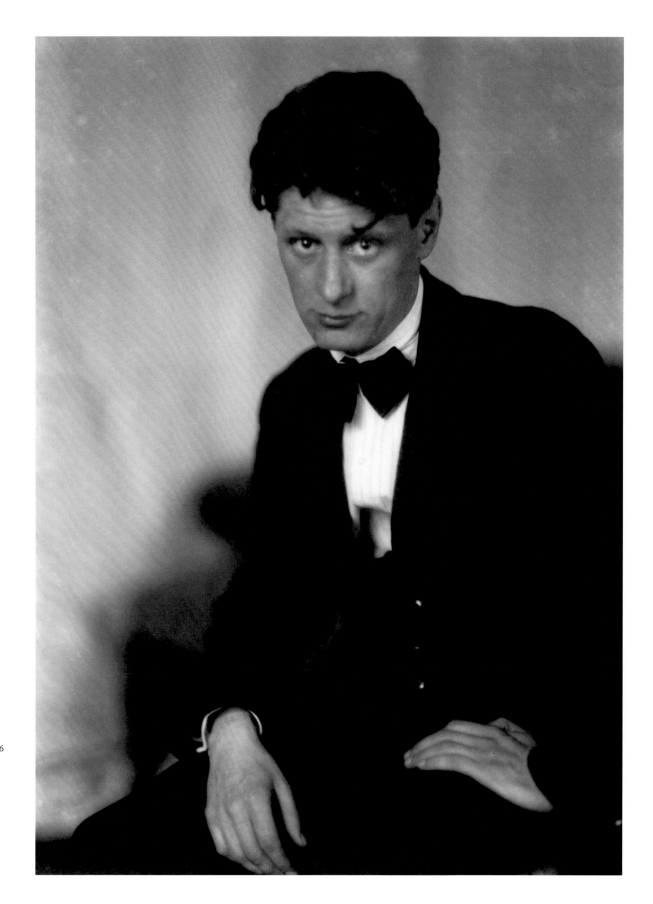

Plate 4
Josef Scharl
Munich, 1926

O'Keefe, he brought with him 36 issues of the journal *Camera Work* for the College library and two hundred fine prints by artists from the New York Secession. The American photographer Frank Eugene, who considerably enhanced the international reputation of the College when he taught there from 1907 to 1913, worked consistently on extending the collection. It was he who brought the debate from New York to Munich about how artistic photography could express different nuances without atrophying into the formalism of imitating painterliness.[34]

We can only guess at the influence this exemplary collection of American photography would have had on Lotte Jacobi. Even before the First World War, starting with Paul Strand[35] who was followed shortly afterwards by Alfred Stieglitz, American portraiture had became freer with respect to the representation of the person and his ambiance. A historian of photography has described Alfred Stieglitz's approach: "Instead of rigidly forcing his portrait subject into a single image and ... aiming for totality, trying to follow the 19th century bourgeois concept and producing an universal statement about the person that completely revealed his human identity, Alfred Stieglitz chose to emphasize the imminent aspect and the varyious facets of the sitter's personality..."[36]. By contrast, German portrait photography was still doggedly clinging to the idea of the total, unbroken image of the individual. It was well into the 1920s before a conception of the portrait in photography began to emerge that provided a glimpse of the new questioning approach to portraiture. If we include the experimental nature of Lotte Jacobi's portraits in the category of "the imminent aspects and the varyious facets," we can see how close she was to the American notion of portrait photography.

Lotte Jacobi was not interested in grandiose ideas, over-exaggeration and stylization; even her earliest portraits are strongly marked by the setting, the atmosphere and the personal characteristics of the sitter. This may have been the reason for her disagreement with Hanna Seewald, which was only superficially about formal photographic questions. It actually centered on a basic difference in approach with regard to what should be communicated about the person in the picture.

During the portrait session, Lotte Jacobi looked for an image that she liked, without neglecting the subject's wish for a likeness of him or herself. She knew how to inspire the person facing the camera to reveal something of themselves not usually disclosed in the face they presented in public. The result was an insight into private realms and intimate feelings without indiscretion or insensitivity. The pictures contained moods people were not accustomed to showing in portraits. Instead of following the canonical approach, Lotte Jacobi tried to establish communication, dialogue and mutual sympathy by watching the sitter thinking deeply, reminiscing, active, and often laughing. Her aesthetic portrayals were born of the specific situation.

The Department of Cinematography

Given her accumulated knowledge of photography, it is hardly surprising that Lotte Jacobi grew bored at the photographic department of the College. She supplemented her studies there by attending Heinrich Wölfflin's courses at Munich University on "basic concepts of art history". In her second year at the College, she switched to the department of cinematography which had been set up in 1922.[37] As the only woman in the department, she was in an awkward position. But unlike her fellow female student contemporaries, she did not let herself be discouraged by the teacher, Mr. Koch, an engineer.

She rapidly developed a great enthusiasm for film-making, and later often recalled how much she had learned there that helped her later as a photographer.[38] In this department, she could pick and choose from a wide range of courses that dealt with technology and technique: in the introduction to the history of art and culture, studies in style and costume, the classes on dramaturgy, directing and acting[39] and in transforming a set and actors into cinematic images. But she seems to have benefited most from learning about the modern art of camera work, close-ups, and set lighting with the new Jupiter lamp.

The course required her to make four student films[40] — two features, a scientific film and an animated film. The subject of one of the two features is especially interesting: the artist painting a portrait — a theme she would return to again and again (pls. 15 & 16). The main character in this ten-minute graduation film was a friend of Lotte Jacobi's, the painter Josef Scharl. The film depicts him preparing a portrait sitting for a friend who had just come into

Film students at the
*Staatliche Höhere Fachschule für
Phototechnik* in Munich at a film
screening in the apartment of the
student Willy von der Mühll;
left front is Arnold Kirchheimer,
in the center, Lotte Jacobi
Munich, 1926

his studio. At the same time she was making the film, Lotte Jacobi also took a photographic portrait of Scharl. One of her earliest surviving portraits, this picture of the painter seated is an excellent example of the method and conception underlying her portrait work (pl. 4). It radiates intense expressiveness and the sitter's concentration on Lotte Jacobi as the photographer; at the same time it remains ambiguous. The spatial setting is vague. The viewer cannot even identify the kind of chair Scharl is sitting on; his glance reveals familiarity but also a hint of skepticism. The posture of his head and body hover between intimacy and reticence. In contrast to her film, where she shows the artist at work, in the photo Scharl appears totally fixated on the camera — and the photographer behind it. He is smartly dressed, almost dandified. Here, Lotte Jacobi's personal signature is unmistakable. We see the clear outlines of the painter's head and hands against the flowing light and dark background. The contrasts evoke, the withdrawal of the body due to the darkness of the suit — but most of all we are aware of the facial expression that sets the mood of the picture.

This very personal portrait of Josef Scharl expresses the affection between the photographer and painter, an affection that would mark their relationship for many years to come. In Scharl's company, Lotte Jacobi was to find a productive exchange and inspiration from artistic and intellectual circles. Meanwhile, in the growing climate of reactionary politics in Munich, he was becoming ever more an outsider. It was in this period that she became an admirer of Karl Kraus, and it was in Scharl's studio that she also met Karl Valentin. She finally succeeded in persuading Valentin to sit for a portrait a few years later in Berlin — by inviting him to a Bavarian meal (pl. 24).

Plate 5
The Kaiser Wilhelm Memorial Church
Berlin, 1932

Plate 6
Berlin, around 1930

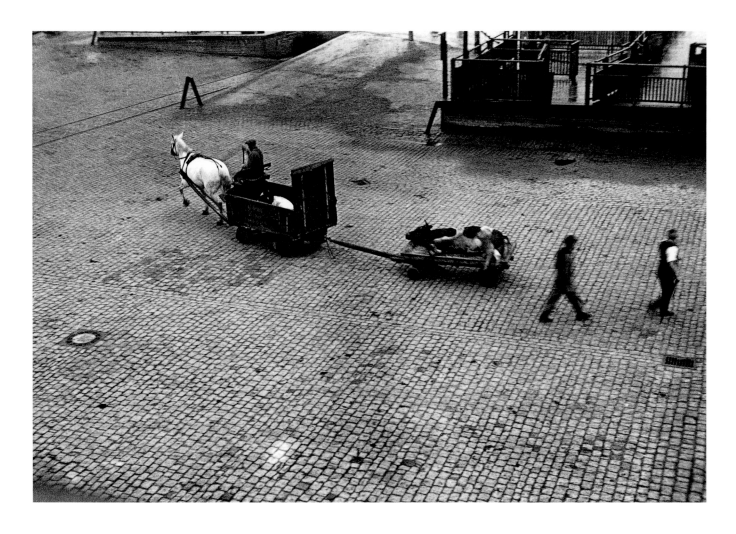

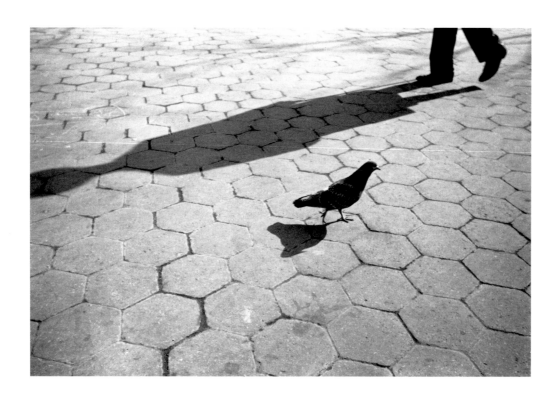

Plate 7
Out for a walk
Berlin, around 1930

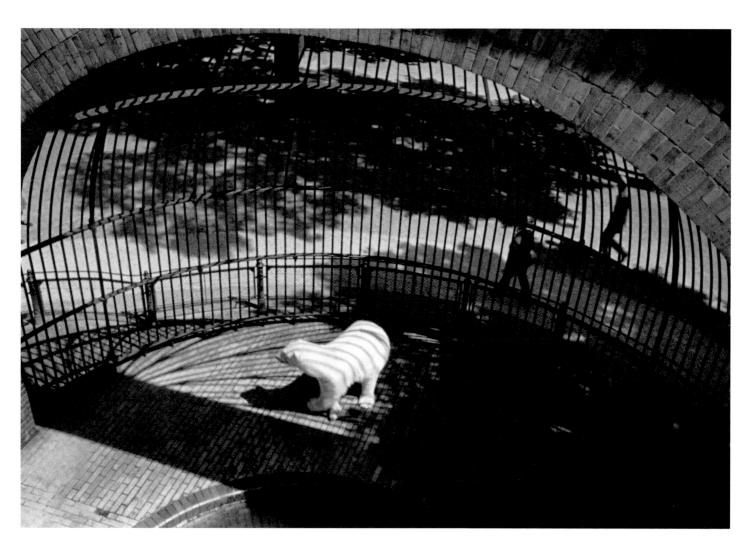

Plate 8
A polar bear at Berlin zoo
Berlin, 1930

Plate 9
Hans Richter
in front of the
Shell House
Berlin, 1931

Plate 10
The Fratellinis
Berlin, 1930

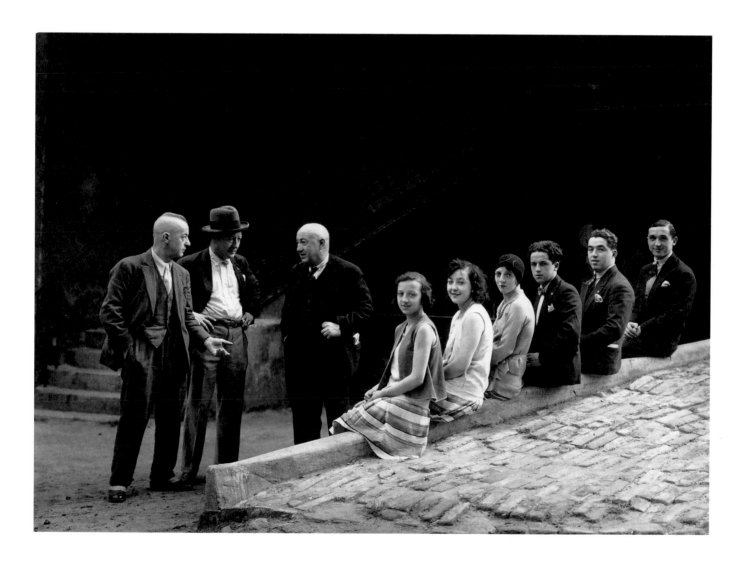

Atelier Berlin

The Berlin Atelier Jacobi was based in an apartment on the first floor in the center of the new west end of the city at Joachimstaler Straße 5, on the corner of Kantstraße. The windows faced north-east, providing plenty of light. The reception room and studio itself were situated in the more sumptuous area of the apartment. The family's private living quarters, by contrast, were rather small and cramped.

Around the turn of the century the new west end had been the birthplace of Modernism, and people of liberal outlook continued moving into the area around the Kurfürstendamm boulevard right up until the 1920s. Like the Jacobis, many were of Jewish origin. They had an attitude of open-minded cosmopolitanism and were eager to keep up with the latest trends, especially with regard to what was happening in America.

The lively atmosphere they created was joyfully reflected in the local cafés, bars and restaurants. Eating and drinking, dancing and entertainment went on around-the-clock. Luxury shops and fashion boutiques settled into the Kurfürstendamm area. Most were exclusive branches of established businesses in Berlin's traditional city center, the Mitte district. The result was a vibrant mixture of mass culture and avant-garde. The neon advertisements around the Kaiser-Wilhelm Memorial Church were not the only way Berliners and their visitors succeeded in turning night into day.

"Kurfürstendamm is the main street for having a good time in Greater Berlin; it has even surpassed Friedrichstraße. You can see row upon row of cinemas, coffee houses, nightclubs, cabarets, and pubs for wine and beer. Tucked in between are bookshops and art dealers with splendid interior decor, elegant boutiques and other luxury enterprises, each completely tailored to meet the needs and cater to the taste of a specific segment of the public. As far as consumption is concerned, the new westend has become independent of the inner city, which a lot of people around here now think of as being for business only and no longer for pleasure."[41]

Lotte Jacobi's decision to rent an apartment with her family in Augsburger Straße in 1920 must have been quite deliberate. The street was located in the middle of the up-and-coming area with the postal code "Berlin W". Her parents arrived from Poznań barely a year later. They were obviously motivated by similar considerations in their choice of location for their apartment and studio. The family was still wealthy enough to be able to afford a studio in a posh downtown area. Sigismund Jacobi was now 60-years-old, but the Jacobis were still adaptable enough to risk embarking on a new course in this district of the city where the lifestyle involved abandoning traditionalism for Modernism.

By setting up a photo studio in the new west end, Lotte Jacobi must have also decided, albeit indirectly, to seek a new kind of clientele. Civil servants, officers and higher-ranking

employees, the classic customers for a portrait studio in the better districts, still preferred the famous name studios with addresses in Berlin-Mitte: Bellevue Straße, Friedrichstraße, Leipziger Straße. These included Atelier Becker & Maass, run by Marie Böhm as well as Zander & Labisch and Atelier E. Bieber, one of the oldest studios in the city. Only a few of the photo studios set up in Mitte in the period before the turn of the century — such as Atelier Dührkopp — made the move to Kurfürstendamm.

The new west end was especially popular with the younger generation born around the turn of the century. They had hopes of profiting from the local Charlottenburg residents, or simply felt attracted by the atmosphere, as Lotte Jacobi was. The circle of photographers included Suse Byk on Kurfürstendamm, Yva (Else Simon) with her studio in Bleibtreustraße — which specialized in fashion — the portrait photographers Hanna Riess in the Gloria-Palast building and Steffi Brandl on Kurfürstendamm on the corner of Uhlandstraße. Erna Lendvai-

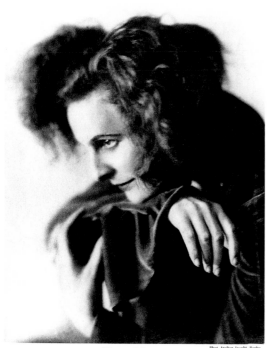

Kleine Sphinx
Die schöne Filmschauspielerin Leni Riefenstahl, die in dem Hochgebirgsfilm „Die weiße Hölle vom Piz Palü" starke darstellerische Kraft verriet
Phot. Atelier Jacobi, Berlin

Little Sphinx — Leni Riefenstahl, in: Scherl's Magazin, vol. 6, No. 2, February, 1930, p. 201
Köhler Collection

Dircksen had her studio on Hardenbergstraße, while Elli Marcus on Niebuhrstraße was Lotte Jacobi's greatest rival in theater photography. Hans Robertson, who concentrated exclusively on dance photography, was also to be found on Kurfürstendamm, along with Alexander Binder and many others whose names were less prominent. The 1929 Berlin area telephone book tells us there were approximately 430 photographic studios in the city; more than thirty percent of which were run by women. In that same year we find the entry: "Lotte Jacobi, Joachimsthaler Straße 5"; in 1933 "foto-jacobi" was listed both under the heading 'photographic studios' and in the section "Industrial & Advertising Photography".

"After her professional training in Munich, Lotte Jacobi transformed her father's portrait photography studio in Berlin into an enterprise for journalistic portraits. She preferred working on commissions from magazines to studio portrait sessions. The magazine work gave her the chance to meet well-known people at home or work. Visual imagination was less important to her; it was her personal curiosity that provided the impetus for her constant production."[42]

In 1927, Sigismund Jacobi asked his absent daughter to come back to his studio in Berlin after completing her studies at the Staatliche Höhere Fachschule für Phototechnik in Munich. His daughter was not at all happy about this, and would much rather have taken up an offer from a film company in the Bavarian capital.[43] Until that time, her sister Ruth, who had undergone training as a photographer at Lette-Haus in the early 1920s, had been working in her father's studio. But she actually much preferred photographing objects and fashion pictures. Now married, she wanted to leave Germany for America.[44] "She really liked it [working as a photographer]," Lotte Jacobi recalled later. Referring to the studio's work for the press, she added, "In the end we were able to compile a whole press kit to send to magazines and newspapers."[45]

Employees handled the darkroom work and the negative and positive retouching, and Lotte Jacobi's mother Mia took care of the business side — which her eldest daughter never managed to grasp properly her whole life. Mia Jacobi was constantly thinking up new ideas to improve sales of portrait photos, and usually managed convince customers that large-format picture cards were much more of a bargain than the usual postcards. Atelier Jacobi boasted prominent clients like Albert Einstein and Erich Mendelssohn; Mia Jacobi had no qualms about persuading them to sit for new portraits from time to time. The screen star

Leni Riefenstahl duly arrived for a portrait sitting after each of her film premieres. Her huge popularity was as yet unmarred by her close association with the Nazis. The fruits of Mrs. Jacobi's persistence can be seen in the bevy of pictures of Leni Riefenstahl in a wide variety of roles and costumes, as well as one of the very few series about her for an illustrated magazine (Ill. p. 51). Mia Jacobi would really have liked an exclusive portrait contract with the actress, but Leni Riefenstahl refused.[46]

"The Berlin Atelier really had problems at the outset ... but after a while things got into swing. My brother-in-law, who worked at the theater, did publicity for us there, which brought a whole lot of theater people to us for portraits ..."[47] Paging through the pictorial lexicon *Unsere Flimmerköpfe* (Our Faces of the Silver Screen)[48], with its portraits of young lovers, salonnières, fathers, ingénues and comedians, we get the impression that there must have been hordes of young actors and actresses who went to Atelier Jacobi for portraits displaying their best screen faces, which they could then tote around when looking for the role of their dreams.

Atelier Jacobi took every available opportunity to enhance its publicity profile. Advertisements in art periodicals draw attention to the studio as a "Special establishment for first-class and reasonably-priced photographic reproductions"[49]. This had always been one of Sigismund Jacobi's specialties; but the Jacobis also took advantage of the latest publicity outlets such as the street showcases, whose contemporary design was hotly debated in the trade press.[50] With an eye towards the more sophisticated advertising campaigns in North America, the showcase was propagated especially as a fair way to fight the growing competition. Atelier Jacobi changed its showcase display every four weeks; its effect on fellow photographers is attested by Ilse Siebert, who worked at the nearby Atelier Steffi Brandl. She remembers how she regularly followed the Jacobi's presentation of new photos to gain inspiration for her own work.[51]

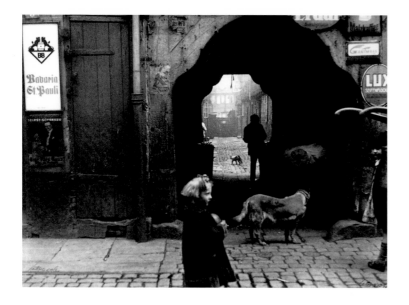

On the Move with the Camera

As time went by, there was an increasingly marked decline in demand from private clients, who had been the basis of Atelier Jacobi's business for generations. This was not only due to the worsening economic situation. A new market for photographers was growing with the rise in book publishing and the rapid expansion of daily newspapers, illustrated magazines, periodicals, journals, weekend supplements printed in photogravure, monthlies and trade journals. The Jacobi family included not only her parents and Lotte Jacobi's son but also "Bemchen", the maid from their Poznań days. In its heyday, the Atelier also had several employees.

Lotte Jacobi therefore faced the simultaneous tasks of using her photographic work to maintain the financial security of her family and adapt to the new demands of the press.[52] By 1927, the guidelines drawn up by magazine editors solely aimed at producing sensationalist journalism. "The basic approach developed by the *BIZ* editorial board placed emphasis on enhancing the visual experience of every event to create the maximum pictorial impact in other words: cutting out anything that was not pictorially interesting but only in terms of content. The significance of the content was not the main criterion for the selection and acceptance of pictures — the sole criterion was the attraction of the photo itself."[53] Since Lotte Jacobi sought out her photographic subjects in places pulsing with life, she was completely up-to-date in media terms. But as a photo-journalist who specialized in individual photos, especially single portraits, she always took second place to her colleagues working in photo-reportage. She did not like reportage at all: "I would never have dreamed of trying it," she once commented when referring to Erich Salomon, the most successful practitioner of this métier.[54]

Lotte Jacobi's constant activity with the camera had a beneficial impact on the new working climate in the Atelier. She always sought out the people she wanted to photograph herself. As a contemporary said later: "... it was better to wait for Lotte Jacobi to approach you".[55] She enthusiastically pursued her interest in contemporary theater, directors and actors, performances and *Ausdruckstanz* (expressive dance). Wherever possible, Jacobi tried to gain access to places like Piscator's Theater, where the great director

Plate 11
Alfred Kerr endorses the
Adler typewriter
Berlin, 1930

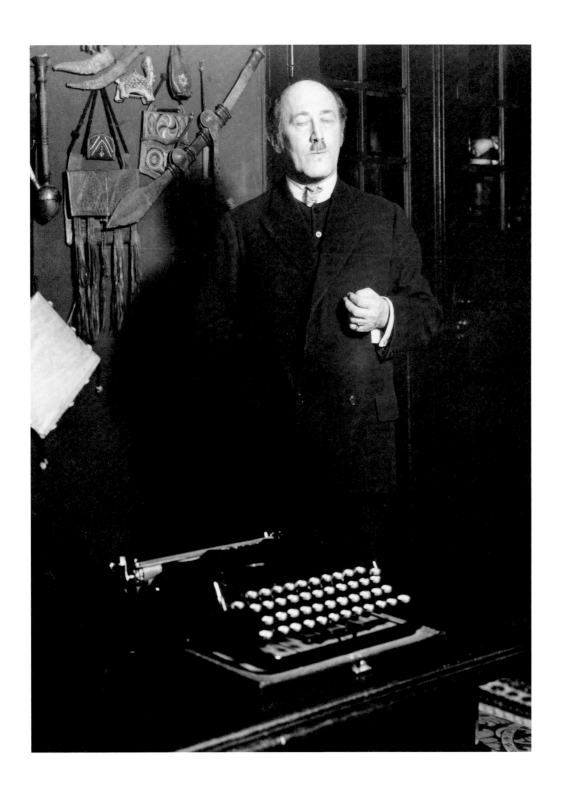

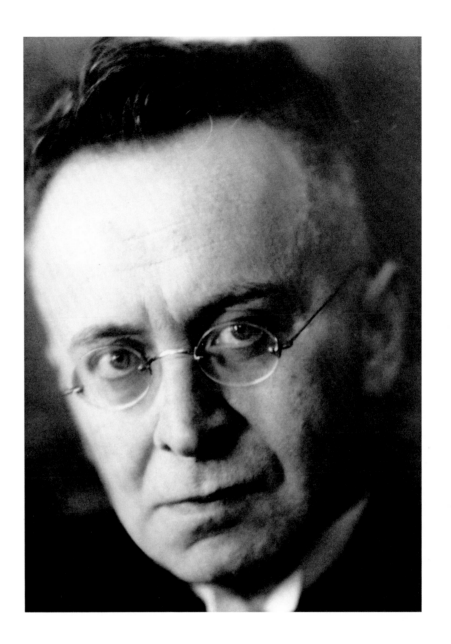

Plate 12
Karl Kraus
Berlin, 1930

himself gave her the permission to photograph there at any time.[56] She sought out not only the Expressionists but the older generation of artists as well, and was inspired by seeing them in their habitual haunts — such as Max Liebermann in his rose garden.

Lotte Jacobi did not only follow her own impulses, but she also seems to have kept very well informed; she had a keen instinct for which premiere would be the next sensation, and which young actor or composer, expressive dancer or writer was destined for success. Back in 1928, who knew anything about Lotte Lenya (pl. 35)? Who had ever heard the name Kurt Weill (pl. 23)? Who was interested in figures like Peter Lorre (pl. 17) and Marieluise Fleißer in those days?

Lotte Jacobi's wide range of interests and incessant activity brought her into frequent contact with other people. She preferred most meeting personalities who had became the focus of public interest because of their nonconformist attitudes and discomfiting state-

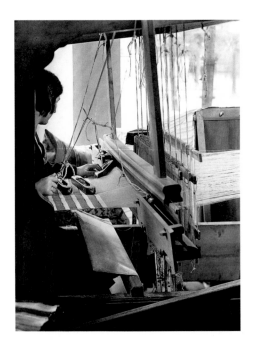 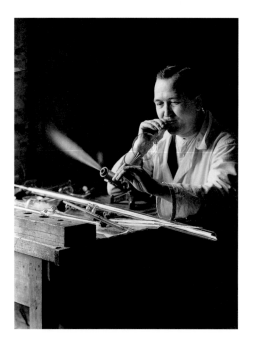 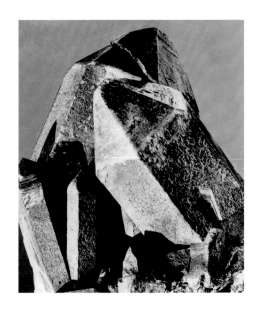

ments. She was a reader of *Die Fackel* (The Torch) and greatly admired its controversial art critic Karl Kraus, whose sensational lectures she followed closely. Her portraits provide a personal memento of Karl Kraus's debate with the theater critic Alfred Kerr. She depicted Kerr — in marked contrast to the intellectual Kraus (pl. 12) — as a petty, close-minded opportunist who went so far as to prostitute himself by appearing in an advertisement for Adler typewriters (pl. 11). A photo from the Kerr series is one of the few illustrations published in *Die Fackel*, where Karl Kraus actually passed up the opportunity to pour ironic scorn on the Zuckmayers, Kerrs etc. because they had reduced themselves to the level of advertisers.[57]

Lotte Jacobi's encounter with Ernst Fuhrmann was also to have a lasting impact on her.[58] Elisabeth Röttgers, her assistant at the time, still remembers their all-night conversations about "everything under the sun".[59] At Fuhrmann's instigation, Lotte Jacobi began exploring totally new ground in photography: the macrophotographic study of a wide variety of crystals.[60] This inspired her to thematically unusual work. Fuhrmann was particularly interested in close contact with photographers. He wanted to spur them to think about specific philosophical questions. He tried to expound his novel ideas by providing examples of natural phenomena and illustrating them with photographs. He once mentioned in a letter to Lotte Jacobi that he did not know how to take photographs;[61] this explains why he sought collab-

Left
Weaver
Berlin, around 1932

Center
Glass blower
Berlin, around 1932

Right
From the crystals series:
Quarz, (Zinnwald/Sanland)
around 1934
Berlinische Galerie –
Photographische Sammlung

oration with Albert Renger-Patzsch[62], Fred Koch, Else Thalemann[63] and, of course, Lotte Jacobi herself. She must have been fascinated by his undogmatic style of thinking. He saw the world as a non-hierarchical structure in which the ego does not selfishly grab center stage, but is part of a whole in the flow of movement. He deliberately distanced himself from any kind of party ideology and felt most at home with the anarchists. This probably created a bond between him and Lotte Jacobi. Fuhrmann was a adherent of Biosophie, a philosophy that at various times attracted people with divergent approaches, such as Theo van Doesburg, Hans Arp, László Moholy-Nagy, and Raoul Hausmann.[64] This led him to investigate ideas about the form and structure of natural phenomena and their significance for artistic design. Underlying this was an enthusiasm for standardization and typification that alternated with fears the growing threat posed by these developments.

Lotte Jacobi's growing interest in political events finally gave her access to the circle of

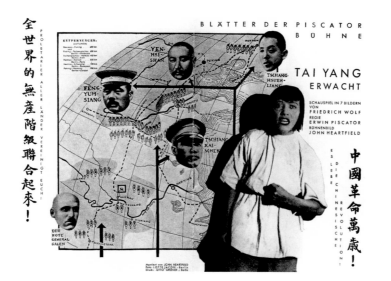

left-wing intellectuals around Egon Erwin Kisch (pl. 13). Kisch was an author of the publishing house Erich Reiss, which was known for its high literary standards. She also met John Heartfield, the fervently anti-capitalist artist, and was fascinated by his socially critical montages. She and Heartfield collaborated on playbills for Piscator's Theater and on the illustrations for Kurt Tucholsky's critical and satirical literary collage *Deutschland, Deutschland über alles*, but in photographic terms their collaboration was by no means one of their best achievements. One event that would prove very important for Lotte Jacobi in the years to come was her encounter with the anarchist revolutionary Max Hoelz, whom she first met when she visited him in prison during the campaign for his release in 1928. In January 1929, her portrait of Hoelz appeared on the front cover of his memoirs, *Vom weißen Kreuz zur roten Fahne* (From the White Cross to the Red Flag), edited by Egon Erwin Kisch and published by Reiss Verlag. Lotte Jacobi's intense friendship with Max Hoelz lasted several years and continued even while he was away in Moscow. It probably had a great influence in stimulating her curiosity to see the Soviet Union with her own eyes. To pave the way for fulfillment of her dream of visiting the Soviet Union, she made a formal portrait of Ernst Thälmann (Ill., p. 116), the Communist Party candidate in Germany's 1932 presidential elections.

At the end of the 1920s and the beginning of the 1930s, Lotte Jacobi regularly attended political events, including Communist Party meetings. She expressed her radical opinions openly, but did not join the party. She was not prepared to place her photographic work

directly at the service of politics — but if we look at her choice of themes and personalities, her sympathies are unmistakable.

So it is not surprise that she formed a deep, though short-lived acquaintance with Tina Modotti, the highly committed photographer and member of the Mexican Communist Party. During Modotti's stay in Berlin in the summer of 1930, Lotte Jacobi offered her own darkroom to Modotti, and organized an exhibition of Modotti's work in her studio before her visitor traveled on to Moscow.[65]

In 1932, Lotte Jacobi was on the scene when Carl von Ossietzky, the renowned pacifist and editor of the weekly political journal *Weltbühne* (The World Stage) was sentenced for alleged treason, an indication of the government's complete contempt for freedom of the press. His friends escorted him to prison. Over the years, her photographic documentation of this incident has become a symbol for integrity and conscientiousness. (Ill., p. 44)

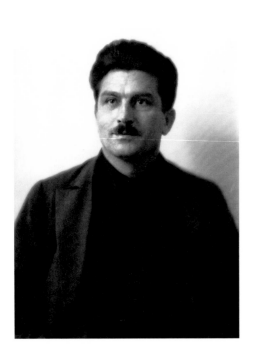

Lotte Jacobi took her camera with her wherever she went. If she needed special lighting equipment and backdrops, as she did for the dance photos of Claire Bauroff (pl. 54) and Rolf Arco (pl. 56), and for the scene she initiated with Trudi Schoop and Grock, Jacobi tried to persuade her subjects to come for a session at the studio. Of course, she also attended press photography sessions, where she experienced the tough competition of her professional peers firsthand. Later, as she described how they tried to push their way in front of each other's cameras, Jacobi made it clear that she had no trouble defending herself against unchivalrous behavior. Among the images which Jacobi brought back from scheduled photo sessions are some less well-known ones of Marieluise Fleisser at the premiere of *Pioneers in Ingolstadt*, Emil Jannings in his dressing room on the Ufa studio lot (pl. 14), the frequently reprinted shots of Harald Kreutzberg (pl. 51), and the famous portrait of Lotte Lenya (pl. 35).

Max Hoelz
Berlin, 1929

Whether on assignment or working on projects of her own, speed was of the essence. Magazines accepted nothing but the very latest and the competition was never far behind; furthermore, the photographically captured moment was gaining in popularity. Lotte Jacobi always emphasized that she learned speed in handling a camera during her training in cinematography. And advances in optical equipment facilitated rapid exposures. In 1928, Lotte Jacobi ordered an Ermanox 9x12 cm, a camera that had been on the market since 1926. It was fitted with a 16.5 cm Ernostar 1:1.8 lens, the fastest then available. Only nine of these made-to-order cameras were ever produced. The motivation behind this purchase was certainly her work in the theater, where the Ermanox would allow her to take pictures during performances outside official photo sessions. It was to remain her camera of choice for many years. She used it in the studio for dance shoots as well as for work in the field. A year later, she bought a Leica, the hand camera which, with its conveniently portable roll film, pushed the plate-backed models off the market in the thirties. But in the studio, she worked with the 18x24 cm view camera, which she fitted with a Perscheid soft-focus lens, as demonstrated by her 1929 self-portrait in Berlin (pl. 2). "Lotte Jacobi remained an incurably curious observ-

Plate 13
Egon Erwin Kisch
Berlin, 1929

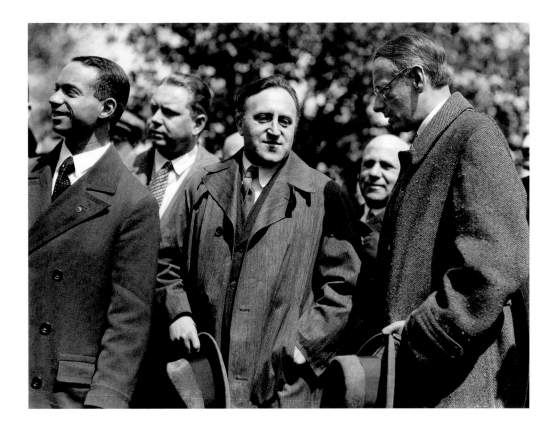

Carl von Ossietzky in front of Tegel
prison; behind him, left, is his lawyer,
Dr. Afred Apfel, beside him, right, is
Rudolf Olden, Berlin, 1932

er… Her self-portrait is probably a truthful image of the way she felt about herself in her pro-
fession at the time."[66]

This self-portrait, one of the few in her body of work, forcefully conveys her restless
nature and assumes an attitude of self-questioning — a stance widespread among artists of
the twenties. With a skeptical, yet searching look, the remote release in her hand and the
studio camera at her side, she cites her bond to the traditions of her craft. Emblematically,
she holds the tools of her trade in hand, as if attached to the equipment by an umbilical
cord, and scrutinizes herself in the mirror — the traditional place for artists questioning
themselves.[67] Who am I, really, when I take a picture? — this is the question which this self-
portrait poses. As if in answer, the photographer directs the light toward her head, the
source of ideas, and the hands, which realize those ideas through the camera, the object on
which the eyes of the viewer fall first. The lighting dramatizes the situation without exagger-
ating it. The rule of artistic photographic composition that prescribes lifting the subject out
of the darkness in order to endow it with significance is violated by the photographer's posi-
tion. She appears inwardly moved and excited, like an actress about to go on stage, while
her body almost disappears into a darkened space. Her wrist and shoulder are cropped out
of the frame, as if she had entered the scene for just a brief moment. Full of the contradic-
tions of a modern artist, she is volatile, yet rooted in tradition. In her self-portrait, Jacobi was
unfettered by a commission and free from any commitment to likeness, beauty, or represen-
tation. The artist confesses something of her state when she focused on herself and released
the shutter. "What am I going to do now?" was how she later commented on this image.[68]

Berlin held limitless possibilities for Lotte Jacobi's interests and inclinations. But the
demands of her family and studio, as well as of trying to juggle assignments and her own
photographic ambitions must have placed enormous pressure on her and restricted her
drive for self-determination.

A Bohemian Paradise

After Elisabeth Röttgers[69] had completed her apprenticeship in Gertrud Hesse's studio in Duisburg in the Ruhr, she worked for a short time as an assistant for Nini and Carry Hess in Frankfurt/Main. Then she sought a job in Berlin. She was just the employee Lotte Jacobi needed and, from 1929 to 1931, she built up the archive and the sales department, maintained contacts with publishing houses, shipped off urgent late-night deliveries, and kept the steadily growing inventory of shots well-sorted and ready for requests from the press or publishers. In the field, Röttgers lent a hand carrying the heavy photographic equipment and changed the plates in the theater. She also had opportunities to take portraits on her own from time to time — usually when Lotte Jacobi, true to her philosophy of doing only what she really wanted to do, took the liberty of skipping a session at an inconvenient time with a disagreeable client. The result of their consistent marketing and advertising efforts was a steady, if limited, flow of images to publishers and a spreading reputation, which arose through photos appearing in a wide variety of mass and specialized periodicals, particularly, those of the Ullstein publishing house: the *Berliner Illustrirte Zeitung* (*BIZ*), its illustrated weekly with the highest circulation; such well-known titles as *Die Dame, Uhu*, and *Der Querschnitt*; the illustrated supplement to the *Berliner Tageblatt: Der Weltspiegel* from the Mosse-Verlag and *Scherl's Magazin* from the Scherl/Hugenberg-Verlag. Scherl's newspaper and book publishers, news agencies, and film companies closely approached the type of modern media conglomerates common today. In addition, Jacobi's work was published in the *Arbeiter Illustrierte Zeitung* (*AIZ*) and the *Magazin für alle* from the Neuer Deutscher Verlag. The Atelier Jacobi also supplied photos to newspapers far beyond Berlin, with work appearing in the *Münchner Illustrierte Presse* (*MIP*), the *Wochenschau*, the supplement to the *Düsseldorfer Nachrichten*, the *Leipziger Illustrierte Zeitung* and the photogravure supplement to the *Frankfurter Zeitung* .[70]

Judging by the number of photos identified so far, the business was flourishing from 1928 to 1930, and the family's living standard was correspondingly satisfactory. As sales began to slow down in 1931, the well-ordered, constantly growing archive turned into a vital capital stock. The success enjoyed by the Atelier Jacobi can be traced primarily to Lotte Jacobi's own lifestyle. She allowed herself to be swept along by the vitality and creative turbulence of the times and carried the studio along with her into the scenes of the avant garde and political utopians. Elisabeth Röttgers characterized the atmosphere in No. 5 Joachimstaler Strasse as "a Bohemian paradise"[71], referring to the milieu of clients, acquaintances and artists who came and went. Her description implies an activity which was anything but bureaucratic and planned. The hospitality of the place was only enhanced by its location, as there was hardly anyone among her friends and acquaintances who did not frequent the surrounding cafés, bars and restaurants. Countless anecdotes are connected with the Romanische Café, the "homeless shelter for the nomadic in spirit".[72] The narrators of these tales do not leave out a single one of the stars they once dined with here.

Lotte Jacobi may well have sat at the journalists' table with Egon Erwin Kisch or with Josef Scharl at the painters' table. Together with Margarete Kaiser, the editor of the modern, middle-class women's magazine *Die schaffende Frau*, and the painter Annot Jacobi, the photographer sat and dreamed of a journey to America.[73] On other evenings, she went to the Lunte, where all the journalists gathered and the women smoked cigars.[74] There she met Fred Hildenbrandt from the *Tageblatt* and the actor Paul Graetz. Little did they realize at the time that the land of their holiday dreams would soon become that of their exile — and what was now generally seen as liberal, cosmopolitan and creative would soon be damned as the manifestations of an "un-German way of life".

Journalistic Stills

Lotte Jacobi's lifestyle was closely tied to her work for the press, which was constantly in search of new feature stories on sensations from far and near as well as photo reports on current affairs and fashionable topics. Newspapers and magazines were still working with single photo-headers, predominantly showing portraits of individuals from high society circles: celebrities, royalty and nobility at home and abroad, military officers, and figures from politics, science and the fine arts. Readers unable to witness official events first hand could now, through the ersatz world of magazines and glossies, at least get a second-hand peek at the private lives of the rich and famous and share in their successes and failures. Being up-to-date meant being in the know, and periodicals in Germany, as in the rest of the world, rushed to be on the spot. A print media ever-aiming for increased circulation strove to draw their readers into the world of images and bring pictures right into their living rooms.

The single-subject photo, depending on the person's social status, became a point of orientation in matters of fashion and make-up, marriage problems and career choices, or in questions of style, interior decorating and the appropriate accessories, the most trendy breed of dog, model of car, and even sports equipment for rest and recreation.

The faces of public figures were in demand, preferably surrounded by their family members — by the next generation, no matter what the occupation. Snapshots of athletes and actors, award-winners, and veteran VIP's standing next to their well-bred daughters and clever sons were especially popular.

The glossies also aimed to provide glimpses into the world of the arts and artists, masters of the great classics, the great entertainers, and occasionally, even the avant garde. Ever well-received were glimpses of the private life behind the public persona, where the famous were free from the dictates of public image, and simple human pleasures made equals of everyone.

The broad field of the single and multi-subject photo-header gave Lotte Jacobi the freedom to decide just how much to follow her instincts and how much to heed the call of duty. It was never her aim to create, or even stylize, a star through the media. Her views into the private lives of her models were in no way intended to cater to the general voyeurism fuelled by the press. Jacobi's approach to people was characterized by a very personal atmosphere in which she never sought an opportunity to expose her subject or reveal an indiscretion. Her intention was, rather, to capture the impression of her subject that she herself had gained during the sitting. But Lotte Jacobi was confronted often enough with the reciprocal influences and interdepencies among those involved in the press photo: the photographer, the subject and the publisher, which, as the client, always tried to exercise some control over the process.

Among Jacobi's very few regular contracts was one for the portrayal of main characters from selected radio programs, published regularly in the radio listings of the *Funkwoche*, but the postage-stamp format nipped any exercise of artistic influence in the bud.[75]

Lotte Jacobi must have been much more interested in the portraits of the women which she took for the cover of the monthly magazine *Die schaffende Frau — Zeitschrift für modernes Frauentum* on the basis of loose commitments.[76] Besides, she was in constant personal contact with its editor, Margarete Kaiser, and took advantage of the assignments to make new acquaintances, for example, with the artist Käthe Kollwitz.

The portraits and their presentation were manifestations of the collusion achieved by the photographer, her subject, and the editor — as working women. The images are neither glamorized by fashion nor manipulated through the lay-out. Lotte Jacobi's close-up angles

Above left
"The Young Mother" in:
UHU, vol. 7, No. 7, April 1931
inside cover
Kunstbibliothek SMBPK

Above right
"German pilot Marga von Etzdorf"
in: *Münchner Illustrierte Presse*,
vol. 8, No. 37, 1931, cover
Friedrich collection

Below left
"In the Beach Café" (Ali Ghito) in:
Berliner Illustrirte Zeitung, vol. 41,
No. 31, 1932, cover
Friedrich collection

Below right
"Käthe Kollwitz" in
Die schaffende Frau, vol. 1, No. 1,
October 1929, cover
Kunstbibliothek SMBPK

UHU

Die junge Mutter
Die Schauspielerin Tony van Eyck mit ihrem Töchterchen

Fot. Jacobi

Münchner
Illustrierte Presse

Verlag Knorr & Hirth, G.m.b.H., München

Preis: 20 Pfennig

Die deutsche Pilotin Marga v. Etzdorf
durchflog die Strecke Berlin-Tokio trotz mehrtägiger Behinderung durch Nebel und einer Zwischenlandung auf offener Steppe in 11 Tagen

Auflösung unseres 2000 Mk.-Preisausschreibens „Was sind die vier?"

Berliner
Illustrirte Zeitung

Verlag Ullstein Berlin SW 68

Im Strandcafé.

Fot. Jacobi.

Die schaffende Frau

Zeitschrift
für modernes
Frauentum

DVD

JAHRGANG 1 HEFT 1 OKTOBER 1929 EINZELPREIS 70 PF.

present her subjects as modern women, a portrayal that was emphasized even more by the typographical and graphic presentation. But the first-edition cover, bearing the face of Käthe Kollwitz (Ill. p. 47), makes it apparent that the portrait's full effect could never be appreciated in the context of the magazine, especially given the typology expressed in the title — "The Creative Woman".

Only when freed from the constraints of the magazine's format does the picture of the professional woman become a true portrait (pl. 22) — a tribute by the photographer to the great artist. The photographer carefully selected the expressive elements, combining the effect of the soft-focus lens — an allusion to classic portraiture — and the severity of the direct frontal perspective and the openness and closeness of her subject.

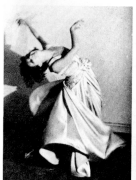
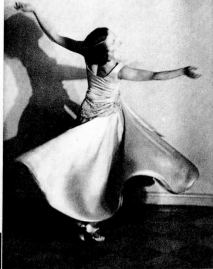

Bewegungsstudien mit der Tänzerin Dorothea Albu

Photogr. Aufnahmen des Ateliers Jacobi, Berlin

Lotte Jacobi's enthusiasm for modern dance led her to make photographs of dancers, too — mostly featuring individual and group compositions on the stage. Occasionally, she had routines re-created in the studio, such as Toni van Eyck's leap (pl. 52), Claire Bauroff's turn (pl. 54), or Lieselotte Felger's spin (pl. 55). Dance photographs were extremely popular and in constant demand with all the magazines. The two nationwide trade journals, *Der Tanz* and *Das Theater* (Ill. p. 81), with their focus on current productions and new performers, were regular clients of the Atelier Jacobi.

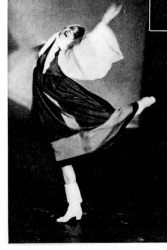
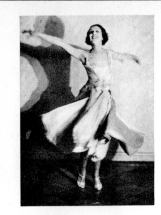

Postcard and album printers were another source of income that was not to be underestimated. They were quick to spot the potential in combining the popularity of modern expressionistic dance with collectors' passions. Many of the hundreds of dance photos that the Eckstein-Halpaus cigarette company used as advertising gimmicks to give smoking the appearance of grace to prospective customers originated from the hand of Lotte Jacobi: *Palucca, the Modern Expressionistic Dancer, Genia Nikolayeva, Former Solo Dancer for the Berlin State Opera; Nini Theilade, in Peasant Costume with Exotic Headdress*, and many more were all collected in an album entitled *Der Künstlerische Tanz* (Artistic Dance).

It was by no means a cheap advertising campaign. The album was elaborately bound with an embossed cover and had space to paste in 312 photographs. "It's all done for the purpose of bringing a moment of joyous exhilaration into the drudgery of these hard times. Doesn't a good cigarette serve the same end?"[77]

"Motion Studies with the Dancer Dorothea Albu" in: *Scherl's Magazine*, vol. 6, No. 6, 1930, p. 646
Köhler collection

A second volume, *Die Tanzbühnen der Welt* (The World's Dance Stages), was also published in 1933. It had a photo of the dancer Heide Woog from the Atelier Jacobi on the dust jacket (Ill. p. 102). Both albums include pictures of modern as well as folk dance. The images display a certain nationalist tendency but are devoid of National Socialist undertones. The selection from the Atelier Jacobi is evidence of the studio's broad range of activity in this genre.

If there was anything that fascinated Lotte Jacobi more than dance, it was perhaps film. At any rate, she liked to relate how she very nearly wound up in the movie business. Given

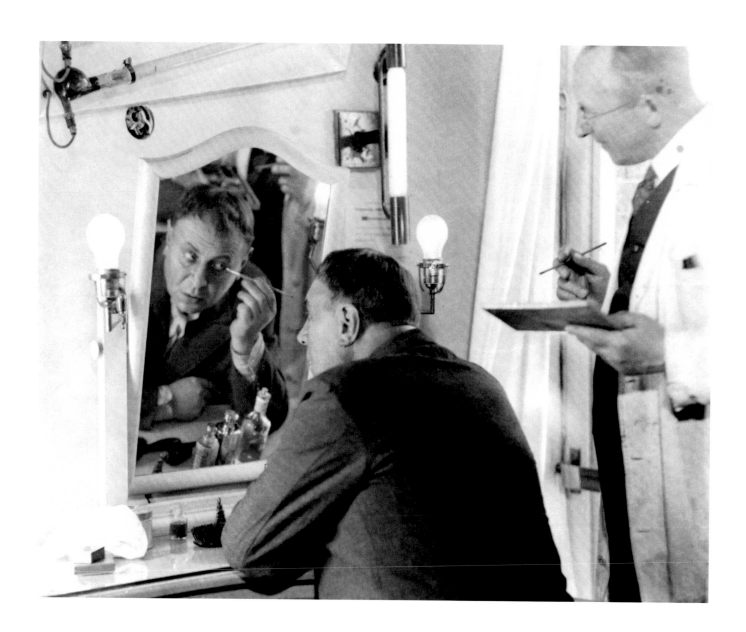

Plate 14
Emil Jannings in the dressing room
Berlin, 1931
Berlinische Galerie —
Photographische Sammlung

her affinity for motion pictures, it came as no surprise when she was spotted with her camera on the studio lots, at location shoots and at press photo sessions with the film stars. Yet her three shots of Emil Jannings, the great screen actor from silent movie days, together with the portraits of film personalities she had personally approached and become acqainted with, such as Lil Dagover (pl. 32), Adolf Wohlbrück (pl. 19) and René Clair (pl. 33), were to remain isolated phenomena in her work.

One might easily imagine how the red tape involved in simply getting onto the studio lot, not to mention the exploitation of the photos by production and publicity firms, and in particular, the condition that a picture depict only the public image and not the real person behind it — how all this must have thoroughly spoiled the attraction of the cinema for Lotte Jacobi.

Be that as it may, in 1931, in a cropped version across its back page, the *Berliner Illustrierte Woche* published her photograph of Emil Jannings applying his own make-up — as the make-up artist looks on — just like an actor of the old school.[78] It was credited "Ufa-Jacobi." For this shot, the photographer chose an angle that gave readers a rare opportunity to steal a glimpse over the shoulder of the great star as he prepared for his next scene.

Lotte Jacobi presumably took this picture of the actor, who was so feared on the set, at a press photo session held during the production of Robert Siodmak's film *Stürme der Leidenschaft* (1931), where she took another of him peeling an apple, and a third of him together with Willy Fritsch, the darling of German cinema-goers. It may be seen as a tribute to her skill in handling people that she got Ufa's two rival stars to stage a boxing match in front of her lens.

Jacobi was well aware that Jannings' worldwide fame would enhance the attractiveness these shots — they were among the few from her archive that she took with her into exile in 1935. In fact, Jannings peeling an apple was one of the first of her photos to be published in America (Ill. p. 137).

Lotte Jacobi rarely experimented with the picture series, a sequence of photos depicting either a short, staged event or an existing situation as opposed to a collection of more or less unrelated images with no narrative structure. So the little story she set out to compose for the *Berliner Illustrirte Zeitung* comes as a bit of a surprise.

Using only three shots, she portrayed Carl Zuckmayer's little daughter, Winnetou, reading a letter, waiting, and then acting surprised at the entrance of the photographer. Lotte Jacobi's picture of the whole family shows that the young playwright's daughter not only had talent as an actress, but, like her elder sister, as an acrobat, too. In what was probably a session to mark the production of Zuckmayer's play, Katharina Knie, the family posed together for the photographer on the terrace of their apartment block in Berlin's Schöneberg district (pl. 27). The play itself is about a family of circus performers.

Lotte Jacobi created another series for *Scherl's Magazine* which demonstrated the rigorous physical training actors were subjected to during the transition from the silent to the sound film. The photographer chose someone she knew quite well for the job: Leni Riefenstahl, then a popular lead-

"Winnetou Zuckmayer" in: *Berliner Illustrirte Zeitung*, vol. 39, No. 21, 1930, p. 933 Berlinische Galerie — Photographische Sammlung

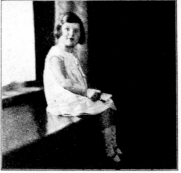

Winnetou, die kleine Tochter des Dichters Carl Zuckmayer. Atelier Jacobi.

DAS *Mikrophon* ALS *ERZIEHER*

Photographische Aufnahmen des Ateliers Jacobi, Berlin

Stimmband-Training für den Sprechfilm

Entspannungsübung vor dem Aufnahmeapparat. Die Filmschauspielerin Leni Riefenstahl und ihr Sprechlehrer Herbert Kuchenbruch

Entspannungsübung mit dem Ball

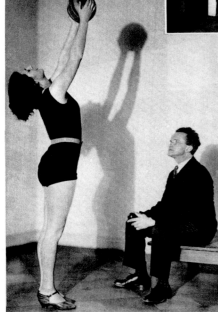

Helmholtz nannte das menschliche Auge ein fehlerhaftes Instrument. Wenn er ein modernes Mikrophon kennengelernt hatte, wäre wohl unser akustisches Organ in seiner Kritik auch nicht besser weggekommen. Denn das Mikrophon ist viel hellhöriger als unser Ohr, es registriert mit pedantischer Genauigkeit das feinste Zischen der Atemschwingungen, jede dünnste Stimmbandvibration. Es arbeitet so gewissenhaft, wie wir es von einer Maschine erwarten. Trotzdem sind wir

empört, wenn bei der Tonwiedergabe durch störendes Krachzen, Verzerrungen von Konsonanten, Lispeln oder andere Sprachverfälschungen der Sprechfilm zur Sprechgroteske wird. Freilich ist das technische Problem durchaus nicht als gelöst zu betrachten, doch häufiger, als der Laie annimmt, wird die unvollkommene Sprechausbildung jener Stimme am Aufnahmeapparat die eigentliche Fehlerquelle unserer Enttäuschung. Bekanntlich klangen die einzelnen Stimmen bei den letzten Tonfilmen recht verschieden, manche kamen wie aus einem zahnlosen Munde, andere klangen fast natürlich. Das künstliche Ohr kennt aber keine Bevorzugung, es verlangt gleiches von allen, um die Wiedergabe brauchbar zu machen, nämlich Reinheit und Klarheit der Stimme. Es verlangt mehr als unser Ohr vom Bühnenschauspieler, mehr als im Theater, wo mancher Schwingungsfehler im Ozean der Schallwellen versinkt. Das Mikrophon stellt eine besondere Anforderung, sagt der moderne Sprechlehrer, nämlich restlose Gelöstheit der gesamten Sprechorgane! Mit diesem Ziele arbeitet er, unter-

richtet Schauspieler und Schauspielerinnen, Tänzerinnen und Darsteller des stummen Films, denen er die Zunge löst. Es wird bei manchem Filmdarsteller nicht leicht sein, der jahrelang gewöhnt war, nur die Lippen zu bewegen und ein paar gleichgültige Worte zu murmeln. Doch jetzt muß jeder Ton.

Ballspielen lockert den Körper, stärkt die Atmung und übt die Aufmerksamkeit

Sprechen mit dem Ball. Die Stimme wird konzentriert

Probesprechen in den Aufnahmeapparat zur späteren Kontrolle der Stimmentwicklung

"The Microphone as Coach", Leni Riefenstahl and her diction coach, Herbert Kuchenbruch in: *Scherl's Magazine*, vol. 6, No. 5, 1930, pp. 506-7
Köhler collection

ing actress in the genre of Alpine films. She played even the most extreme scenes without using a stand-in and was known in the business as an indomitable, highly skilled and disciplined actress. Lotte Jacobi covered the program in five images — conceived like a short film — titled "The Microphone as Coach". Jacobi used composition and lighting to enhance the tension in Leni Riefenstahl's muscles. The actress exercised under the stern gaze of the coach, as the photographer turned the training session into a play of light and shadow with real and imaginary characters.

Lotte Jacobi also tested her abilities on a number of series in an entirely different genre. She photographed interiors furnished with Bauhaus pieces in the *Haus Lewin*,[79] designed by Walter Gropius. She also took pictures of Erwin Piscator's apartment (Ill. p. 52). The first group was never published, but two of Jacobi's photos appeared together with others by Sasha Stone in the women's magazine *Die Dame* under the title "Piscator's Home — a Functionalist Apartment" in 1928.[80]

The interior shots of the *Haus Lewin* bear witness to Lotte Jacobi's professional photographic approach to using a medium that was relatively unfamiliar to her. The commission came from the Ullstein Verlag, probably with the intention of publishing the shots in *Die Dame*, which regularly focused on modern interior designs. Her spatial perspectives and accenting of the light and shadow, so typical of Bauhaus architecture, follow the functional style of architectural photography of the time, which was subordinated entirely to aesthetics

and function.[81] Only once did Jacobi allow a human being to enter the scene.[82] This view of the combined living and dining room is a kind of self-allusion which violates the neo-objective, functionalist photographic representation of uninhabited spaces.

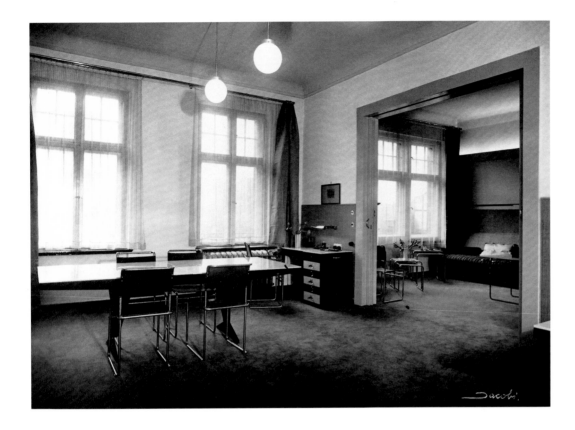

Erwin Piscator's apartment:
dining and living rooms
(furnishings by Marcel Breuer)
Berlin, 1928
Bauhaus-Archiv, Berlin

The photographs from the Atelier Jacobi most often published by the press were situation portraits which conveyed something about their subjects — personalities from art, literature, drama and the dance — through the setting, action, or a particular composition. Portraits like those of the Zuckmayer family (pl. 27), Heinrich George carrying his son on his shoulders (pl. 39), Karl Valentin and Lisl Karlstadt (pl. 24) and Grock and Trudi Schoop (pl. 58) exemplify Lotte Jacobi's dramaturgical talent for transposing the moment at hand into photographic composition.

Her pictures of Ernesto de Fiori in his studio must have been precisely what the glossies were looking for. The portrait photographer portrays the portrait sculptor — one of the very few of his kind who was able to maintain a lucrative business with busts of attractive models. Like himself, Fiori's subjects were the top figures in their fields: the boxers Jack Dempsey and Max Schmeling, and the actresses Elisabeth Bergner, Marlene Dietrich and, in this case, Mady Christians (pl. 16).

For the shot of Mady Christians in de Fioris' studio, the photographer chose an angle from which she could observe the artist as he compares his bust to its living subject. Depersonalized and replicated in series, the busts embody the image of femininity popular at that time: flawless, fragile and aloof. Through the work of the sculptor, the photographer demonstrates the supremacy of type over the individual portrait.

Even more so than the situation portrait, the "face" as such served an important function in the glossies. At that time, it had yet to become a subject for art and media historians, but

Left
Renée Sintenis: "My Friendship with
a Horse" in: *UHU*, vol. 8,
No. 12, 1932, pp. 14-15
Kunstbibliothek SMBPK

Right
"The Blonde" and "The Original
Woman" in: *Velhagen und Klasings
Monatshefte*, vol. 45, No. 2, October
1928, p. 187
Friedrich collection

publishers nevertheless recognized and used its potential to disseminate ideology.[83] Everything personal, individual and distinctive had to be suppressed as far as possible in favor of the universally ideal human being. The *Berliner Illustrirte Zeitung*, for instance, regularly graced its front page with well-known faces, alternating between politicians, artists, and, quite often, actresses, to be joined in the late twenties by men in modern occupations — known as "contemporary figures".[84] Until the end of the twenties, the covers of *Uhu* and *Scherl's Magazine* almost exclusively presented faces of the "New Woman"-type — mostly in the traditional medium, drawing.

In 1932, following the same tendency to emphasize the type over the individual, the *BIZ* printed a front-page photo of a young, modern woman, self-confident and provocative, but nameless. As if inviting the viewer to take some time to relax, it was entitled, "In the beach

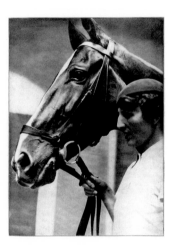

Die Blonde (die Schauspielerin Grete Mosheim)
Photographie Jacobi, Charlottenburg

Die originelle Frau (die Tänzerin Valeska Gert)
Photographie Jacobi, Charlottenburg

café" (Ill. p. 47). This was, in fact, Lotte Jacobi's photo of the highly popular screen actress Ali Ghito. *Velhagen und Klasings Monatshefte* made similar use of Lotte Jacobi's portrait of actress Grete Mosheim, the caption reading simply, "The Blonde". A description of the actress written by film critic Rudolf Arnheim in 1931 comes much closer to capturing the impression made by the portrait (cf. pl. 30): "She makes her appearance inconspicuously, as if to deliver a letter to the diva and leave again immediately. There is nothing dazzling about her — the evening gown clings reluctantly to her… She has nothing of the saturated fullness of the highest paid starlets who appear so dreadfully perfect and in no need of any assistance from the audience. She is pale and distressed. But, as always, her eyes are veiled by a gossamer curtain."[85]

The treatment of images of people, particularly of women, that was at first only to be seen in advertising, increasingly became the norm in the periodicals. "At present, advertising as practiced by the major magazines is shifting away from objective representation and toward a psychologically manipulated perception. The possible associations that a photo might call up are assessed for their marketing potential. It is no longer the product itself which is photographed, but an idea connected with the product that will get consumers to read the ad."[86] Replacing the word "product" with the word "portrait" reveals something about the methods of the news media in their treatment of the individual and the personal.

The theater journals *Das Theater* and *Der Tanz* were primarily exceptions to this rule. Although *Die schaffende Frau* type-cast the subjects of its covers as professional women, at least it did not force them into a context entirely foreign to the one intended by the photo-

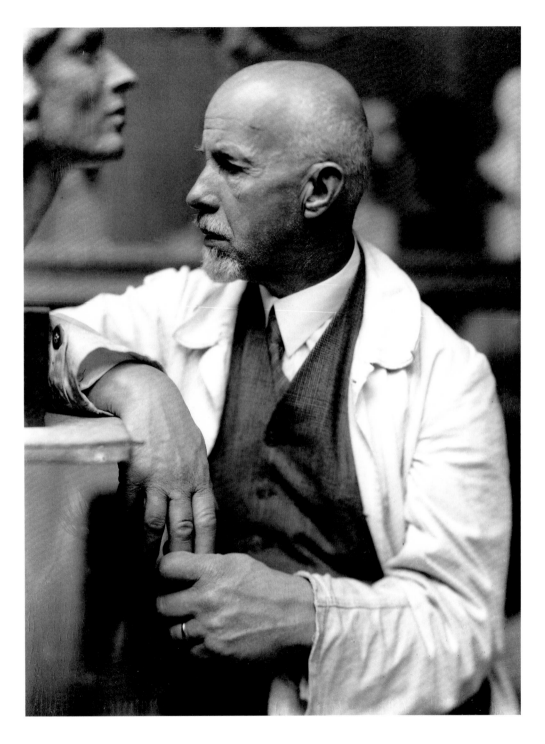

Plate 15
Fritz Klimsch
Berlin, around 1930

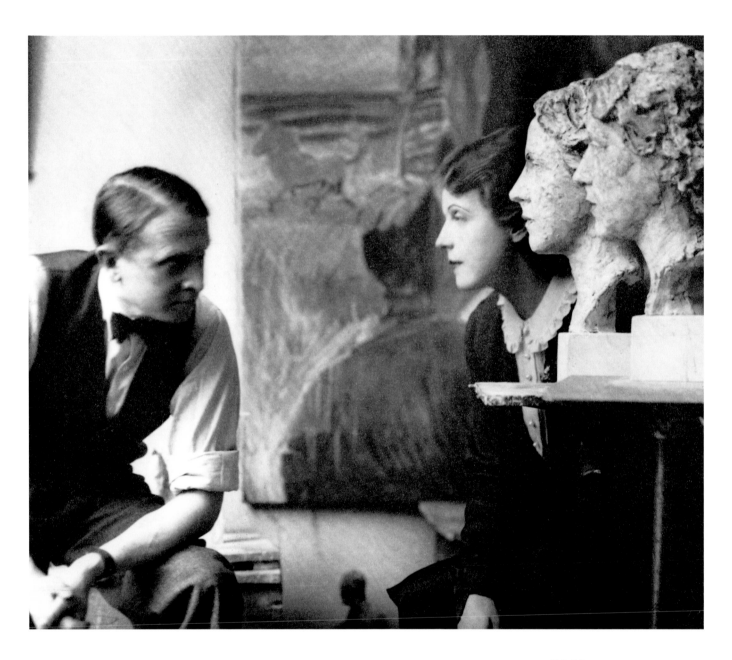

Plate 16
Ernesto de Fiori
and Mady Christians
Berlin, 1930

grapher (cf. ill. p. 47). But the publishers of books, compendiums edited according to subject matter, and magazines for the educated middle classes made increasing use of portrait photos purely because they represented types, in other words, simply as "heads", "faces" or "figures".

In 1931, *Uhu* ran a feature on "The Captivating Male Face — a Collection of Characters. How a Woman Sees Them" (*Das fesselnde Männergesicht — Eine Sammlung von Charakterköpfen. Wie eine Frau sie sieht*)[87] to which Paul Klee, Eugene O'Neill, Rudolf Belling and other well-known intellectuals were obliged to lend their physiognomies. To cite an example of psychological typage, in 1930, *Velhagen und Klasings Monatshefte* published one of Lotte Jacobi's photographs of a dancer, left unidentified, with the caption: "The spiritual, somewhat melancholy face of a modern dancer". In the same publication, one of the least "original" shots of Valeska Gert appeared under the title, "The Original Woman" (Ill. p. 53). "Our

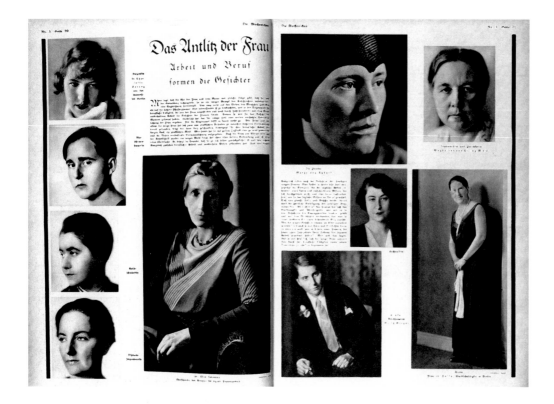

"The Face of Woman"
in: *Die Wochenschau*,
No. 3, January 1931, pp. 20-1
Museum Folkwang, Essen

Time in the Faces of 77 Women" underscores the "forces and currents of its representatives",[88] and in 1931, *Die Wochenschau* brought together a number of individual portraits by Lotte Jacobi under the title "The Face of Woman".

Nothing could have been farther from Lotte Jacobi's purposes than to photograph a human being as a specimen of typological features. To her, nothing would have been more unthinkable than to violate a person's identity — which she respected above all else — by misappropriating it for unauthorized purposes. She never followed a pre-conceived visual code in her pictures. Instead, Lotte Jacobi used the camera to enhance the intensity of an experience. At the end of the decade, running parallel to the increasing, ostensibly democratic tendency of mass publications to present photos of individuals in their typological aspect, a trend towards collective representation took hold in all the visual arts.

"My style is the style of the people I photograph"

"My style is the style of the people I photograph"[89], is how Lotte Jacobi once described her approach to photography, a method that was as apparently simple as it was contradictory. Her objective of rendering the unique style of the individual may seem like a guiding principle for all portrait photography, but it is, in fact, the full expression of Jacobi's personal relationship with her models. From the invention of photography until well into the twentieth century, portrait style had been developed from the client's concept of self-representation. But in the decades following the Second World War, an approach Lotte Jacobi had no regard for whatsoever became common practice, with photographers using the portrait to portray themselves, as so many of her colleagues did.[90]

Her desire to allow the models to speak for themselves was frequently mistaken for either modesty or even feminine reserve. It was neither.[91] Her declaration that her style is the style of the people she photographs is, in a sense, a dialectical expression of a relationship between equals and reflects a desire for exchange through dialogue.

Lotte Jacobi chose portrait photography because it was the best means for expressing her feeling for life. And this was at a time when the decline in the popularity of the portrait had reached an initial peak amid criticism decrying the loss of individuality. Ever new variations on the theme of the individual and his identity as manifested in the photographic image, even up to the present day, show that this lament did not go unheeded.

The notion of the multiple subject has supplanted yesterday's individual, whose desperate struggle against his gradual disintegration in the visual arts, especially in photography, is still discussed, it seems, at every turn today. The idea of being able to assume various identities — as contrasted with the past conception of the complete individual — is now taken for granted[92], and "the bourgeois attempt to assert the individual in the international process of mass culture has failed once and for all."[93]

During the 1920s feelings of insecurity and disorientation began to spread after the First World War had already undermined the social order and, along with it, the belief in the uniqueness of the human personality. "In the destruction of all values, a kind of madness took hold of bourgeois circles — until then always unshakeable in their sense of order."[94]

The Jacobi family did not remain immune to this upheaval. In 1919, they were forced to abandon their long-established, traditional studio in Poznan and build new lives in Berlin, a city plagued by poverty and inflation. Moreover, the profession of the photographer as Sigismund Jacobi had known it had undergone radical change in less than a decade. Classical portrait photography had almost completely lost its function. "But, just as every physical cri-

sis simultaneously indicates that the afflicted organism has mobilized its defenses and gives rise to justified hopes of a quick recovery, the purported decline of portrait photography — in reality nothing but the fading away of bourgeois image types — opened the way for a new beginning."[95]

The question of what a human being is had lost nothing of its importance. Instead, it became ever more urgent and was soon answered in new ways. It was no longer a question of the differences — the individual and inimitable — but rather of the shared, common traits, the human as a type — even under the most contrary of ideological portents. "Seriously, they have no respect for the human being any more — I mean for the human as the bearer and expression of spiritual and moral forces... When I view the portraits of the verists, who are famed for their particular objectivity, then I can't help getting the impression that a new ideal human — based on the white-collar criminal and idiotism — is on the rise."[96]

Yet attempts to shore up the façade of the holistic image of the individual, still practiced in the painters' and photographers' studios of the old school, were doomed to failure and greeted only with scorn by critics of the waning bourgeois world.

In hindsight, we know better what pitfalls and hazards lurked in the opposite approach of representing the type as the essential social element in man. "The human face and the human, wherever they are still integrated into photographic images, are degraded to the status of a compositional pretext. They are no longer photographed for their own sake... As compared with the classic bourgeois portrait, both (the German and the American) image-conceptions signify debasement of the individual — at the very least, they imply a depersonification of the portrait."[97]

The focus on types in photography opened the door to the world of the glossies, so that virtually anyone could follow, if only fleetingly, the trend of the era and the fashions. The masses and their fashions were the voucher for the success of mass publications, which valued the quality of sameness in their images of people — the sameness of people. This is exemplified by the title of a feature about Albert Einstein that appeared in the *Berliner Illustrirte Zeitung* in 1929 to mark the great physicist's fiftieth birthday. It was called "Albert Einstein — the person". In one shot, he was shown playing the violin, and in another, taken by Lotte Jacobi, maneuvering his sailboat on the Wannsee.[98]

In this phase of re-discovering the points of orientation, such photographers as Erna Lendvai-Dircksen, August Sander, Hugo Erfurth evolved widely varying approaches to the treatment of the photographic portrait, all of which were classified as "world-view portraits"[99]. The proponents of "New Seeing" took a different approach. They made the medium itself the subject of their experimental shots, based on their view of technology as a means to compensate for the insufficiencies of man.[100] Alexander Rodchenko intended to make up for the loss of the individual through images of the solidarity of the masses.[101] On the other hand, original and formally innovative positions such as those of Helmar Lerski, Umbo (Otto Umbehr) and Florence Henri were lumped together under the label of the new, or modern, portrait.[102] The Americans Alfred Stieglitz and Paul Strand should also be mentioned in this connection. Before the holistic view of man had even become an issue in Germany, they had already begun to challenge the idea in portrait series[103] and closely cropped views of heads.[104] Lotte Jacobi challenged every dogma and flaunted social convention as she steered a course between all these positions and pursued her own approach to the portrait. She allowed herself to be guided by a sense of the moment and unfailingly made the human being the center of her work. A few years later, Gisèle Freund was moved by similar intentions when making her portraits of artists in Paris. Freund's images derive their particular effect from the play of color.[105]

58

Having been raised by her family in the tradition of the bourgeois portrait, Lotte Jacobi must have experienced the dissolution of the representational canon into a diversity of views of the individual as a radical innovation. This revolution in seeing must have suited her temperament quite well, considering that she turned the great variety of new compositional possibilities to good advantage. Her portraits move between the two extremes marking the broad spectrum of photographic conceptions of the 1920s: the likeness, emphasizing character and similarity and, above all, representing the individual as expressed by the face; and the image of a person so dominated by graphic and compositional factors that the individual and personal are virtually lost within them. The splintering of society according to newly created social classifications, particularly for women, are reflected in methods of visual representation, whose vast range is unparalleled outside the work of Lotte Jacobi.

"It is not a Pantheon, but a document which cannot be catagorized neatly in terms of a single aesthetic. Lotte chose not to be governed by preconceptions so that each experience might challenge her to discover a visual idea which reflected her response. … Her work had developed in reaction to the contrived formulas of the studio tradition, and it represents a period of transition, towards instantaneous photography."[106]

She introduced a new approach to portraiture that was equally applicable to public figures, artists, friends, men and women: the head-and-shoulders shot, often with the head leaning on one or both of the hands. The face and hands — the unadulterated and sole remaining expression of individuality — were positioned as closely as possible within the frame. "The face was the heir to the body, in itself a part of the expression of individuality, at least inasmuch as it is not covered by clothing… The particular spiritual personality is certainly bound to a particular, distinctive body through which it may always be identified. But under no circumstances can it tell what kind of a personality it is; only the face can do that."[107]

A slight tilt of the camera, a seemingly insignificant change of distance, a shift of the fill light to the front or more to the side — these are all means of varying the effect of this modern full-figure, bust or head shot. Lotte Jacobi displayed incredible resourcefulness in utilizing them. The portraits that have passed the test of time are those whose effect is derived from the visual-compositional realization — but also those that tell of the encounter between the photographer and her subject.

Head of a Dancer, Adolf Wohlbrück, Kurt Tucholsky, Peter Lorre, Lotte Lenya, Lisl Karlstadt and Karl Valentin, Erika and Klaus Mann

The picture titled *Head of a Dancer* (pl. 21) counts as one of the few examples of Lotte Jacobi's work whose effect can be entirely attributed to the formal composition. The anonymity of the title conceals the identity of the Russian dancer Niura Norskaya. Everything that could reveal something about space and time has been excluded. Not one single detail of physiognomy betrays the model's indentity. Instead, the severe geometricization of the face creates an image of timeless beauty. The even lighting enhances the featurelessness even more, and the body seems to be swallowed up in contrasting white and black surfaces. Not even the model's transfixing gaze is able to awaken her from her anonymity.

Lotte Jacobi met Niura Norskaya in 1929 at the Russian ball in Berlin, where the dancer was crowned Russian beauty queen. All evidence indicates that *Head of a Dancer* was not published at the time.

The reverse-image double portrait of the actor Adolf Wohlbrück (pl. 19) is the product of another type of experiment that Lotte Jacobi only rarely attempted. Judging from the number of surviving photos of him, she must have been especially fond of having her good friend sit for her as a model. Their intimate relationship may have given her the confidence to try out experimental and, for her, unusual ways of dealing with the medium. The image's allure and effect arises from the artificial construct of the double exposure, yet in spite of this stylized alienation of the subject — and in contrast to the *Head of a Dancer* — the outcome is a portrait of a friend. The dual faces reinforce the seriousness of the model's expression. On the one hand, it refers to the classic pose of the man as a thinker, pressing a finger against his temple. On the other hand, the ornamental effect of the play of light breaks the torso up into facets, creating a negative montage that reflects Cubist patterns of pictorial composition by sectioning its subject into multiple views. True to the photographer's sense of the inviolability of the personality, the head and face remain untouched by graphic manipulations. The dual and multiple faces were often used to signify motion. In this image, however, it is more suggestive of the Janus aspect of the person and time. Shortly after Lotte Jacobi left Germany in 1935, Wohlbrück fled into exile in London together with his friend, the photographer Alexander Bender, who had learned his trade from Jacobi.

The detail shot of Kurt Tucholsky in profile (Ill. p. 62) is yet another that hardly would have met the demands of the standard magazine portrait. Here, the photographer concentrated on the eyes, nose and mouth. She dispensed with all elements which might have defined the subject more closely or located him in space and time, opting instead for this radical type of solution.[108] To fully appreciate the photographer's approach to this portrait, it helps to know the circumstances of the actual session.[109]

Lotte Jacobi is said to have been quite surprised at the respectable appearance of Tucholsky, a razor-witted critic of everything reactionary. She greatly admired him for his diatribes against the Babbitts and lowbrows as well as for his loyalty to republican views. Apparently, she found it difficult to reconcile this image with the actual appearance of the man who showed up at her studio, and she was hard put to develop an idea for the portrait.

So, once again, she relied on her overall concept for portraiture and her own style — to capture the model in the style that is his own. The Tucholsky portrait exemplifies the dialectical nature of this process: the photographer and the model alternate in the roles of subject and object. Although the photographer chooses the model, the model decides which face to present to the camera, influencing in turn the photographer, who develops her concept according to her newly gained impression of the model.

From this reciprocation of presenting and responding, of representing and projecting, the portrait is created, as the result of a multi-dimensional dialogue — continued hypothetically even beyond the actual encounter between the model and photographer — and the influence it exerted on the composition. "And so, the amateur photographer moves to the fore … He does what he does out of love for the thing itself, with no consideration for clients, competitions, prizes, prices and money. Among these amateurs, it is the women who often surpass their male colleagues — often, but not always."[110]

The cynical villains Peter Lorre created for the silver screen in the late 1920s and early 1930s sent chills through cinema audiences. His sinister face was the stuff of many a nightmare. But Lotte Jacobi was not content with character portraits of the actor (pls. 44, 45). She also wanted to make photos of him in private.

He agreed to her suggestion with a grudging, "Yes, but only one". He came to the session in a respectable white collar and tie. The result is a portrait in which Jacobi very nearly violates the accepted norms for polite distance, yet without distorting the facial details into

Plate 17
Peter Lorre
Berlin, around 1932

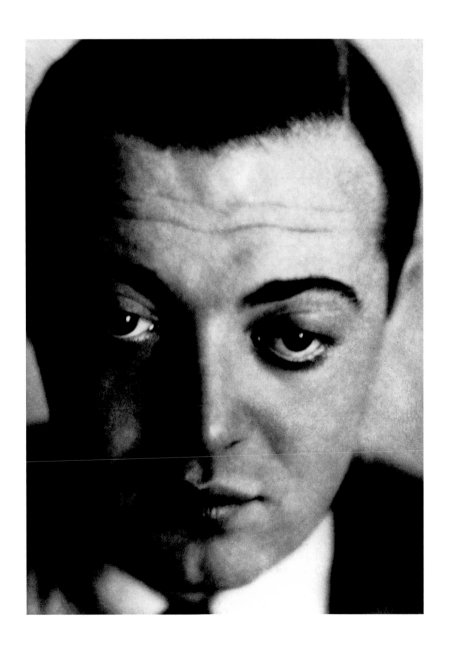

decorative elements (pl. 17). The formal elements that characterize her technique — the frontal perspective and filling out of the frame — strike a balance, with the definition of space created by the view slightly from above, and especially from the hint of shoulders. The raised position of the camera not only helps to ease the somewhat unnerving directness, it also softens the impression made by the demonic look so typical of Lorre.

Jacobi's photo of Lotte Lenya, which oscillates between type and individual, helped to establish Lenya's image in the world's consciousness (Pl. 35). It was taken during the rehearsals for *The Three-Penny Opera* at the Theater am Schiffbauerdamm in Berlin shortly before the premiere in August, 1928. Lenya's favorite picture[111] would make a place for itself in the film and photo history of the 1920s as the prototype of the "New Woman". At the time, the actress's name was known only within a very small circle of theater enthusiasts.

Kurt Tucholsky
Berlin, around 1930

The relatively minor role of the prostitute Jenny made her famous virtually overnight, and G.W. Pabst's film version, featuring the "Song of Pirate Jenny" by Kurt Weill (pl. 23), spread her fame throughout the world. Lotte Jacobi had arrived for the official photo session and joined other photographers in the wardrobe. Like her competitors, she had to work under the conditions attendant to public appearance. The close-up shot that resulted must be attributed to a keenness of her eye that went above and beyond her professional handling of the camera.

Shot in horizontal format, in reference to the cinema picture frame, the portrait shows Lotte Lenya in a turtle-neck sweater and page-boy haircut, holding a cigarette. Quite aware of her cool beauty, she captivates the viewer with her gaze, but maintains her distance with an arm thrust diagonally across the frame. Lenya's asymmentrical features and all the seductive and indecent charm dictated by her stage persona are caught up in the compositional balance. In this photo, the person, the type and stage persona are inseparably melded into one. And who would want to separate Lenya, the New Woman, and Pirate Jenny from one another and consequently be forced to decide for or against the person, the type or stage persona? There is no record of this picture of Lenya having been published at the time it was made. Perhaps the person, the type and persona did not suit the taste of the popular press.

Lotte Jacobi was partial to working with double portraits — perhaps because they offered more possibilities to arrange and choreograph the scene. Only rarely did she resort to conventional poses: the frontal view of the subjects side-by-side in one plane, either as a full

figure or head-and-shoulders shot; or the parallelism of the subjects as in early Romanticist friendship portraits (cf. pl. 99).

Artist couples, married couples, friends, brothers, sisters and co-workers — she produced endless variations on the basic themes of dual and multiple figure portraits. The protagonists, many of them stage or screen personalities, often participated in the process with improvised or existing routines, so the person was merged with the stage persona, as, for example, in the portraits of Grock and Trudi Schoop (pl. 58), or Lisl Karlstadt and Karl Valentin. Jacobi captured the relationship between the two comedians in a shot taken during a visit by the team to her studio in Berlin. Dependent on one another to the bitter end, Valentin and Karlstadt could never have achieved fame without each other, but were unable to attain happiness as a couple. This is hardly surprising, observing that, in this photo, Lisl Karlstadt is quite literally pushed to the edge, (pl. 24) and is thus forced to see the world from a completetly different perspective. The photographer succeeded in transposing the spirit of their stage hit — the irony and sarcasm of their cabaret routine — into the image.

The changes in social conditions during the 1920s led to new forms of social communication. The double portrait of Erika and Klaus Mann (pl. 29), in which the subjects embody the androgenous type of the period, serves as an illustration. "They no longer aspire toward individuality. Over the past few years, a desire for sameness has taken hold — people want to be as much alike as possible, at least outwardly. There is an absolute consensus of ideals," — is how the *Berliner Illustrirte Zeitung* commented on the male-female double portrait with the caption "The common face — the similarities are amazing." It continued: "Fashion was once limited to clothing. Now it applies in the same degree to the face and figure. It's the fashion of elective affinities."[113]

Like the picture in the magazine, the shot of the two Mann children exemplifies everything the 1920s held in store for defining gender roles for men and women. Lotte Jacobi's two-shot proclaims the matter-of-factness of an androgynous self-identification, in one sense through the apparent harmony between the photographer and the brother and sister, and, in another sense, through the impression of an intimate rapport between Klaus and Erika Mann. But the *Berliner Illustrirte Zeitung* expresses amazement at what they label an obsession with similarity, which it considers to be largely due to the masculinization of women as well as the growing tendency of men to present a clean-shaven look.

With her photo of Erika and Klaus Mann, Lotte Jacobi did more than document a relationship between brother and sister. She also created a double portrait of unparalleled modernity for its time. It addresses the issue of the individual and society, of personality and type, and adds the dimension of gender roles.

Erika and Klaus Mann embody modern, casually dressed intellectuals. He is clad in a sport shirt, she in a similar blouse. Both have their sleeves rolled up, are wearing ties and smoking. They are seen in a private moment, he from slightly below, she in profile, in an imaginary room bathed in soft light. They are not at all disturbed by the presence of the photographer. It was the end of the 1920s, when their collaboration was at its height. "In my life, only those things in which she played a role had any real substance and reality", Klaus Mann was to later write about his sister in his memoirs.[114] Erika Mann is turned towards her brother, reflecting the role she had assumed in their lives. He looks toward the camera, appraising the effect he is having as if quite enamored of himself. This photo appeared in *Tempo* during the summer of 1930 with a note about their upcoming automobile tour through Africa.

Plate 18
Alexander Bender
and Adolf Wohlbrück
Berlin, 1933

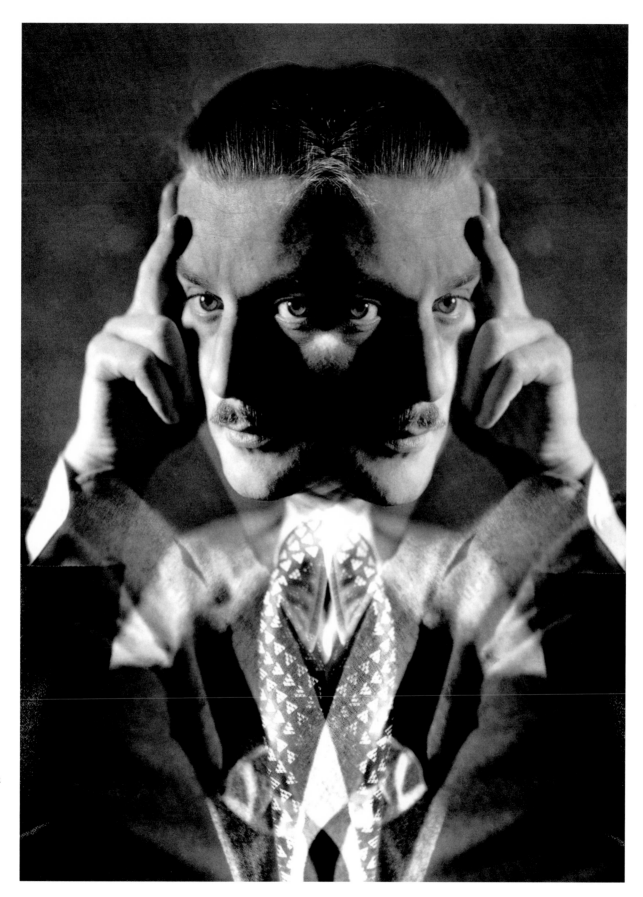

Plate 19
Adolf Wohlbrück
Berlin, 1932

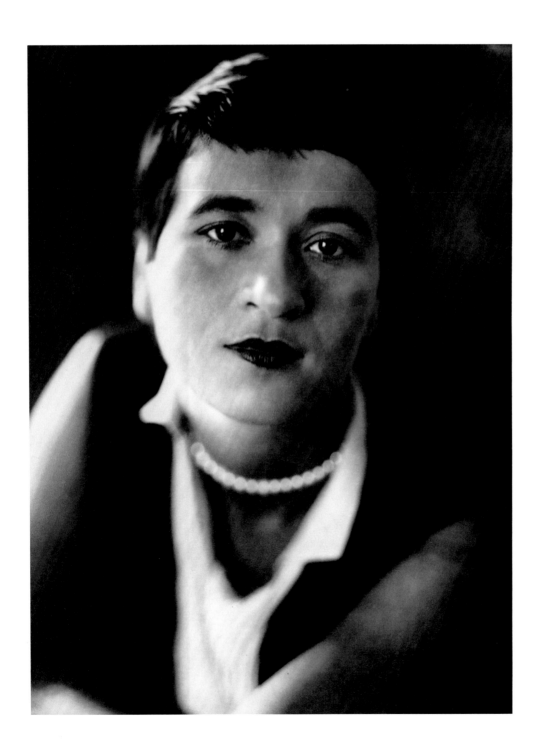

Plate 20
Valeska Gert
Berlin, around 1930

Plate 21
Head of a Dancer
(Niura Norskaya)
Berlin, 1929

Plate 22
Käthe Kollwitz
Berlin, 1929

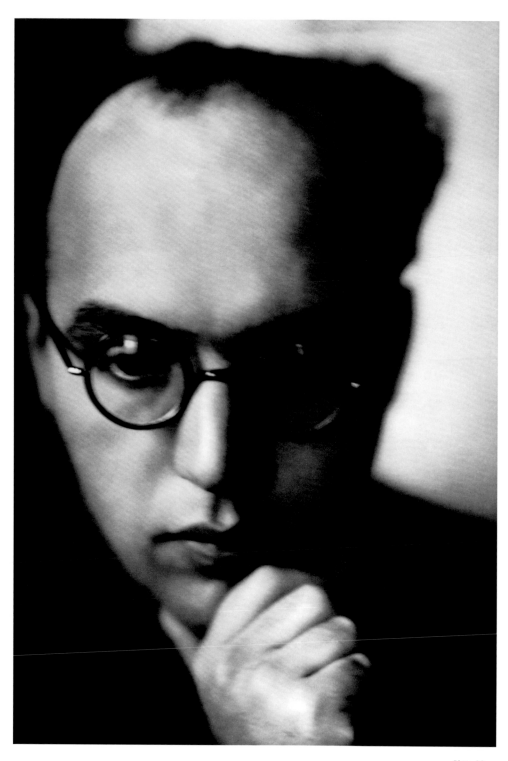

Plate 23
Kurt Weill
Berlin, 1928

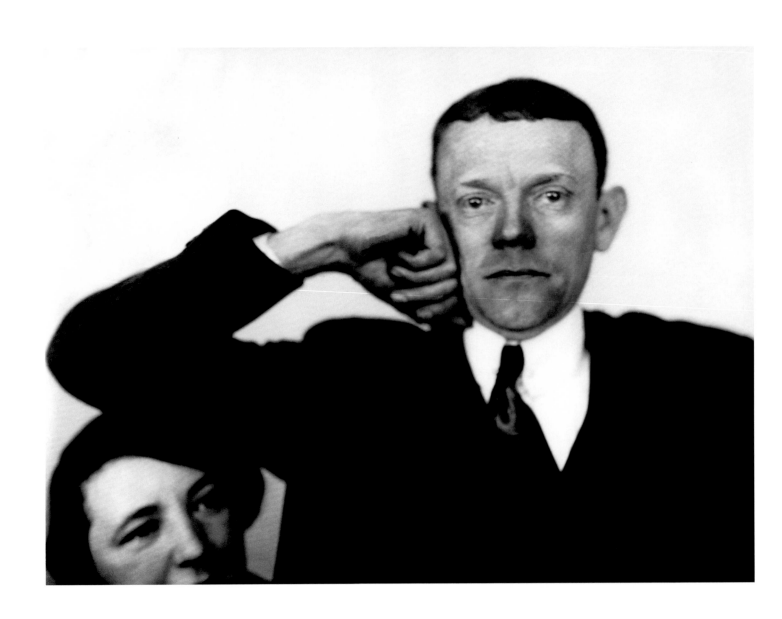

Plate 24
Karl Valentin and Lisl Karlstadt
Berlin, 1928

Plate 25
Hans Richter
Berlin, around 1931

Plate 26
Renée Sintenis
Berlin, around 1930

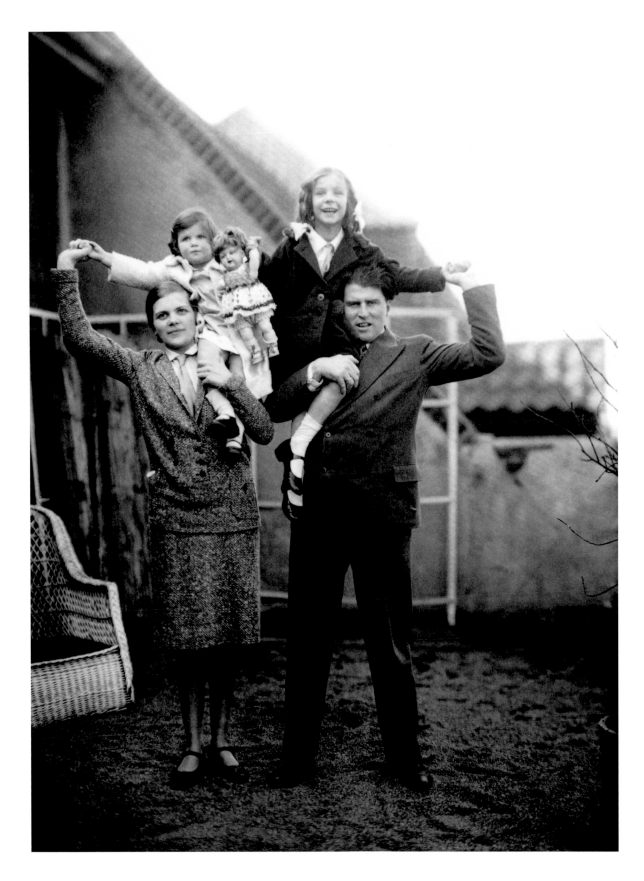

Plate 27
Carl Zuckmayer
with family on the
terrace of
his apartment
Berlin, 1928

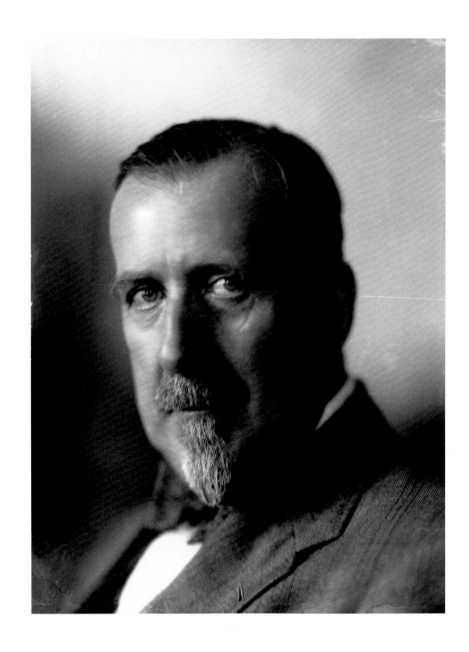

Plate 28
Heinrich Mann
Berlin, around 1930

Plate 29
Erika and Klaus Mann
Berlin, 1930

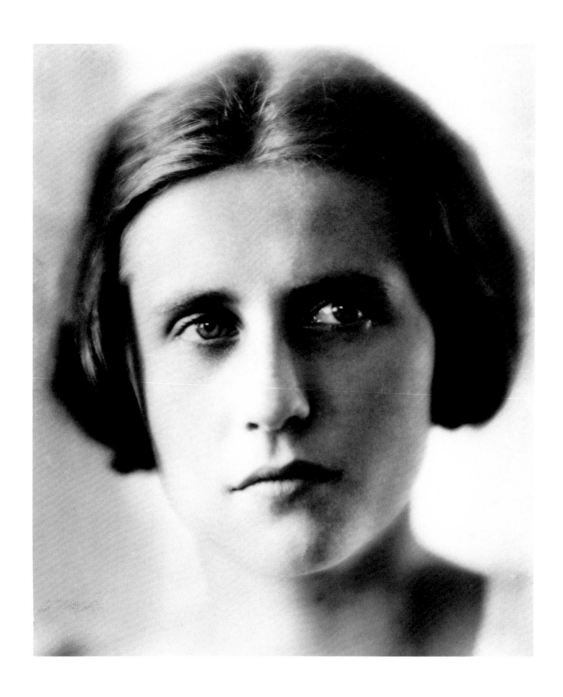

Plate 30
Grete Mosheim
Berlin, around 1930

Plate 31
Francis Lederer
Berlin, around 1930

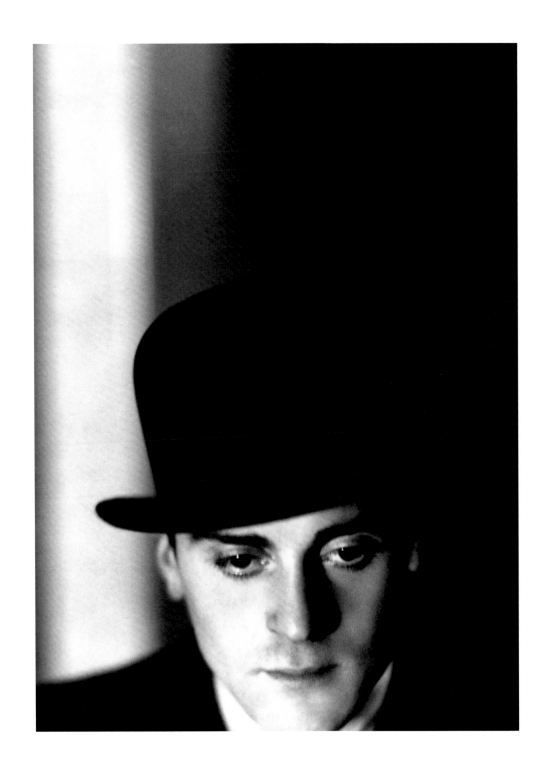

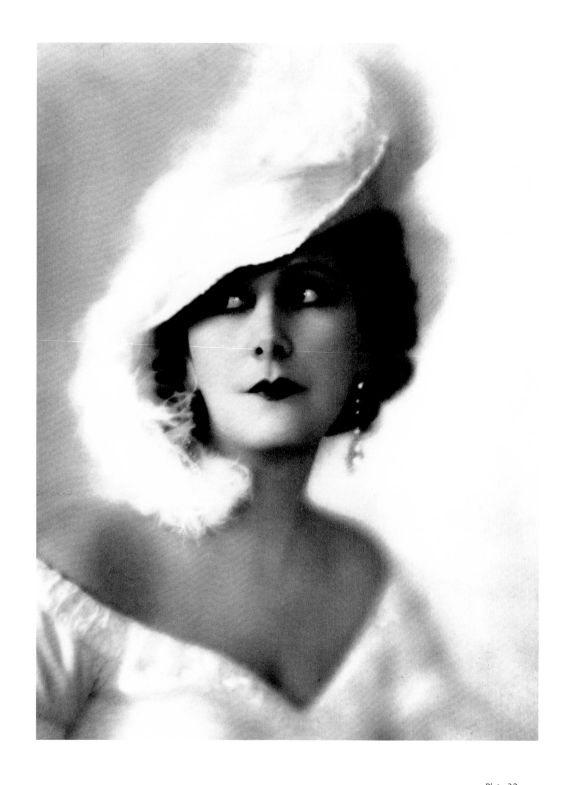

Plate 32
Lil Dagover
Berlin, 1928

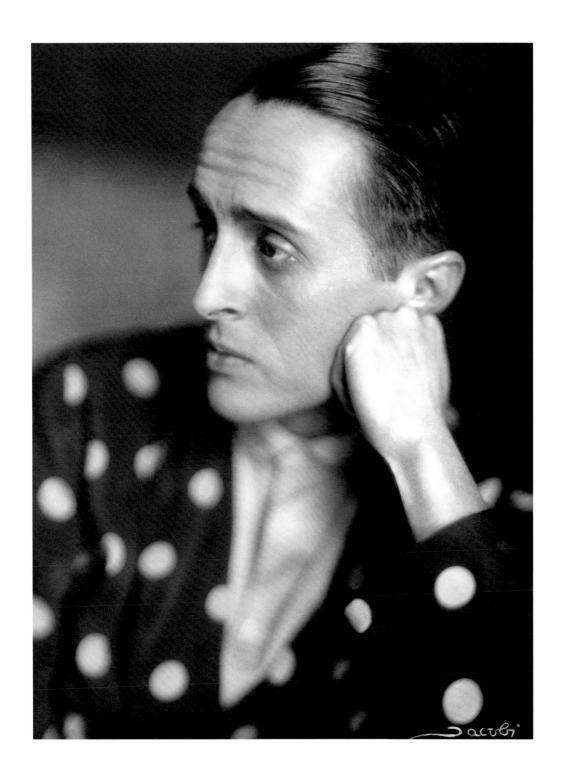

Plate 33
René Clair
Berlin, around 1930

The Camera as an Admission Ticket — Theater Photographs

The camera was Lotte Jacobi's ticket to the world of the theater which had so fascinated her ever since she was a girl and which she had a great desire to be a part of. As a photo journalist and chronicler, she finally found a role perfectly suited to her, for it allowed her to continue to nurture her love of the theater. The period of her professional interest in the stage began the year after she returned from Munich. Hardly a day went by when there was not a photo session or a premiere to attend at one of the more than forty theaters in Berlin.

For the Atelier Jacobi, theater photography became a new and, for several years running, perhaps its most lucrative business activity.[115] The vast selection of stage photos, the scene stills taken during performances, at photo sessions or in the dressing rooms, the character shots and particularly the portraits of actors and directors made in private surroundings give some idea of how deeply Lotte Jacobi immersed herself in the world of the theater.

Technological advances in photo equipment gave the photographer the mobility she needed to capture the action as it happened on stage. Once freed of her dependence on the director for choosing the subjects, she was finally able to make her own decisions about viewing angles, scene arrangements and the right moment for a character shot. The production still broke free of its limitations as a posed, static, photographic document and came into its own genre.[116] As program photography, it was bound to the narrative content. The main artistic challenge facing the photographer lay in recreating the unaccustomed theater lighting in the image. Lotte Jacobi must have been just as intrigued by this aspect as she was by the contact with the actors behind the scenes, where her own talent for acting and improvisation served her better than any photo-technological innovation.

Lil Dagover with her Shih-tsu
Berlin, 1928

Demand was greatest for pictures of shows at the *Admiralspalast*, the operettas at the *Metropoltheater* and the comedies on the variety stages. The productions of the municipal opera were covered almost exclusively by photographer Suse Byk, but Lotte Jacobi managed to get one or two opera photos of her own published in the magazine *Das Theater*. The stages she visited most often were the *Theater am Schiffbauerdamm*, the playhouse on what was then Königgrätzer Straße, and the Max Reinhardt and Erwin Piscator stages, where Sasha Stone did much of his photography, but to which Lotte Jacobi always had free access.[117]

She may well have felt the competition from other photographers most at press photo sessions in the theater. She was, at any rate, obliged to contend with a long list of both well-established and newly emerging specialist studios. Old post cards — which still turn up occasionally today — along with the carte de visite photographs from the Becker & Maass and Zander & Labisch studios give some hint of how tight the working atmosphere in the theater must have been.

In the 1920s, Baron Wolf von Gudenberg and Karl Schenker became specialists in the field. Before taking up photography, they had both been painters and were in great demand as portraitists, especially in the more affluent social circles. But as time went on, they shifted increasingly to photography for the press, working alongside Alexander Binder, Ernst Schneider, Sasha and Cami Stone, Margarete Willinger, Suse Byk, Elli Marcus and Lotte Jacobi.

In Berlin, there were no exclusive contracts with one theater as there were in smaller cities. No one had the kind of contracts that Trude Fuld, and, for a short time, Josef Breitenbach had with the Munich *Kammerspielen*.[118] By the same token, the press did not commit itself to any one photographer or studio, since it was the show and the circle of readers that decided which pictures were to be published when. Whether sophisticated, popular, sensational, avant garde or political, the first priority was to serve the tastes and expectations of the reading audience. Theater lovers snapped up photo-postcards of their idols and stars, but theater historians and collectors, too, such as Walther Unruh and Carl Niessen, provided a ready market for the stacks of theater photos being printed.[119]

During these years, innovations in lighting technology greatly facilitated both theater art and theater photography. Improved cameras made it possible to record on film the new developments in scene design with all its nuances of stage lighting. "I went to the theater as often as I could. I had my Ermanox at the time and photographed a lot during the rehearsals."[120]

The choice of camera alone shows how important stage photography was to Lotte Jacobi: the Ermanox 9 x 12 cm plate-backed camera, which was nothing less than a sensation among photographic equipment at the time. She used it exactly as advertised: "Night and indoor shots without a flash. You can take photos in the theater during the performance, with short or instantaneous exposure times. The Ermanox camera — small, easy to operate and inconspicuous."[121]

In 1924, the Ernemann Company produced the first in a series of easily manageable, small-format plate cameras: the Ermanox 4 $\frac{1}{2}$ x 6 cm, fitted with the high-speed 1:2 Ernostar lens. Apparently, it was quite well received by, among others, friends of the theater. By tradition, the magazine *Das Theater* preferred to devote its pages to current theatrical events rather than the latest developments in camera technology, but its January

"Lil Dagover"
in: *Das Theater*, vol. XII,
No. 2, 1931, Cover
Kunstbibliothek SMBPK

1925 edition carried a complete report on "Instantaneous Photography in the Theater", presenting the capabilities of the new camera.[122] That same year, the Leipzig trade fair was held "In the Spirit of High Speed" and afterwards, the *Fachblatt für Berufsphotographen,* a professional journal for photographers, wrote that the Ernemann-Werke AG, Dresden had set the pace at the fair with their Ernostar 1:2. "The Ermanox camera for stage, night and interior shots without a flash is now available in the $6^1/_2$ x 9 cm format with a 12.5 cm focal. In the very near future, the Ernostar, the lens for use with the Ermanox camera, will be appearing in a 1:1.8 speed version. Recent tests have shown that it is possible for this lens to achieve the most commonly used focal lengths without the image being subjected to the slightest vignetting."[123]

These cameras represented a major step forward in the development of photographic equipment. Advertisements for them soon appeared in newspapers and magazines. So it can be assumed that Lotte Jacobi had heard of this state-of-the-art camera while still at school in Munich. Moreover, in early 1926, Hans Böhm, a theater photographer in Vienna, had presented his study entitled, "The Vienna Reinhardt Stage in Photos — the First Season, 1924/1925" with se-

lected photos. With Max Reinhardt's permission, Böhm had taken pictures during performances over the course of one season, using the Ermanox $4^1/_2$ x 6 cm and the $6^1/_2$ x 9 cm, both equipped with the high-speed 1:2 Ernostar lens, and had tried out all of the cameras' capabilities. His belief that, "the only way to achieve good pictures of the stage is to free oneself of all hindrances and shoot the photos while the play is in progress" was, for the first time, made practicable by this equipment. He adhered to a strictly documentary approach that aimed at showing "all details in full realism", though he did allow for the possibility

Constantin Stanislavski
Berlin, around 1930

of artistic manipulation during the enlargement and printing processes.[124]

In December, 1926, Ernemann introduced yet another improvement in its technological innovation with the Ermanox 9 x 12 cm and the 16.5 mm Ernostar 1:1.8, the fastest lens of the day. The lens yielded an unusually good picture quality, while the size of the camera and its plates made them relatively easy to handle in spite of the considerable weight and the necessity of using a tripod in the tight spaces between rows of seats in the parquet or the mezzanines, where Lotte Jacobi preferred to set up. Depending on the speed of the lens, the plate emulsion reached a speed of 27 to 28 scheiner, which corresponds to approximately 17 DIN.[125] Lotte Jacobi acquired this custom-made Ermanox, one of only nine ever built, in 1928. She had outfitted herself with the best equipment then available for theater photography. Compared not only to the 18 x 24 cm plate cameras, but also to the smaller-format

Plate 34
Erwin Piscator, Paul Baratoff
and Reinhold Schünzel
Berlin, 1929
private collection

Ermanoxes still used by many of her peers, it opened up entirely new opportunities, including a degree of freedom from the lighting conditions and their restrictions on the choice of camera placement. "The stage photographer has more or less to re-compose the setting to be able to reproduce its characteristic and descriptive appearance. And so, within the context of the stage choreography, the theater reporter has to do his own choreography, based on considerations essentially confronting him with the choice of being an illustrator, portrait artist, or Sunday painter,"[126] wrote the Munich theater photographer Trude Fuld.

Re-composing the theater scene for the camera, photographically reproducing a vivid impression of the action on stage, communicating the inner motive forces as manifested through gestures and facial expressions — these were the standards Lotte Jacobi set for her work in the theater. "But there you have to bear in mind that you aren't a film director, who may compose each of the picture's smallest details to suit his own taste."[127] No doubt, however, Lotte Jacobi was able to capitalize on the fact that she had learned the craft of the film director for a short time during her studies. It helped sharpen her ability to react to the action in progress on stage and capture the decisive moment without hesitation. While in filmmaking, a scene is repeated until it is perfect and "in the can", on the stage, once a moment passes, it is lost irretrievably.

Lotte Jacobi's preference for Erwin Piscator's stages as a place to observe rehearsals and performances reflects her deep political convictions. Nowhere else was she better able to blend her photographic activities with her political commitment than in this like-minded theater troupe. She could spend afternoons discussing the widening polarization between the republican forces and the champions of capitalism and nationalism with Max Hoelz and Egon Erwin Kisch. And in the evenings, she found these self-same views and fears being expressed to the audiences of Piscator's productions in literary and musical forms by him and his authors and performers: Walter Mehring, Alexander Granach, Hanns Eisler and Ernst Busch. She hardly missed a single one of the avant garde productions of such politically controversial plays as *Der Kaufmann von Berlin* (*The Merchant of Berlin*) or Carl Zuckmayer's translation of *Rivals*. In the former, Walter Mehring turned the subject of inflation into a defiant social analysis, and Erwin Piscator tried out some ideas for the staging that were so ambitious that they very nearly spelled failure for the production. "From the beginning, I saw the play divided into three levels as suggested by the material: a tragic one (the proletariat), a tragi-

The creative team in
the Theater am Nollendorfplatz
during rehearsals for
The Merchant of Berlin
by Walter Mehring
Berlin, 1929
drama department collection
University of Cologne

comic one (the middle class) and a comic one (the upper class and the military). These sociological divisions gave rise to the three-level system of the stage."[128] In the image of the generals sitting in a macabre sort of seance, with the skull and cross-bones as their flag (pl.40), Lotte Jacobi caught an "unguarded moment" through which both the mise-en-scène and the photographer give the audience a glimpse into the evil doings of the military. The ominous atmosphere evoked by the disassociation of the characters from one another is reinforced by the play of shadowy figures on the backdrop. Other social groupings are portrayed in the pictures titled "Booze-Drinking Bankers" and "People Standing in a Breadline". One of the most impressive scenes is presented in the shot of Ernst Busch as the leader of a male choir (pl.41), performing the *Cantata of War, Peace and Inflation* to music by Hanns Eisler. Appearing as a ghostly head lit in stark contours by a single beam of light, he stands at the tip of a choir which itself disappears into the darkness on stage. It is as if an invisible net fixed each individual into the matrix of a ruling idea. The mood of the scene — and of the photograph — is derived from the deep black against which the few light surfaces stood out in contrast.

László Moholy-Nagy, with Alex Strasser and János Reissmann in the Theater am Nollendorfplatz during rehearsals for *The Merchant of Berlin* by Walter Mehring Berlin, 1929

Lotte Jacobi was also present with her camera during the final rehearsals for *The Merchant of Berlin*. From various positions, she took pictures of the creative team standing on a platform and watching the work on the stage set. Seen from below are László Moholy-Nagy, who designed scenery and decor, Alex Strasser, who made the films to be projected on the stage's rear wall, the photographer János Reissmann, and a fourth team member, perhaps Paul Urban, who is hidden behind a motion picture camera. The photographer shot the same team from a different perspective, backlit, perched atop the somewhat constructivistic platform, transforming them into performers in the photographic scene. A very personal expression of Lotte Jacobi's enthusiasm for the protagonists of this production was the group portrait of the director, Erwin Piscator, and the two leading actors, Reinhold Schünzel and Paul Baratoff, which she herself arranged outside the theater (pl.34).

The Merchant of Berlin is one of a large number of what were known as *Zeitstücke* — plays that dealt with current social and political topics or court cases. Most were produced between 1928 and 1931. Even if Lotte Jacobi showed no desire to apply her photographic work to achieve political ends, she obviously felt drawn to socio-political themes in the theater. There is hardly a single production of this type from the period that she did not docu-

ment in her photographs: *Die Ursache (The Cause), Die Verbrecher (The Criminals), Die Rivalen (Rivals), Giftgas über Berlin (Poison Gas over Berlin), Revolte im Erziehungshaus (Revolt in the Penitentiary), Pioniere in Ingolstadt (Pioneers in Ingolstadt)*, and lastly, *Cyankali (Cyanide)*, Friedrich Wolf's play which dealt with an issue of concern to many artists — abortion — from a literary perspective.

Her pictures of the anti-war play *Poison Gas over Berlin* (pl. 42) by playwright Peter Martin Lampel, whose *Revolt in the Penitentiary* met with unexpected success, were to gain a special significance as photographic documents. *Poison Gas over Berlin*, which denounced the covert rearming of Germany, was never performed in public, ostensibly because the actor in the role of the general bore a striking resemblance to the former chief of staff, Hans von Seeckt. If performed, the theater ran the risk of being sued for defamation of the military. But the ban — and a very few private performances of the play — only served to push the anti-war piece even further into the spotlight of attention — at least in theater circles.

With her pictures of a production of Friedrich Schiller's classic *Don Carlos*, Lotte Jacobi demonstrated her genius for capturing the essential moment of a play while evincing a sense for the theatrical and literary aspects of a work. Much like the choir scene with Ernst Busch in *The Merchant of Berlin*, this shot of Fritz Kortner in the role of Philipp II of Spain and Lothar Müthel as Marquis Posa relies for its effect on the stage lighting design (pl. 43). Only the heads and hands of the adversaries emerge from the darkness. A minimum of gestures and props suggests the action of this key scene. The king sits bent over the table, lost in thought; the lion's head before him indicates the place of the sovereign, and, as dictated by hierarchy, Marquis Posa stands bowing at his side. Reduced to the sense of sight, the shot succeeds in communicating the core statement of the play: the fundamental contradiction of the two principles as embodied by the two antagonists, the ruler and the enlightened, thinking man.

Beyond the stage and scene photos, the private and character portraits of actors are not to be overlooked. "It was for good reason that the task of recording a production and the actor in his role was entrusted to photography. What you see with the naked eye is faithfully transmitted by the camera's eye, but it is only able to reflect something of the soul of a human being when an artistic eye clothes him with its own vision and face."[129]

It is plain to see by the portraits of performers that the photographer thoroughly enjoyed the element of play and her skill at bringing people — people with stage experience — under her spell. And one can also sense the fun her subjects must have had at photo sessions where the photographer gave herself a free hand to work out her own ideas for staging. A few examples worth mentioning are the shot of the two pie-eyed soldiers with cigarette butts hanging on their lips in the anti-war play *Rivals* (pl. 50), the acrobatic Zuckmayer family (pl. 27), and the private view of the character actor Heinrich George as a loving father (pl. 39).

Character portraits like those of Ernst Deutsch as the condemned prisoner Seiler in the play *The Cause* (pl. 46), Werner Krauss as a middle-aged Peer Gynt (pl. 38) — taken with an 18 x 24 cm plate camera — and many others, including portraits of Eugen Klöpfer, Heinrich George, Alexander Moissi, Max Guelstorff and Frieda Richard, have taken their places in theater history. Her photo of Lotte Lenya (pl. 35), shot during the rehearsals for the premiere of *The Threepenny Opera*, has become an icon among the photographic portraits of the 1920s.

86

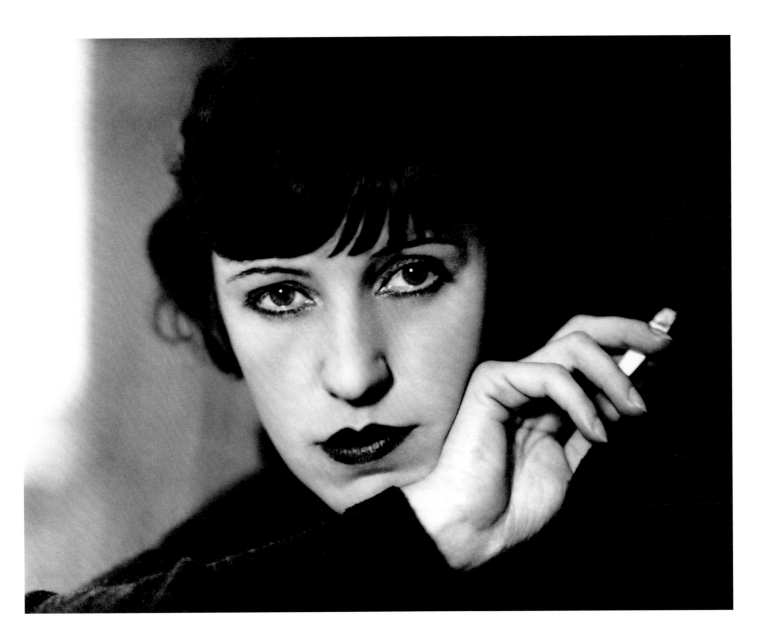

Plate 35
Lotte Lenya
Berlin, 1928

Plate 36
Alexander Moissi
Berlin, around 1930

Plate 37
Julius Caesar by
William Shakespeare
at the Volksbühne
Berlin, 1930

Plate 38
Werner Krauss as the
middle-aged Peer Gynt
at the Deutsches Theater
Berlin, 1929

Plate 39
Heinrich George and
his son Jan Albert
Berlin, 1934

Plate 40
The Merchant of Berlin
by Walter Mehring at the
Theater am Nollendorfplatz
Berlin, 1929

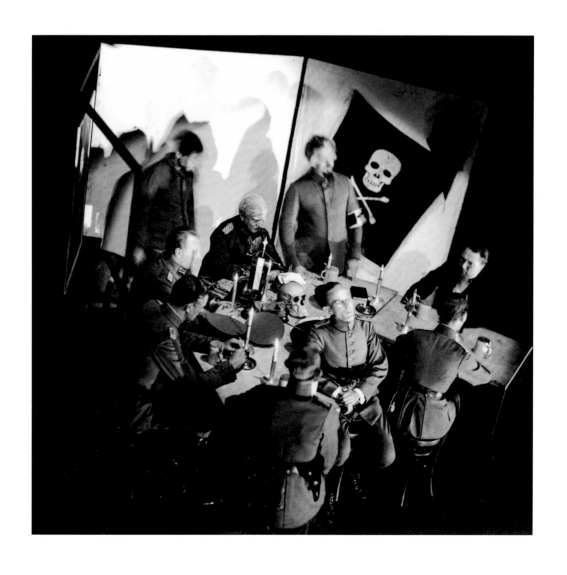

Plate 41
Ernst Busch with choir in
The Merchant of Berlin
by Walter Mehring at the
Theater am Nollendorfplatz
Berlin, 1929
private collection

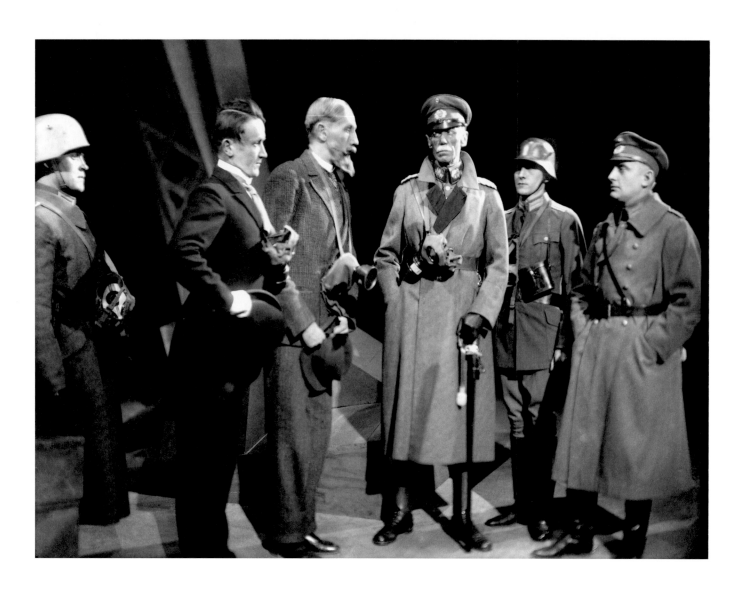

Plate 43
Fritz Kortner as
Philipp II and
Lothar Müthel as
Marquis Posa in
Don Carlos by
Friedrich Schiller at
the Staatstheater
Berlin, 1929

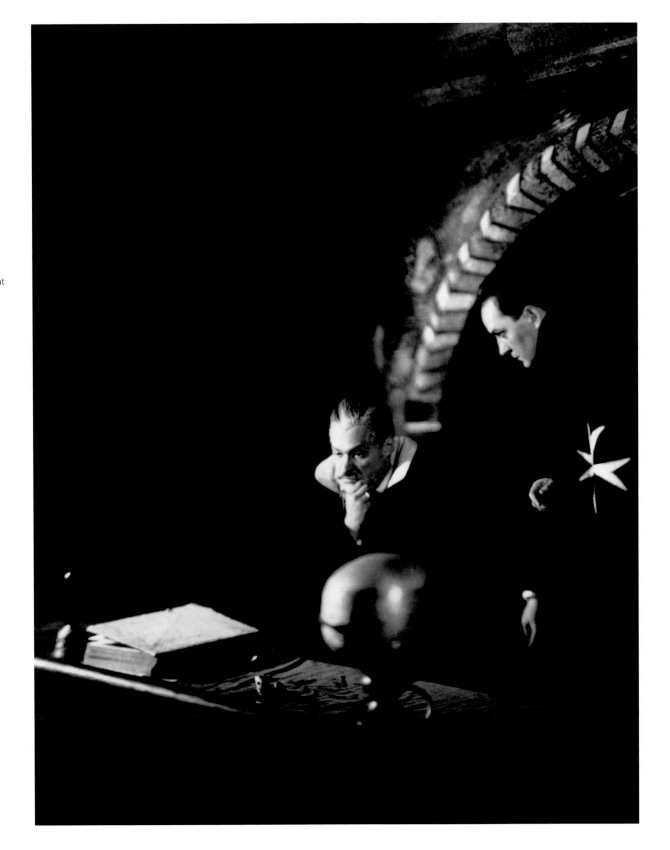

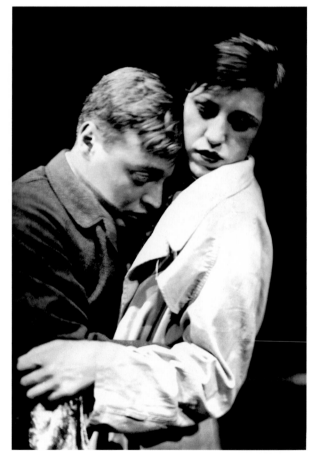

Plate 46
Ernst Deutsch as the condemned
prisoner Seiler in *The Cause* by
Leonhard Frank at the
Kammerspiele
Berlin, 1929
Drama department collection
University of Cologne

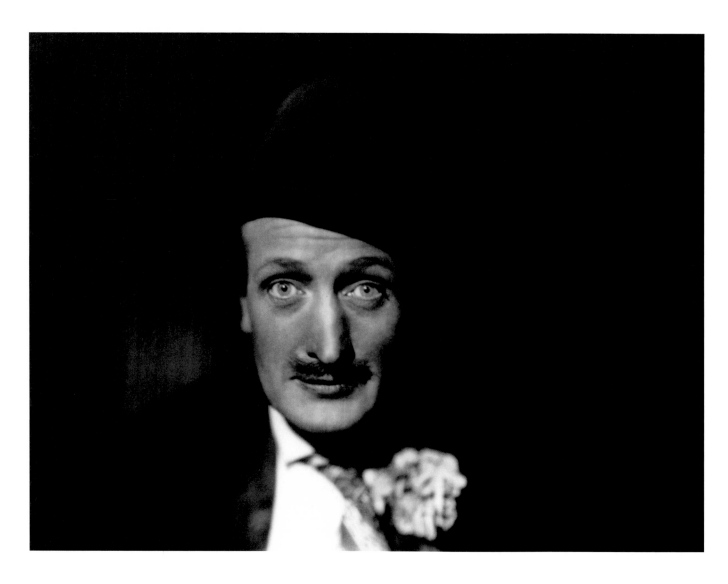

Plate 47
Hans Albers as Tunichtgut
in *The Criminals* by
Ferdinand Bruckner at the
Deutsches Theater
Berlin, 1928

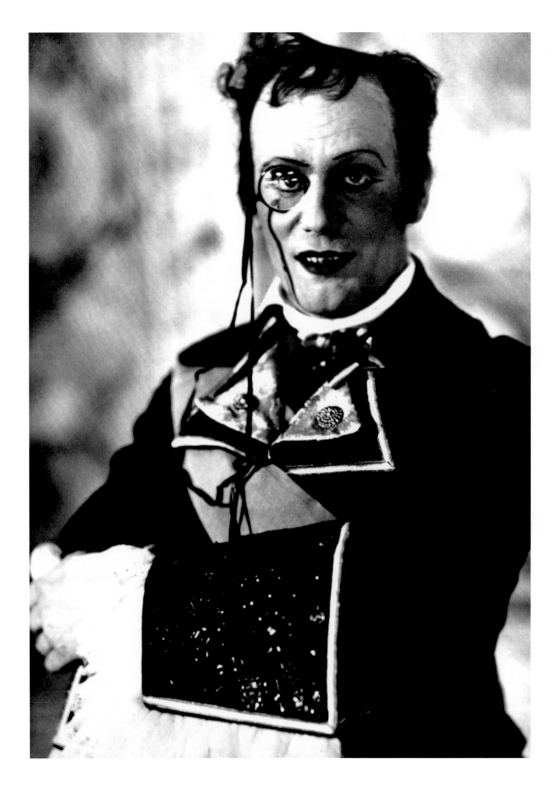

Plate 48
Gustaf Gründgens as Antonio in
The Bandits by Jacques Offenbach
at the Städtische Oper
Berlin, 1931

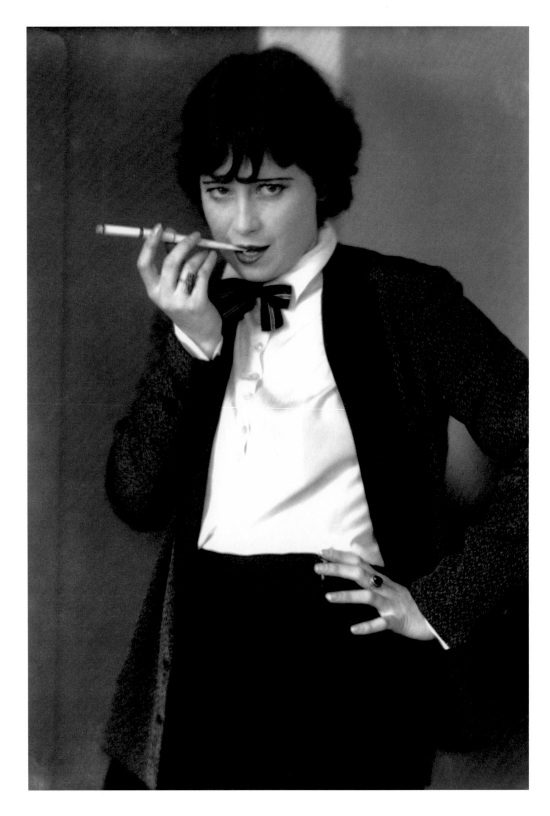

Plate 49
Valerie Boothby
Berlin, around 1930

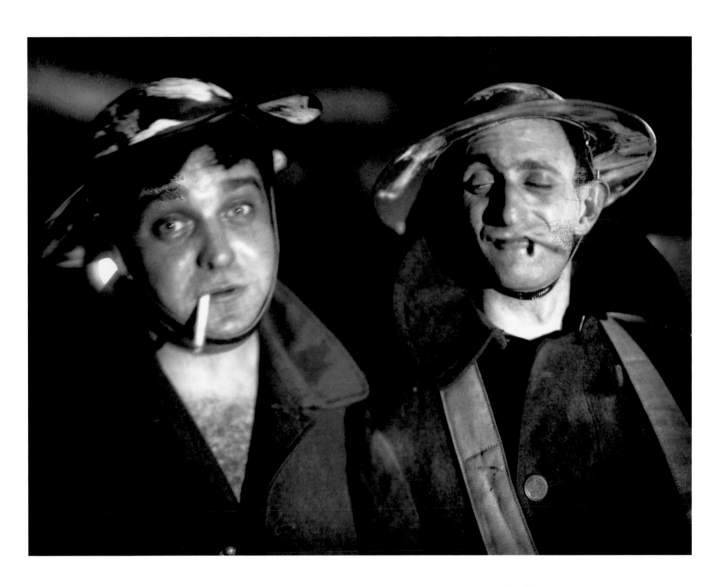

Plate 50
Hermann Speelmans and Siegfried Arno in
Rivals at the Theater an der Königgrätzer
Straße
Berlin, 1929

Dance — Photography — Motion

Lotte Jacobi's dance photographs bring all the possiblities of the instantaneous exposure to bear on the Ausdruckstanz at the zenith of its era.[130] The combination of the two, with their emphasis on the visual effect of the moment, was perfectly suited to express an epoch in motion. Advances in photographic equipment had made it possible to capture on film the motion of the body in a fraction of a second.

Lotte Jacobi had developed a fascination with moving pictures through her study of film. She went to rehearsals held especially for the photographers at concert and dance halls, as well as dance studios and classrooms. She also invited the dancers to come for sessions at her studio.

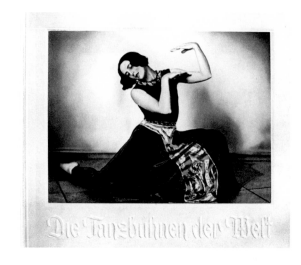

In addition to traditional images of dancers in static poses and playing specific roles, many specimens of Lotte Jacobi's work achieve a standard for instanteous photography that remain unsurpassed, even with today's advanced technologies — works like "The Top" (pl. 55), "The Jump" (pl. 52), and "The Turn" (pl. 54). They visualize dynamics and motion as abstract forces that are divorced completely from the performer and devoid of underlying themes.

At the end of the 1920s, Ausdruckstanz as a liberating physical art entered a phase of diversification. This was greeted with enthusiasm by the public. A related form of the dance was even used as physical exercise, before the Nazis recognized its potential for exploitation in the service of their aims. Its expressive characteristic was exaggerated and distorted into the sentimental. What had been movement for entertainment became charged with nationalistic and ideological overtones, while the ecstatic and satirical aspects of the dance were dispensed with in short order.

Die Tanzbühnen der Welt
Eckstein-Halpaus GmbH
Dresden 1933

In those days, Berlin was the city of modern dance. Lotte Jacobi got to know internationally acclaimed dancers like Mary Wigman, Gret Palucca, Harald Kreutzberg, Yvonne Georgi and Claire Eckstein, all of whom made regular guest appearances in the capital. Others, such as Max Terpis and Rolf Arco, Claire Bauroff, Berthe Trümpy and Vera Skoronel, and Margarete Wallmann, director of the Wigman school, set up dance training studios there. Only a few had regular engagements or were part of the regular ensemble for the opera or the dramatic stage, such as Max Reinhardt's troupe at the Deutsches Theater, or for Erwin Piscator, who employed choreographic consultants for his multimedia productions.

Within the field of Ausdruckstanz, Lotte Jacobi preferred the dynamic style of Palucca or the abstract tendency of Skoronel to the more rigid forms developed by Mary Wigman. She

found the abstractly playful figures of Claire Bauroff, Marianne Winkelstern, Louis Douglas and Rolf Arco, as well as the pantomimic technique of Trudi Schoop appealing, but could also appreciate the satirical character of Valeska Gert's dancing.

Lotte Jacobi's equipment was ideal when she began photographing dancers in 1928. She used the Anastigmat Ernostar 1:1.8 and the Ermanox 9 x 12 cm with a focal-plane shutter that permitted exposure times short as 1/1000 second. With the Ernostar, she could photograph bodies in motion by almost the same lighting she used for portraits. In the studio, she used the legendary adjustable Jupiter Light[131], which she had gained experience of in her work with lighting for motion pictures at the cinema technology department. The Jupiter Light's brightness approached that of daylight, making it possible to photograph the dancers with a studio camera. Advances in the production of plates, film packs and rolls had also

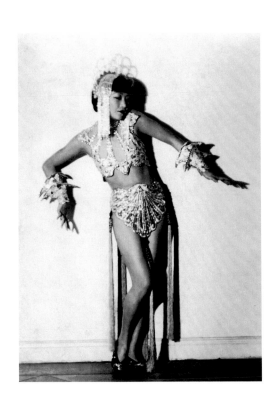

reached a stage that made it possible to bring out the slightest nuances in the gray scale. "Do what the moment calls for… setting aside your own style… forgetting the technology while shooting; you have to be very fast"[132] — those were guiding the principles that Lotte Jacobi used in her work. Dance photography called for an even greater speed of perception and reaction.

The demand from both publishers and mass print media was great and varied widely depending on the publication. The entertaining illustrated glossies were looking for images of attractive poses and rehearsal shots with the emphasis on fancy costumes for their dance enthusiasts. More sophisticated magazines wanted to present extravagant stars, while the dance journals, with which Lotte Jacobi was apparently in regular contact, were interested in the latest studies of choreographers and dancers. And finally, there were the postcard and album publishers, who were adept at combining the popularity of Ausdruckstanz with the public's passion for collecting and tapped into a source of income that was not to be underestimated. A maxim that is just as valid for dance photography today as it is indisputable and for its close relative, sports photography, is that "The great press photographers … always managed to transcend their medium and their assignment and foray into the realm of the autonomous art of the photographic image."[133]

Anna May Wong
Berlin, around 1930
Galerie Bodo Niemann, Berlin

In Berlin, Hans Robertson had taken over Lili Baruch's studio in 1928 and specialized in dance photography. There was hardly a single choreographic work of Harald Kreutzberg, one of the best-known practitioners of Ausdruckstanz of that era, that Robertson had not photographed. Other photographers, including Lotte Jacobi, expanded their program to meet the demands of the press for images from dance and the theater. Alexander Binder, Becker & Maass, and occasionally Marta Astfalk-Vietz were among the other studios which supplied the press. Suse Byk used a motion picture camera to record Valeska Gert's satirical dances. Excerpted frames from the film were published as small photographic series. The publications in the press reflect the broad array of photographs on offer from Berlin studios. On the other hand, magazines like *Die Dame*, the *Berliner Illustrirte Zeitung* or the *Münchner Illustrierte Presse* wanted their photo spreads to have a more international flair and regularly commissioned work from the Paris studios of Madame d'Ora, Atelier Lipnitzki and Atelier Manuel; James Abbé supplied the glossies with photos from London, while the studios of Trude Fleischmann, Koliner and Feldscharek covered Vienna.

Germany's best-known dance photographer at that time, Charlotte Rudolph, had her studio in Dresden. In 1929, at least ten years after the publication of American dance pho-

tographer Arnold Genthe's *The Book of the Dance*[134], Rudolph wrote down observations she'd made as she photographed the motion of dance. Genthe had given the highest priority to liberating dance photography from its dependance on posed shots. He wanted the images to depict more of the dance's transitory and fleeting nature. Despite the elegance and grace of his pictures, technical constraints prevented him from achieving his ideal. Charlotte Rudolph had studied under Hugo Erfurth, who had also worked for a short time with dance photography.[135] She shared Genthe's goal of expressing motion through photographic media. With the help of the latest equipment, Rudolph was able to systematize dance photography in theory[136] and realize her goal in practice: "…Dance photography is the reproduction of the motion of the dancer in the image — that means that the dancer is dancing while the photograph is being taken."[137]

Rudolph made the successful rendering of a dance movement fully dependent on releasing the shutter at exactly the right moment: "I dissect the dance into peak moments and transitional moments. Peak moments are those characterized by the highest tension, the moment of greatest relaxation, and moments during which the dancer appears to be floating. Transitional moments are those I would describe as a transition from one movement into another, impulses that are drawn from a completed movement, or moments drawn from a short rhythm."[138]

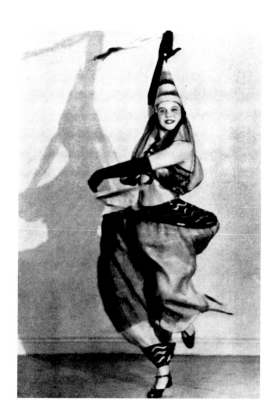

The photographer must be able to observe a sequence of movements in exact detail and know specific dance steps well. She must also possess the key ability to signal the exposure to the camera just a moment before the dancer's body has reached the position the photographer has envisioned. Both processes, the movement in space and following that motion with a camera, are staggered by only fractions of seconds. At this moment, dance photography — primarily as an expression of the movement of the body through space — and sports photography — whose images aim to show athletic achievements played out across time — are closely related to one another.

Although Lotte Jacobi did not write about the theory behind her technique, her approach must have been comparable to that of Charlotte Rudolph. Jacobi's primary but unspoken aim in taking the photograph was to capture the expression of a dance in such a way that the instant represented by the image was able to stand for the whole dance.[139]

Lotte Jacobi long remembered Austrian dancer Claire Bauroff's quick reactions to her prompting during a session at the studio: "I watched her dance for a moment, saw something I liked, and said: You'll have to repeat that."[140] In the close confines of the studio — the parquet floor and the baseboard mark the limited space — Bauroff reproduced a move reminiscent of the "attitude"*** pose of classical dance, which concentrates all the dimensions in itself (pl. 54). The viewer can almost feel the breeze lifting the fabric around the dancer. By reflecting the image of the dancer again in shadows moving across the wall, Lotte Jacobi transcends the spin itself and creates the impression of a never-ending motion. "There were lots of lights I could use in that studio, but I always used as little as I could. I liked to move them around so that the illumination was soft."[141]

Lotte Jacobi succeeded in creating an abstract image of motion in the photograph titled "The Wasp Waist" (*Wespentaille*, pl. 55), as one of her two photographs of a dancing Liselotte Felger has come to be known. The shots can also serve as convincing evidence of the preference for more conventional photography by the press. Even the trade journals show this tendency toward standards of popular illustration. Compare the two pictures that Lotte Jacobi

Lieselotte Felger performing her dance *The Top* in: *Das Theater*, vol. XXII, No. 2, Feb. 1931, p. 40 Kunstbibliothek SMBPK

took of Lieselotte Felger as she executed "The Top" (*Kreisel*) in a studio session. The magazine *Das Theater* published the shot of the dancer dressed as a top (Ill. p. 104); her motion is frozen in the instant and her gaze fixed on the observer.

A second image from the same session was not published, however (pl. 55). In it, the photographer takes the motion of the endlessly spinning top to visual extremes. The proportions of the human body are distorted, and the picture takes on a surreal character. It is less the expression of a real event than an apparition. The dancer is reduced to two whirling cones created by her hat and her skirt. The impression of endless rotation is emphasized further by the concentric ornamentation of the costume — the body becomes an abstract figure of motion. Rhythm is added by the bars of light and shadow in regular intervals on the wall.

"The Top" recalls the dance photographs that are representative of that time, like "The Leap", a photo Charlotte Rudolph took of Gret Palucca. Rudolph's image was published by László Moholy-Nagy in his manifesto *Malerei, Fotografie, Film* — opposite a picture of a racing motorcyclist — the juxtaposition reflecting the treatment of speed, or "tempo" characteristic of the time.[142] Appropriately to the abstract dimension of this and other photographs, Jacobi opted not to title the images. Even so, the name of the dance itself, "The Top", formalizes abstract associations.

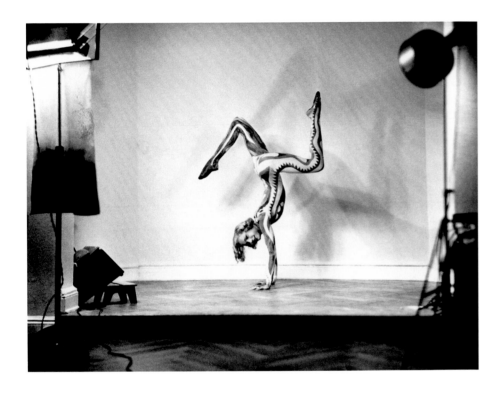

Marianne Winkelstern
in Atelier Jacobi
Berlin, around 1930

But Ausdruckstanz moved beyond a body language that ranged from the spirited to the ecstatic. Its repertoire also encompassed pantomimic, playful and satirical traits. In addition to freezing the moment on film, Lotte Jacobi also traced the nuance of the subtle gesture full of wit and evocations of everyday life. *Das Theater*, for example, described the black tap-dancer Louis Douglas (pl. 57) as someone "who tells us little stories of day-to-day life with his feet."[143] Another photograph of him was published in the magazine *UHU*.[144] In this portrait taken with a studio camera, Douglas, with his hand to his ear, plays the eavesdropper who is himself being eavesdropped.

Harald Kreutzberg appeared in his piece, *Choral*, in 1934, as if he had come from an entirely different world. Lotte Jacobi photographed him after a performance. The dancer is absorbed in his own thoughts — his gaze cast downward and his gesture arresting all movement (pl. 51). Ascetically costumed — his body emerges from the darkness of the room under the light trim on his dark robe. Only his head and hands signal his presence. Spread in a motif suggestive of the gesture of Christ, the open palms suggest self-sacrifice and, at the same time, inapproachability. In her three-quarters shot of the dancer, the photographer brought the esthetics of a vision together with a mood of mystical contemplation.

Rolf Arco, under contract with the National Ballet (*Staatsballett*) as a soloist, was also a guest in Lotte Jacobi's studio. But the photographer dropped in on him frequently at the

dance school where he taught as an assistant to Max Terpis. In his performances, Arco often used accessories or props and told little stories, which the camera recorded on film. Lotte Jacobi once photographed him in profile playing "The Hunter". The effect of a drawn bow and tensed muscles is heightened by the horizontal format. Another time she captures him, seemingly weightless, in mid-flight. The shot of Rolf Arco with a mask is an ironic variation on the two shot, a composition employed frequently in portraiture (pl. 56). The dancer, scared stiff by a mask that represents his co-star, appears cornered. Through the power of suggestion present in this close-up shot, Lotte Jacobi stimulates the viewer's natural impulse to rescue the dancer from the choking embrace of the villain. But does the porcellain hand belong to the good guy or the bad guy?

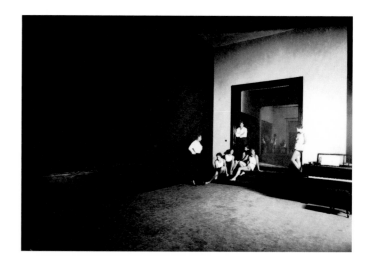

At the opposite extreme, the photographer worked with perspective to create an impression of three-dimensional space in a photograph of Rolf Arco, Max Terpis and a group of pupils resting on the steps in a corner of the room at Terpis's school. Here, Lotte Jacobi used the spatial relationships to produce a deceptive effect in the image, in which the back of the room appears as a faint reflection of the foreground.

Lotte Jacobi's picture of Vera Skoronel is rather unique among her dance photos (pl. 59). It was published once in conjunction with Skoronel's appearance at a dance convention in Munich in 1930[145] and a second time in 1932 as part of her obituary. A product of the Wigman School, the dancer moved off in a very different direction, creating abstract dances based on her own choreography. Skoronel's pose seems aggressive and shocking — almost as an ironic parody of the elegiac, esthetic dance figures typical of Mary Wigman. The mirror only serves to heighten the effect. The stiff, angular pose and the hand stiffened into a claw contrast sharply with the conventional image of supple beauty. The dancer rejects an esthetic of harmony, and the photographer intensifies her display of "antidance" by further distorting the image in its own reflection.

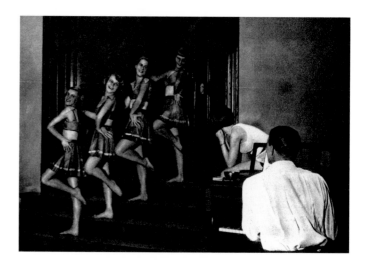

The characteristics found in Lotte Jacobi's portraits also feature in her dance photographs. Intensity is directed at the statement of the dances, but in connection with a creative diversity that resulted from Jacobi's continually striving for new inspirations. As she had done cabaret artists Lisl Karlstadt and Karl Valentin (pl. 24), Lotte Jacobi staged a little performance with Trudi Schoop and Grock (pl. 58) on the stage in her studio for the camera. Schoop — whom Jacobi had met during the political dance pantomime *Fridolin* — and Grock never had worked together before their joint photo session. The photographer had a taste for the clownesque, and by putting a contemplative and morose Schoop together with the musical clown Grock, she was above all fulfilling one of her own creative wishes.

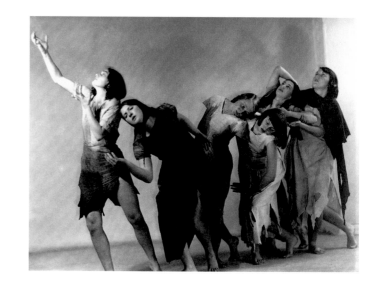

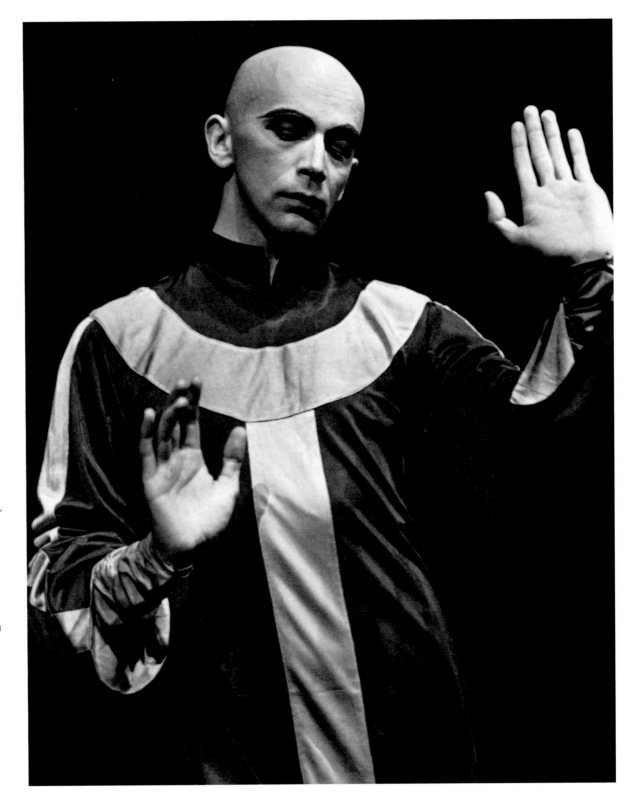

Max Terpis, Rolf Arco
and a group of pupils
in a room of Terpis' school
Berlin, 1930
German Dance Archive
Cologne

Practice at the Terpis
Dance School
in: *Die Wochenschau*, No. 52,
Dec. 1930, p. 12

Students of the
Wallmann School
Berlin, around 1930,
Berlinische Galerie —
Photographische Sammlung

Plate 51
Harald Kreutzberg in
the Dance *Choral*,
Berlin, 1934

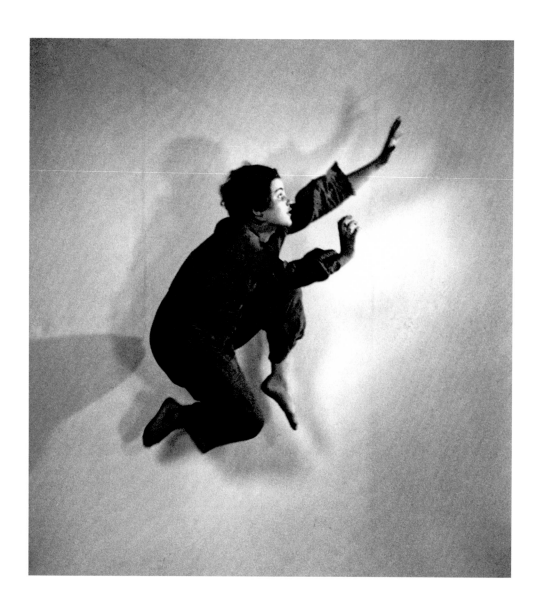

Plate 52
Toni van Eyck
"The Jump"
Berlin, 1930

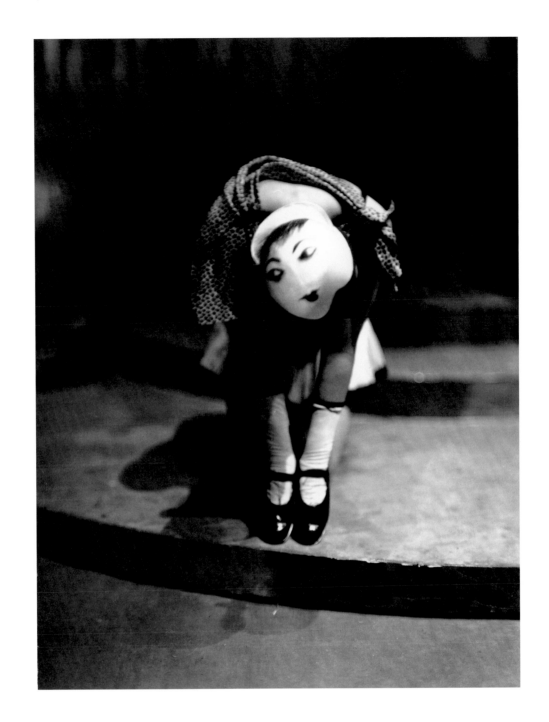

Plate 53
Atelier Jacobi:
Girl
Berlin, around 1930
Museum Folkwang,
Essen

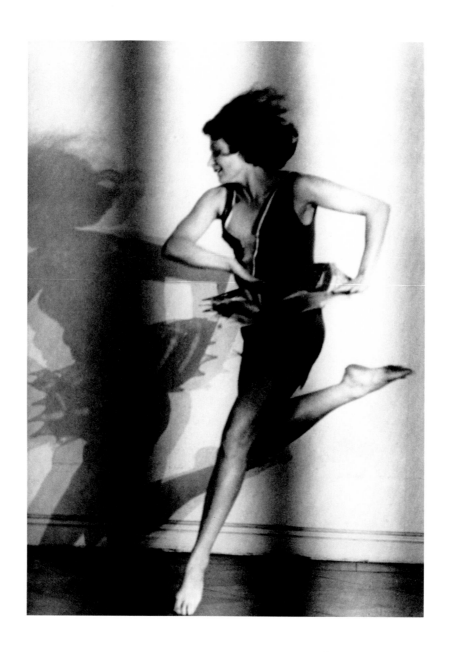

Plate 54
Claire Bauroff
"The Turn"
Berlin, 1928

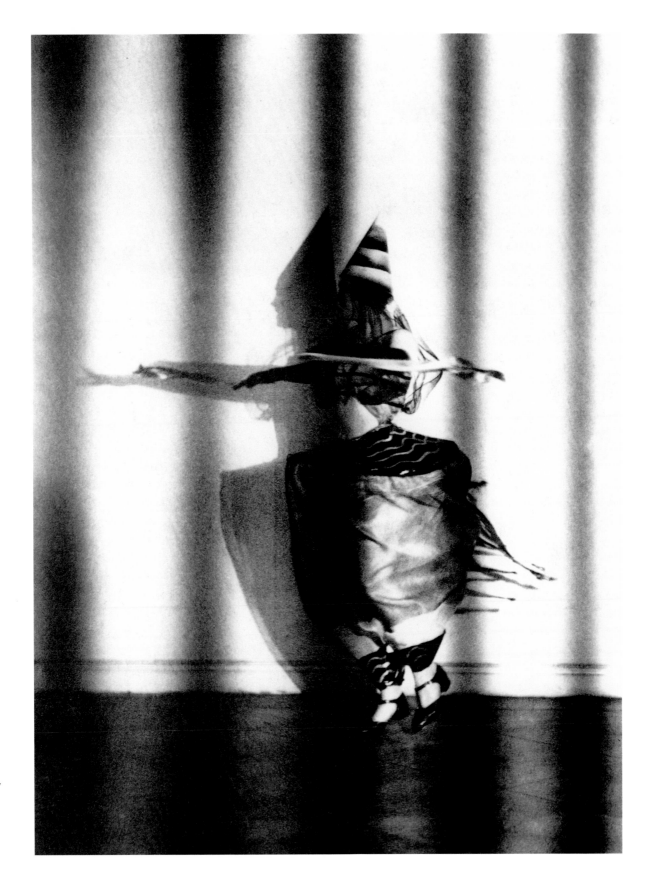

Plate 55
Lieselotte Felger
"The Wasp Waist"
from the Dance
The Top
Berlin, 1931

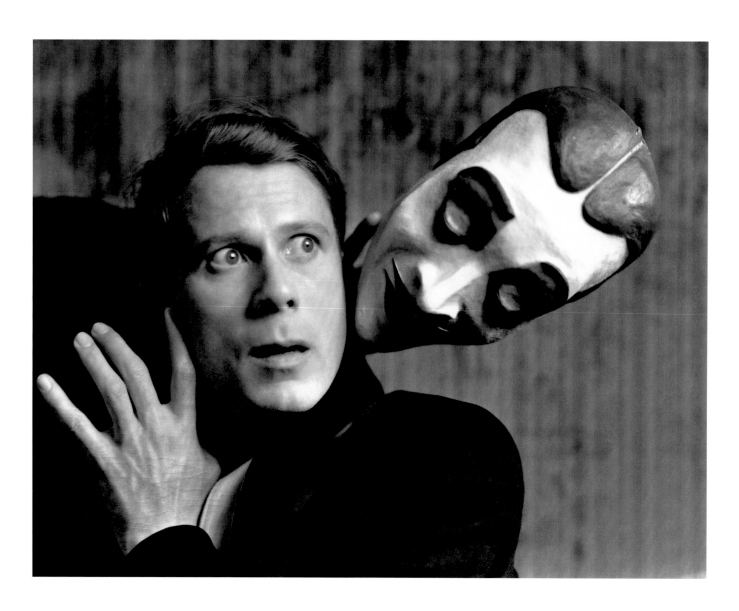

Plate 56
Rolf Arco with Mask
Berlin, 1931

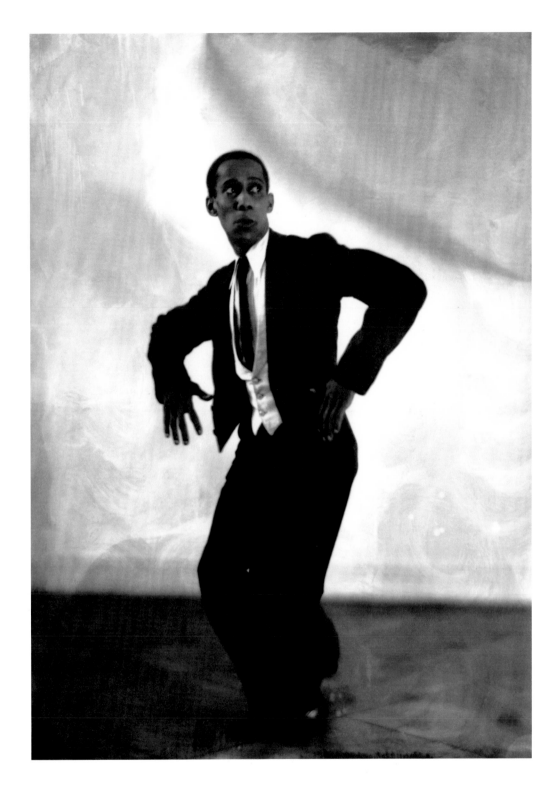

Plate 57
Louis Douglas
Berlin, around 1930

113

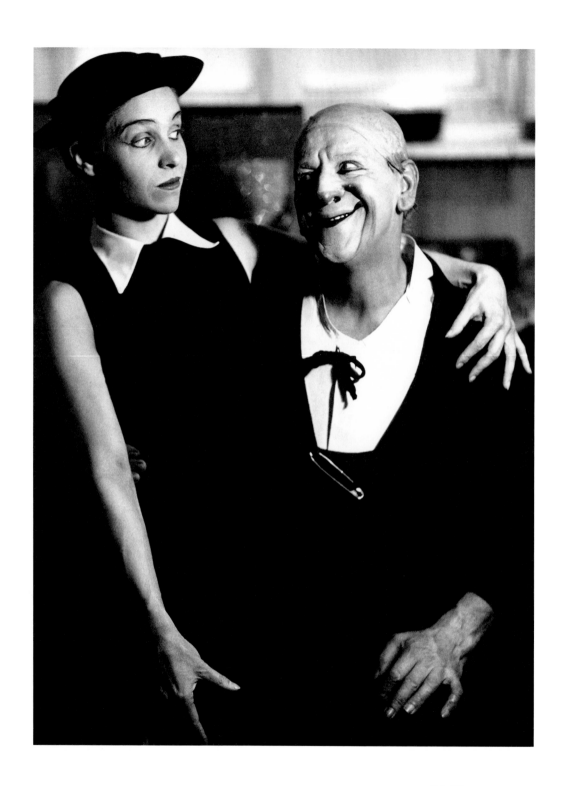

Plate 58
Trudi Schoop and Grock
Berlin, 1932

114

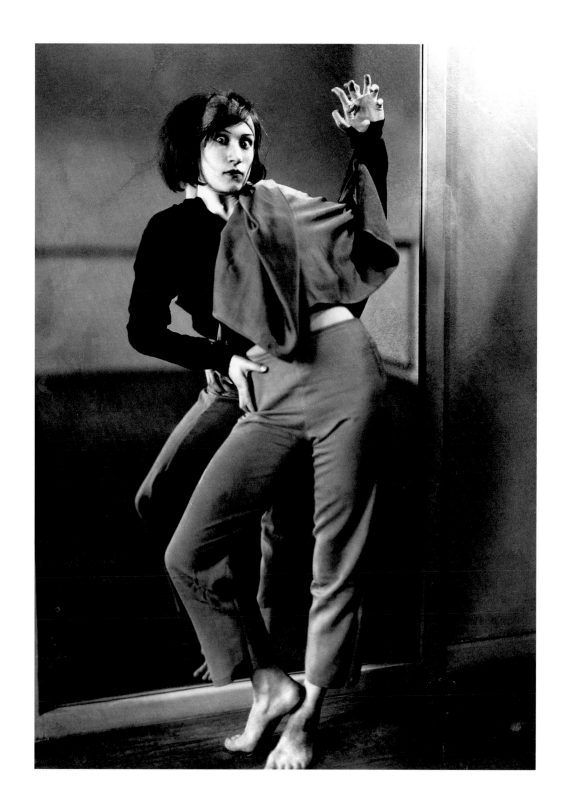

Plate 59
Vera Skoronel
Berlin, 1930
German
Dance Archive Cologne

Seeing the Soviet Union with One's Own Eyes

The *Arbeiter-Illustrierte-Zeitung* (*AIZ*) published a portrait of Ernst Thälmann, on the cover of its third February edition in 1932. Earlier that year, Lotte Jacobi had received the commission to photograph him for his candidacy in the upcoming German presidential election. A perspective in three-quarter profile was selected from a series of head shots taken from different angles, including left and right profiles as well as several frontal shots. It had been intended to furnish a likeness that a broad spectrum of voters could identify with and presents less the politician than the private individual. Only the symbolic cap identifies him as a champion of the working class.

Over the years, Lotte Jacobi's portrait for the *AIZ* has come to stand for the very image of the Communist party politician per se. Artists and propagandists have used it again and again for every imaginable purpose, fostering a gradual identification of the subject with this likeness and transforming the portrait into a sort of icon. The picture chosen for the campaign poster — although unsigned, it was also made by Lotte Jacobi[146] — differs from the *AIZ* portrait only in that it shows the KPD's candidate for German president, the *Reichspräsident,* without his cap, thus emphasizing the private aspect of his character even more. The photographer put her faith entirely in the strength of her subject's character and the openness of his winning expression, without feeling the need to stylize, exalt, or represent him as a figurehead or resort to an agitatorial slant or political symbols of any kind. Lotte Jacobi always referred to her trip to the Soviet Union in direct connection with this portrait series of Ernst Thälmann, perhaps because the fee she received for it helped finance some travel expenses, or perhaps because these photos established her credibility as a sympathizer of communist ideals for the first time[147]. In any case, she must have long been planning to see the Soviet Union with her own eyes and capture her experiences on film.[148]

In Germany, these were the years of steadily rising tensions between supporters of the Weimar Republic and followers of the Nazis, accompied by the ever growing fear that democracy was doomed — a fear which only helped instill a determined political commitment in Lotte Jacobi. Her connections with politically active friends, such as Egon Erwin Kisch and Max Hoelz, brought her together with people who were avidly following the

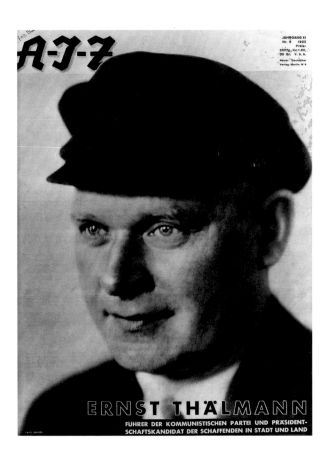

Ernst Thälmann on the cover of the *Arbeiter-Illustrierte-Zeitung,* vol. XI, No. 8, February, 1932

growth and development of the post-revolutionary Soviet Union: Ernst Toller, Paul Loebe, Adolf Behne, Otto Klemperer, Max Pechstein, Count Georg von Arco and Eduard Fuchs, all of whom she had already met while taking portraits for the media. As active members of the "Society of Friends of the New Russia"[149], they worked in bourgeois intellectual circles to promote greater understanding between Germany and the Soviet Union with lectures, study trips, academic presentations, exhibitions and musical evenings.

There were certain contacts Lotte Jacobi was not willing to do without, even at the risk of conflict with her politically conservative father. Even Mia Jacobi was not pleased to see Lotte associating with Communists, although she seems otherwise to have been quite interested in the Soviet model. What else could have motivated her to spend her holidays outside Moscow in 1931?[150] Her fears that it might be bad for business if the public were to discover that John Heartfield had used portraits and genre motifs from her daughter's photographs in his anti-capitalist collages illustrating the publication *Deutschland, Deutschland über alles* were not entirely groundless.[151]

For about a year — until the spring of 1931 — and probably for financial reasons, Lotte Jacobi worked for the sales department of the *Press Clichee Moskau* photographic agency, whose head office was located at Alte Jacobstrasse 128 in Berlin's newspaper district, until, for reasons now unclear, "her press clichee was taken away from her".[152] Under the influence of Max Hoelz, she became more and more convinced of the necessity of politically inspiring the people. For a short time, she played with the idea of "only working for the party"[153] but dispensed with it very quickly, simply because she was not at all suited to taking photos that served political propaganda purposes.

She wrote to Max Hoelz, "As it happens, everything is going quite badly for us right now: there's hardly anything to do, but the major obligations remain."[154] She must have already been planning to take her studio into the as yet untried venture of travel photography, expecting to be able to sell the photos well upon her return. Shots of people and places, preferably depicting foreign cultures, were quite popular with the press and highly sought after by agencies and publishing houses for publications of all kinds.[155] Lotte Jacobi may well have been thinking of an illustrated edition of two volumes by Egon Erwin Kisch, "Tsars, Priests, Bolsheviks" and "Asia — Dramatically Changed", published by the Erich Reiss Verlag in Berlin in 1927 and 1932.

When Lotte Jacobi finally boarded the train for Moscow in August, 1932, she was not yet certain she would be able to follow through on her intention to travel across Central Asia. But in the first days of Jacobi's stay in Moscow, Kisch arranged a meeting for her with Abdurakhim Khodjibayev, the vice president of the then Tajik Soviet Socialist Republic, whom Kisch had met on his trip in 1930. The Tajik vice president was then in Moscow in his capacity as chairman of the Council of the People's Commission. Apparently, Khodjibayev was so impressed by Lotte Jacobi's photos[156] that he invited her to Stalinabad (now Dushanbe), so she could tour Tajikistan and Uzbekistan and record their level of development on film.

As a woman photographer travelling alone at this time, Lotte Jacobi embodied the new type of confident woman of the 1920s and early 1930s, characterized — aside from her appearance — by being professional, educated, athletic, but most especially by being well-travelled.[157] But the motives for travelling, as with the male colleagues, were widely diverse:

Plate 60
View of Moscow and the Kremlin
January, 1933

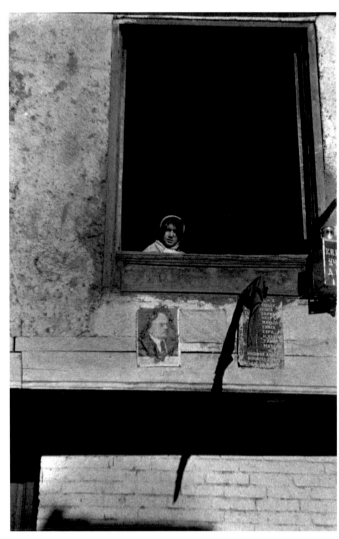

Plate 61
Moscow, 1932

Plate 62
Moscow, 1932

archeological or ethnological research, a weariness of Western civilization, a thirst for adventure, or just plain curiosity. A case in point was the Swiss travel author, Ella Maillart, who had already travelled across Central Asia in 1931, taking photographs to illustrate her accounts.[158] However, Lotte Jacobi and the American industrial photographer Margret Bourke-White[159] were the only ones to date who had travelled through the Soviet Union with official permission to take pictures. Lotte Jacobi had a contract with the *Unionbild* Agency, which had reserved the sole distribution rights in Germany for all photos made during the trip. *Unionbild* authorized *Soyuzfoto* to act as its agent in Moscow, handling copying and shipping, as well as assuming responsibility for providing photographic supplies and obtaining legitimization from the authorities. In return, it was agreed *Soyuzfoto* would receive a fifty percent share of returns. All the negatives were to remain property of the photographer.[160]

During the journey, she kept notes on the subjects of her photographs. Although incomplete, her writings allow for a reconstruction of her route, the stops, and frequently even the length of stay, the places she visited and the people she met. The notes also reveal something of the personal concept guiding her in the creative photographic process.[161] She would not allow political tendentiousness to cloud the view she had through the camera,

nor could she be unmitigatedly impressed by technological innovations. The subjects of her shots belie her intentions: they are primarily of people as they personify the new living conditions and standards in Moscow and life in the factories and on the streets. They also evoke the contrast between traditional oriental and modern Soviet lifestyles as seen in the public image of life in the Central Asian republics.

Among the views of Moscow, we find the panorama of the city center with the Moskva waterfront and, in the background, the Kremlin (pl. 60), which Lotte Jacobi photographed on one of her private sojourns through the city, and the newsstand, with the *AIZ* positioned in the frame as a sign of a free press (ill. p. 117). Other shots indicate that she took advantage of official photo sessions, most of which exhibited the latest achievements of Soviet society. The collision of the Czarist and the socialist eras is particularly apparent in her shots of the illustrious Metropol Hotel in Moscow. The Czarist-era hotel, a piece of history in itself, had witnessed the passage of turbulent times. The splendor of the *fin-de-siècle* luxury hotel had by then faded, but a sign from the old days still hung in the lobby, announcing in German and English "Dance Fox-Trot every evening at 8 o'clock in the dancing place". The reactionary

Metropol Hotel
Moscow, 1932

White Guards met in the Metropol in the days before the October Revolution — until they were ousted by Lenin, who set up headquarters here for the Executive Committee of the Bolsheviks. Afterward, it became the Soviet Union's second address in lodging elegance after the Lux Hotel, which was reserved for Comintern officials. Max Hoelz was given a room at the Metropol. On September 22nd, 1932, Lotte Jacobi was invited to be the official photographer at a banquet in honor of the French writer, Henri Barbusse, who had arrived the day before in his capacity as representative of the International Bureau of Revolutionary Literature (IBRL).

In both urban and rural settings, Lotte Jacobi observed the ways photography was present in public life. Street photographers appear in her photos again and again. One shows a little Muscovite who has been placed by his mother in front of a picture backdrop. He looks askance at the crowd of spectators, among them Lotte Jacobi with her camera. His mother points toward the path leading up to the castle on the tapestry, as if evoking a vision of a great future (pl. 65).

In Central Asia, Lotte Jacobi's photographic eye was attracted to the bazaars, the heart of public life in the Orient. Often, such an incidental detail as the red star on the lapel of a modern jacket worn by a Mongol potato seller sporting a turban and a golden earring is all there is to hint at Sovietization. In adherence to strict interpretation of Islamic law, the women never appear in public without being veiled in the Tadjwan (ill. p. 125), as if the revolution had not penetrated the cloth shroud. Jacobi's notes contain several entries describing meetings with women in high-ranking positions: "Comrade directress of the Stalinabad silk factory", or "Comrade Khehengerova, the first Tajik woman to have put aside the veil, active opponent of the Basmatch, now active on the Commission for the Improvement of Women's Lives".

The photos reveal the differing conditions existing simultaneously side-by-side: Soviet Moslem women going to school or the theater, working in the fields and the factories, or women in Stalinabad asserting their new-found rights in a united front, their gaze fixed squarely on the camera, on the occasion of the 15th anniversary of the October Revolution on November 7th, 1932 (Ill. p. 125). The direct frontal perspective emphasizes their insistent stand, while the view from slightly below enhances the women's strength and unwavering determination.

Lotte Jacobi's photographs of Soviet Central Asian life in Bukhara, Samarkand, Stalinabad, Khudzhand, and Tashkent are primarily declarations of kinship with the people she encountered there. The street scenes, the workplaces, the schools and theaters depicted in her images tell of the cares and the newly won freedoms, and of how the old and new ways of life continued to exist side by side, with and without one another: the mosque and its modern replacement, the "Red Corner Club", the Oriental tea houses and the workers' clubs, the

Henri Barbusse
Moscow, 1932

Plate 63
Helen Eliat in front of
a billboard saying
"From backward water
transport to the mighty
Soviet Fleet"
Moscow, 1932

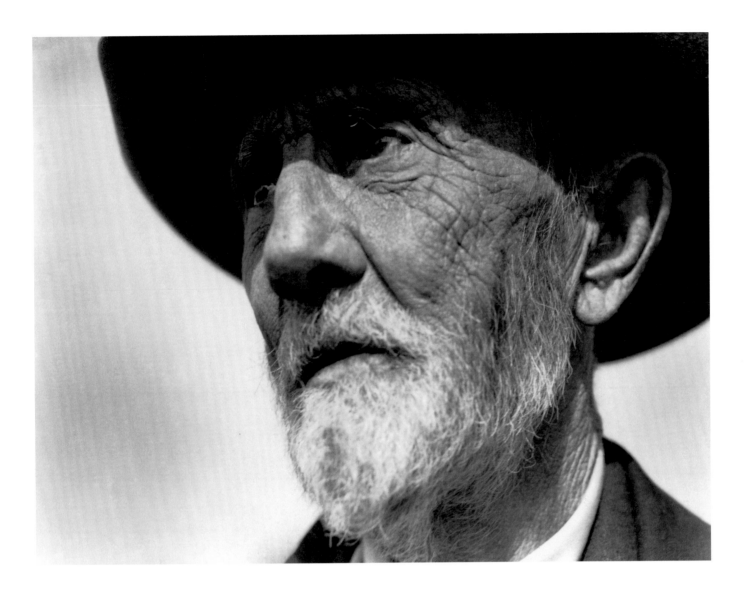

Plate 64
Ivan Vladimirovich Mitchurin
Mitchurinsk, 1932

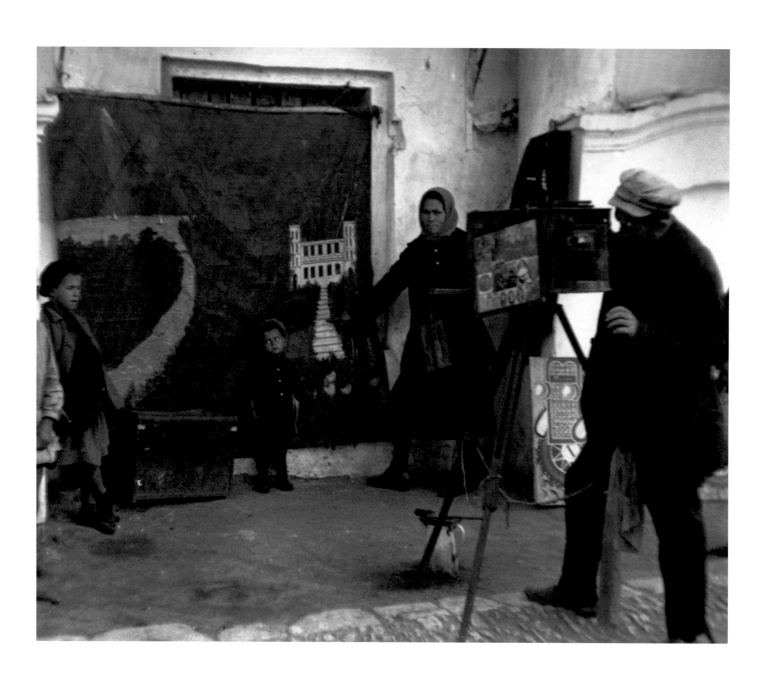

Plate 64
Street photographer
Moscow, 1932

bazaars and kolkhozes, the veiled Moslem women and the female comrades in the factories, the mullahs and the party functionaries.

Lotte Jacobi always chose her subjects according to her own personal criteria and way of seeing things, in which she never lost sight of the human being. She was not swayed by any program or obligation to limit her reporting to extolling the advances of Soviet society, as one might have expected of a guest photographer. Not even the stock showpieces of progress — the showcase projects of industrial production — tempted her into any sort of photographic exaggeration.

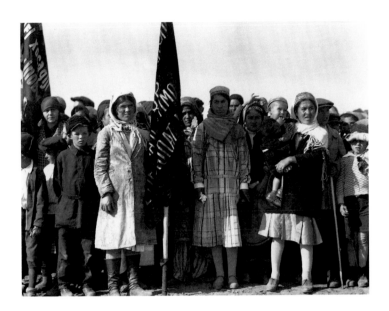

Her portrayals of people of many different ethnic origins once again testify to her skill as a portrait photographer. She did not choose her subjects according to social or professional standing, nor religious or national identity. Neither was she out to conduct ethnographic studies. As with the portraits she made in Berlin, the crucial moment is Lotte Jacobi's personal experience, even if the anonimity of the subject today tends to bring the aspect of type to the fore. Unabashedly and unpretentiously, she managed to capture her subject in a moment of rapport and natural tension, even in the hustle and bustle of the Central Asian bazaar. With the aid of her handy Leica, she was able to compose facial shots at close quarters with people she had never met before, enhancing the effect of the picture even more through the close-up perspective. For pictures taken in portrait sittings, such as the photo of the daughter of Tajikistan's president (ill. p. 133) and of the botanist, Ivan Vladimirovich Mitchurin (pl. 64) she took along her 9 x 12 cm Ika artist's camera. Even from this extremely low angle, the natural lighting softens the man's features and brings out their personal expressiveness.

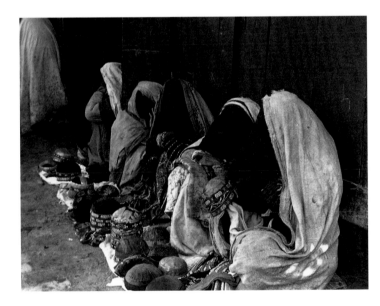

The likenesses of Kyrgyz, Afghans, Jews, Tajiks and Uzbeks — the Kyrgyz boy with the feather in his cap as a good-luck talisman or the Moslem woman in a Tadjwan woven of horsehair, the Uzbek and Tajik men, children and women wearing colorful tiubeteykas, a cap whose decoration indicates membership in a certain tribe — are at one and the same time historical and ethnographic documents.

Above
Tajik women at the celebrations for the 15th anniversary of the October Revolution on November 7th, 1932, in Stalinabad

Below
Veiled Uzbek women selling tiubeteykas
Samarkand, 1932

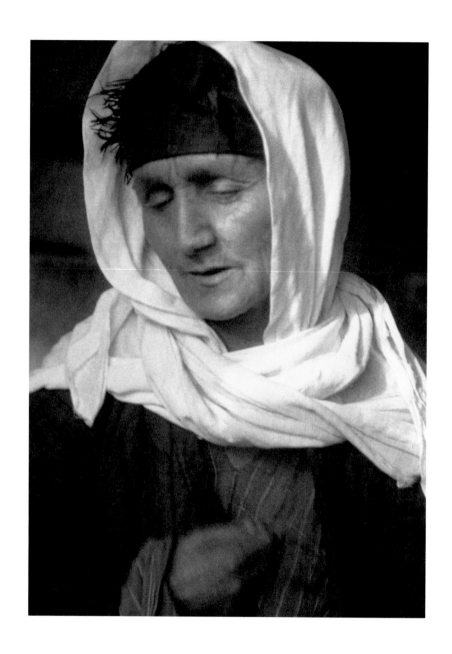

Plate 66
"Madonna" — the aunt of
the bank director,
Comrade Khojeiff,
Stalinabad, 1932

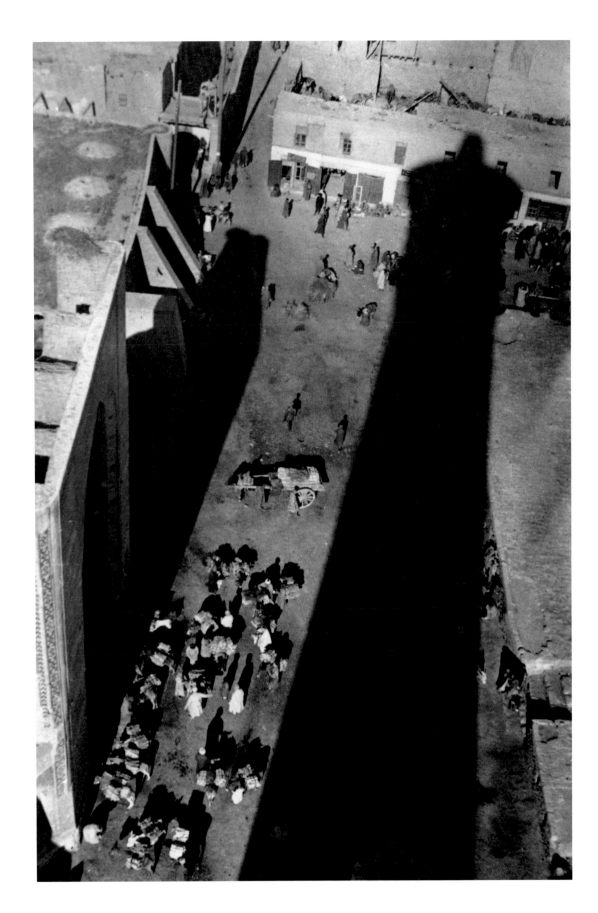

Plate 67
View from
the Tower of Death
Bukhara, 1932

Plate 68
Cobbler at the bazaar
Central Asia, 1932

Plate 69
Uzbek traders at
the bazaar
Central Asia, 1932

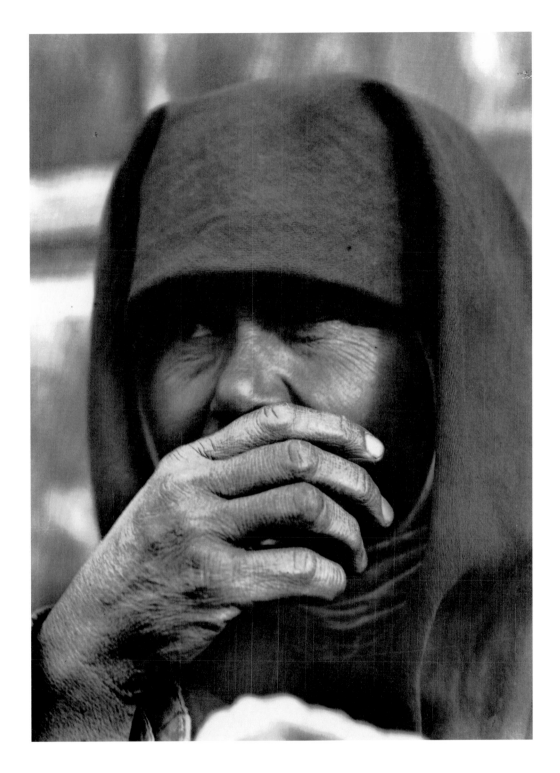

Plate 70
Tajik woman
Stalinabad, 1932

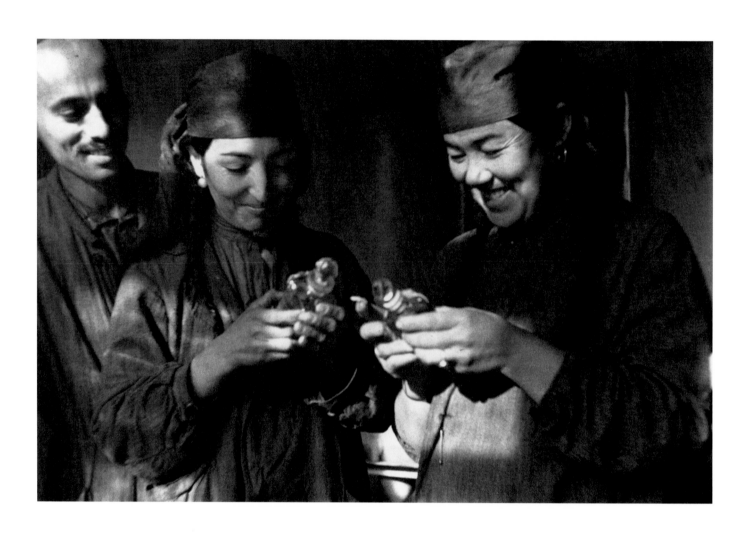

Plates 71 and 72
At a factory for etheral oils, chemicals
and perfumes
Khudzhand, 1932

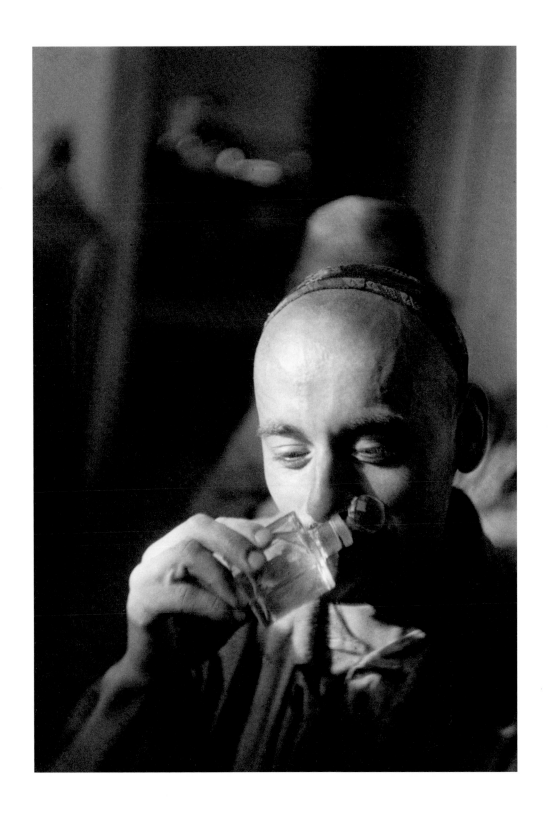

"Warning! Photographer Banned!"

By the time Lotte Jacobi returned to Berlin in February, 1933, the mere fact of her friendship with Max Hoelz could have put her life in danger. Moreover, her trip no doubt made her suspect as a Bolshevik sympathizer. Upon arrival, she was subjected to hours of interrogation; her family, however, was left in peace for the time being. Even so, the transference of power to the Nazis spelled impending doom for the Atelier Jacobi. With each passing day, it was becoming more and more difficult for Lotte Jacobi to work.

It cannot be stated with certainty that the change in the studio's listing in the 1932 yellow pages to "foto jacobi", rather than the family name, was a precaution taken to avoid persecution. It corresponded to a change of address to Kurfürstendamm 216 at the intersection with Fasanenstraße, a move that took place while Lotte Jacobi was still in the Soviet Union. Financial pressures most likely brought about both the re-location and the trade-in of the 18 x 24 cm studio camera for a 9 x 12 cm Stegemann, which was appreciably cheaper to work with.

Now, on top of financial difficulties, political persecution became a direct threat to lives and property. Many of the customers who had kept up good relations with the family and studio insisted it was fear, not antipathy, that was keeping them away[162] — a friendly gesture, perhaps, but not of much help in saving the business. The attacks and boycotts against Jewish enterprises, together with Goebbels' systematic elimination of freedoms of press and speech, produced an ever widening circle of effects and, of course, did not leave the Atelier Jacobi untouched, even before the laws consolidating the Nazi regime came into force. Once the Nazis had brought the Ullstein publishing house into line, the photographs from Atelier Jacobi bore the stamp: "Warning! Photographer banned!" on the back.

By the fall of 1933, Lotte Jacobi had begun to conceal the studio's work by using pseudonyms. First, she took up the offer of a partnership with Ernst Fuhrmann under the name "folkwang-archiv". What had originally been planned as a joint archive business now became a matter of survival. It lasted about nine months, until mid-1934.[163] The *Crystals* photos, to which Jacobi had been inspired by Fuhrmann, were published in the popular scholastic magazine *Volk und Welt* in 1935. On the back, the imprint "foto-jacobi" can still be made out under the "folkwang-archiv" stamp. *Volk und Welt* — "this was also a continued claim, after 1933, to give the culturated German citizen the sense that he was still able to participate in world affairs, indeed from a lofty standpoint. More modern, for example, than *Westermanns Monatshefte*, it was similar to *Atlantis*, although this was admittedly more cosmopolitan … and the photos were taken by all those with a name in German press and illustrative

photography, of course with the exception of Jews, left-wingers and "cultural Bolshevists". Both the text and the illustrations repeatedly focussed upon central concepts of the German national system of values."[164]

It is not clear why Lotte Jacobi discontinued her cooperation with the folkwang-archiv, which was, apparently, a harmless activity politically speaking. For two months, she tried out another partnership under the name "Behm's Bilderdienst" together with Mister Behm, who was employed in marketing for the studio.

She was no longer able to sell the photos she had brought back from the Soviet Union. Her contract partner, the *Unionbild Agentur*, had been affiliated with Münzenberg's *Neuer Deutscher Verlag* and was forced out of business during the first few months of 1933. Now, unknown parties were apparently helping themselves to the archive. For example, the portrait taken in Stalinabad of the daughter of President Nusratullo Makhsum of the Tajik SSR appeared on the cover of the January, 1934, issue of the travel magazine *Atlantis*. But the photographer is not credited, and the picture's caption identifies its subject as the "daughter of a farmer from Garm". The accompanying article, entitled "Customs and Traditions of Turkestan" is illustrated with twelve photographs altogether, of which six by Lotte Jacobi are signed with "Heinz Neustadt" and the others with "Friedrich Ahlfeld". A full-page portrait of the girl is printed again to illustrate the article and captioned, "daughter of a farmer from Garm; the features of this young Tajik girl, so closely resembling those of Europeans, clearly reveal the Arian race of this native people of Turkestan."[165]

In another instance, one of Lotte Jacobi's shots from the Soviet Union was published on the cover of the magazine *Die Umschau in Wissenschaft und Technik* (Ill. p. 134) under the name of "H. Neustadt" in 1935. This lends weight to the supposition that piracy of her photos from the journey through the Soviet Union was widespread.

She had maintained good contacts with the magazine *Der Tanz* for many years, and as late as September, 1935, the editors issued her a press card. Starting in the fall of 1934, photos from the Atelier Jacobi were credit-

The cover of the travel magazine *Atlantis*, vol. XX, No. 1, 1934. Lotte Jacobi's portrait of the daughter of President Nusratullo Makhsum of the Tajik SSR Stalinabad, 1932, is titled: "Daughter of a farmer from Garm"

ÖSTERR. SCH. 3.— SCHW. FR. 2.—

ATLANTIS

HEFT 1 JANUAR 1934 RM. 1.50

ed with the alias "Bender u. Jacobi" and, in April and May of the same year, occasionally with "Lloyd", the origin of which has not been identified.

In April 1935, pragmatically anticipating the difficulties of reestablishing herself and her studio in a foreign country, Lotte Jacobi had the Berlin chamber of trade write up a certification showing that she was the owner of a "photographic enterprise". She had had the Berlin studio transferred from her father's name to her own in October, 1934.

Until her emigration in 1935, she ran the studio under the name of "Bender und Jacobi".

Der Steuermann auf dem Wachsch
einem Grenzfluß in Russisch-Turkestan

Alexander Bender was the secretary of Adolf Wohlbrück. Bender wanted to learn photography from Lotte Jacobi and was prepared to lend his name to the company in return. But as it happened, his own family failed to meet the requirements of the Arian race laws. On June 6, 1935, the Reich Chamber of Culture sent a letter to the company of "Bender und Jacobi" informing them of their immanent expulsion from the Reich Chamber of the Press. The reason given was: "A non-Arian cannot be expected to possess the inner conviction that must serve as a prerequisite for a successful effort in the spirit of the above-mentioned objective", namely "to shape the National Socialist world view."[166]

For Lotte Jacobi, this amounted to an absolute ban on practicing her profession. She appeared before the authorities in person and managed to win a three-month period of grace, after which she was to present proof that the studio had been handed over to "Arian" management. But the proof never arrived. Lotte Jacobi, her mother and her son started putting their efforts into realizing a decision already made long before — the decision to emigrate. Sigismund Jacobi had died on March 16th that same year.

Early that September, Lotte Jacobi left Germany, with no plans to return. She went first to London by ship from the Hoek of Holland, while her son came through Bremerhaven. Three weeks later, she travelled on to New York on a visitor's visa; Jochen stayed on in England for the time being. Mia Jacobi stayed behind to arrange the transport of their belongings, the transfer of the lease to the photographer Hein Gorny, and her own departure.

That part of the Jacobi archive, which Lotte Jacobi was forced to leave behind when she emigrated, has been missing since the end of World War II. It contained almost all of the 9 x 12 cm and 18 x 24 cm glass plate negatives. Jacobi was only able to take along thirty of the portrait, dance and theater glass plate negatives 18 x 24 cm and some of the 9 x 12 cm most important to her. Among the prints and the negatives she managed to save were the shots from her trip to the Soviet Union.

"Helmsman on the Wakhsh"
Cover of the magazine
Die Umschau, vol. XXXIX, No. 2, 1935.
This photo by Lotte Jacobi was printed under the name of "H. Neustadt"

Plate 73
London, 1935

Atelier New York

On September 29, 1935, Lotte Jacobi, travelling on a visitor's visa, arrived in New York City from Southampton aboard the *Georgia* of the Cunard Star Line. At that time, she could hardly have known that she would not be using the return ticket until nearly three decades later, in 1962, when she took her first extended European post-war tour, including stops in Berlin and Torun. Nevertheless, everything indicates that she had long since made an inner commitment to the United States and New York City as the place she would start a new life in exile.

She had left London, the first stop after her emigration, after only three weeks — although she could have looked forward to a long series of photographic commissions with backing from Kodak, with whom Sigismund Jacobi had long maintained good business contacts in Berlin. "Europe smelled like war coming,"[167] she later described the atmosphere during these years. And until the outbreak of World War II, Great Britain's political stance vis-a-vis Hitler's Germany was anything but clear, a factor that probably contributed to Lotte Jacobi's decision to travel on to America.

She temporarily left her then 18-year-old son with acquaintances in London, while her mother was still in Berlin making preparations for her own emigration. Before Lotte Jacobi left Germany, she assembled a portfolio from the tens of thousands of negatives, positives and glass plates that made up her archive, a collection that represented the family's only real capital. But her photographs soon proved to be ill-suited to the esthetic standards of the print media in America, and consequently, of little value.

In retrospect, however, the choice seems foresighted. Rather than works that corresponded to the taste and style propagated in the glossies, the portfolio consisted predominantly of portraits which have since made photographic history with their artistic and modern visual language.

At first, Lotte Jacobi was taken in by her sister, Ruth, who had only arrived in New York City a few months earlier with her husband, Dr. Szolt Morris Roth. She had only managed to obtain a visitor's visa for a maximum stay of six months because her relatives were able to provide the financial guarantees for her support. That left Lotte Jacobi little time to get permission for herself, her son, and her mother to immigrate legally. At the same time, she put all her energy into setting up a new studio and having the pictures she had brought from Berlin published. A public reputation could accelerate the granting of an immigration visa.

From the *New York Herald Tribune*,
Sunday, December 29, 1935

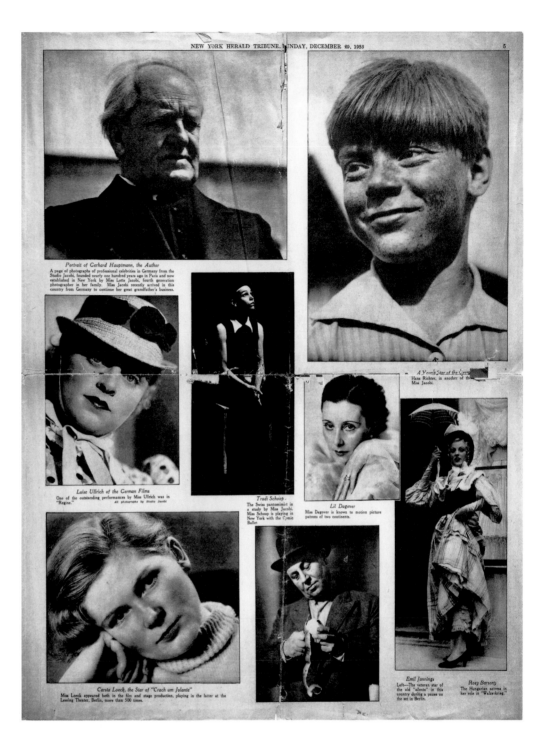

Portrait of Gerhard Hauptmann, the Author
A page of photographs of professional celebrities in Germany from the Studio Jacobi, founded nearly one hundred years ago in Paris and now established in New York by Miss Lotte Jacobi, fourth generation photographer in her family. Miss Jacobi recently arrived in this country from Germany to continue her great grandfather's business.

Luise Ullrich of the German Films
One of the outstanding performances by Miss Ullrich was in "Regine." *All photographs by Studio Jacobi*

Tradi Schoop
The Swiss pantomimist in a study by Miss Jacobi. Miss Schoop is playing in New York with the Comic Ballet.

Lil Dagover
Miss Dagover is known to motion picture patrons of two continents.

A Young Star of the Opera
Hans Richter, in another of the Miss Jacobi.

Carola Loeck, the Star of "Crach um Jolante"
Miss Loeck appeared both in the film and stage production, playing in the latter at the Lessing Theater, Berlin, more than 500 times.

Emil Jannings
Left—The veteran star of the old "silents" in this country during a pause on the set in Berlin.

Rosy Barsony
The Hungarian actress in her role in "Walzerkrieg."

On October 30, 1935, just four weeks after her arrival, she opened a photographic studio near Central Park, at Sixth Avenue and 57th Street, together with her sister Ruth. As a visitor, Lotte Jacobi was not allowed to pursue gainful employment. She noted the first portrait sitting at the studio on November 11th, and on December 29, 1935, the first of her photographs appeared in the intaglio print supplement of the *New York Herald Tribune* Sunday edition, "a page of photographs of professional celebrities in Germany from the Studio Jacobi, founded nearly one hundred years ago and now established in New York by Miss Lotte Jacobi, fourth generation photographer in her family."[168] The full-page feature consisted of eight images from Berlin and a short tribute to the photographer herself, with particular emphasis on the long tradition of Atelier Jacobi — as if pointing out that this was a qualification not to

be matched in America. In addition to the picture of poet Gerhart Hauptmann, the newspaper's editors chose production stills and portraits of actors, including Berlin's up-and-coming performers, as well as stars whose fame had already spread across both continents: Emil Jannings peeling an apple on the Ufa lot, Lil Dagover, and the Swiss mime and dancer, Trudi Schoop (Ill., p. 137).

Trudi Schoop had made a name for herself in America with her performances in New York in 1934. When she returned for a guest performances in 1936, Lotte Jacobi saw it as a good opportunity to revive the Berlin tradition of her studio on the other side of the Atlantic. She arranged a dance recital for Schoop at the studio and invited friends and acquaintances. The following day, the *New York Herald Tribune* wrote, "The Misses Lotte and Ruth Jacobi entertained at their studio ... for Trudi Schoop ..."[169]. George Grosz, Paul Graetz, Annot and Rudolph Jacobi, Friedrich Kiessler, Emanuel List and Elsa La Roe were all in attendance. Lotte Jacobi had always loved social occasions at which she could entertain and exchange ideas with her guests. But in New York, she discovered very quickly that combining one's social life with business interests and public advertising was a basic rule of survival.

As the organized persecution of Jews in Germany became ever more systematic, more emigrés were arriving in New York with each passing day. Jews, leftists, free-thinking artists and actors were greeted by the press as "Hitler's gift to the USA".[170] She had already met up with Peter Lorre, run into Lotte Lenya on the street, encountered Max Reinhardt and Helene Thimig, and contacted a long-time friend of the family, the actor Alexander Granach. Lotte Jacobi also had a little reunion with two schoolmates from the academy in Munich, Arnold Kirchheimer and Frank H. Bauer.

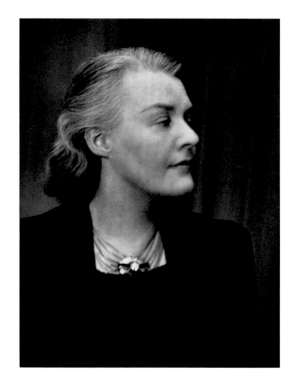

They supported the photographer by sending commissions her way. Lotte Jacobi used these new American contacts to arrange immigration affidavits and aid for those still in Europe. Her association with the American journalist Dorothy Thompson must have been of inestimable value in this endeavor. According to Lotte Jacobi's diary, the two women became acquainted in the summer of 1936 and met regularly for many years thereafter.

Jacobi and Thompson discussed the question of America's role in relation to Nazi Germany, which was becoming more pressing every day and had taken on top priority for all politically involved citizens. But, in addition to current events, they also had their own experiences of political developments in Germany and the Soviet Union to talk about. Dorothy Thompson had worked intermittently as an American correspondent in Berlin from 1925 until 1934. During the same period, she went on a six-week trip to the Soviet Union in order to gain a first-hand impression of conditions there. Thompson's book, *I Saw Hitler* was published in 1932.[171] Clear and acerbic in its portrayal of the National Socialist movement, the book caused an uproar in America. And the journalist continued to shape public opinion with her column, in the *New York Herald Tribune*, called "On the Record", which was published three times a week beginning in 1936. Thompson was a member of the Republican Party until 1940. Her change of allegiance to the Democrats proved to be no small contribution to the re-election of President Franklin Delano Roosevelt. With the support of her friendship to Eleanor Roosevelt, Thompson made a personal difference in the lives of many individuals through her efforts on behalf of the emigrés.[172]

Dorothy Thompson
New York, 1936/37

Despite the problems attendant to gaining legal resident alien status for Lotte Jacobi and her family as fast as possible, on top of having to deal with the comparatively tough conditions that accompanied her new start in business, Lotte Jacobi adjusted to the "American way of life" quite easily. Ever since she was a child, she had wanted to travel to the United States, the land to which Mia Jacobi's father had fled after taking part in the failed revolution of 1848 and who was known in the family from then on simply as "the American".

The fact that the long-awaited adventure had turned into a flight from persecution may have dampened her joy. But refugee status did nothing to quell her initiative in getting off to a new start. Lotte Jacobi summed up her emigration succinctly as a kind of emotional homecoming.[173] Speaking English was apparently no problem for her. In no time at all, she was writing business letters in her adopted language and reading German literature in translation, but throughout her life, she never lost her unmistakeable German accent.

Even amidst all these concerns, the miserable economic situation in the New World could not have escaped her. The Great Depression was a long way from over and unemployment continued to plague the land. She found that conditions in the U.S., did not differ greatly from those in Germany at the end of the 1920s. Yet Lotte Jacobi could hardly have foreseen the hardships that awaited her in her career. Some photographers had the good fortune to be taken on for projects with the newly established Resettlement Administration or the Farm Security Administration (FSA). Others tried to land photo assignments with the newly launched magazine publishing houses. Only a few managed to find full-time jobs. And trying to support oneself solely with the proceeds from freelance photography without making compromises of some kind was out of the question. Lotte Jacobi had to come to terms with this situation, but she did not succumb to it, and kept up her efforts to achieve what was most important to her with persistence and determination.

Perhaps she would have reacted in much the same way Lotte Lenya did when asked for her first impressions of New York: "We didn't have any first impressions. We've all seen the films of Joseph von Sternberg and Erich von Stroheim."[174] Whatever the shape of Lotte Jacobi's American dream, it is likely that New York City as a capital of finance and power, and America as the land of technological progress, doubtlessly held little fascination for her. Although her thinking took on an increasingly cosmopolitan bent, she remained committed to the ideas of individualism and a humanity in which there was no place for dominance of the machine over man. The first pictures she took in New York — on the day of her arrival — are characteristic of this attitude. She happened to pass by a group of Native Americans who were commemorating the day they were driven off of Manhattan Island and onto a reservation. Having no prior knowledge of the event itself, she took the time to stop and photograph it. Men, women and children dressed in tribal costumes performed ritual dances for the public with the American flag flying over their open air stage near the spot they had once lived, now known as the Inwood Quarter. Lotte Jacobi moved towards the ceremony with her camera, recording it in a series of long shots of successively closer angles.

Before the expiration of her visitor's visa, Lotte Jacobi got the affidavit she needed to become a resident alien. With the help of the National Council of Jewish Women, she managed

Da Coda the Indian
New York, around 1940

Central Park
New York, 1936

to persuade her uncle, Adolf Lublintz, who owned a ready-to-wear shop on Broadway, to give her the personal her guarantee that freed the state from any obligation to provide financial support. This was a process much feared by the emigrants since, in the end, it decided their fates.

On January 20, 1936, Lotte Jacobi took the train to Toronto in order to officially immigrate from Canada four days later. This immigration process went relatively smoothly, because in that year, at only 22 percent for the period, the quota for Canada had been undershot by far. One month later, her mother arrived in New York, most likely carrying a guarantee from two of her nephews in the Lublintz family. Six months later, on September 4th, Lotte Jacobi's son Jochen reached American soil and changed his name to John F. Hunter. An old family friend from the days in Berlin, Curt Riess, had arranged for Jochen's entry into the US. Riess was then working for the French newspaper, *Paris Soir* as its correspondent in New York.

Not quite a year after she had arrived in New York, on September 19, 1936, Lotte Jacobi opened her own studio at one of New York's leading addresses, 24 Central Park South at 59th Street. With relatively few, albeit affluent customers coming in, the high rent of this showpiece apartment, which served as both the studio and living quarters for the entire family, came to be a burden. "I borrowed and borrowed again; I had no money. The one thing that impressed them at the bank, it seems, is that when I couldn't pay, I told them in advance."[175] A number of changes of address followed shortly thereafter. Some of the subsequent apartments were so modest that she put the darkroom in a closet or rented out the foyer. On some evenings, Lotte Jacobi even allowed a dancer, who paid a small fee, to use the studio as rehearsal space.[176] During the entire period, however, the photographer made sure of one thing: that she never had to leave her preferred borough of Manhattan.

The years that followed in New York were marked by concern for friends who had yet to emigrate from Europe and Lotte Jacobi's own struggle for survival. Part of that struggle was the establishment of funds for emigrés like Ernst Fuhrmann, who, during his initial years in

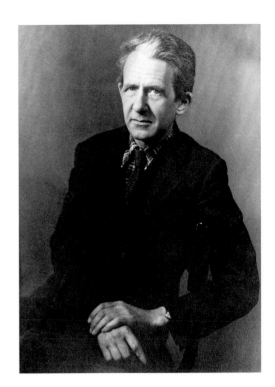

Left
Mia Jacobi
New York, 1940

Right
Ernst Fuhrmann
New York, around 1942

America, depended on money that had been collected from friends and acquaintances. They each contributed five dollars to his support. Lotte Jacobi herself had taken the initiative.

The rest of her energy she devoted to building up the studio. She could not yet afford the luxury of turning down onerous assignments. Child portraits, wedding pictures, and portraits as mementoes, tokens of affection, or as demonstrations of social status remained her most important source of income for a number of years. In Berlin, Lotte Jacobi's employees had taken care of such comissions, but here, the only job she could afford to pass on was the retouching work. The photographer Arnold Kirchheimer, whom she had known since her days in Munich, was willing to work for her at specially reduced prices. "I never charged you the prices I normally should have. In fact, I've repeatedly pointed out to you that I didn't add in anything for spotting out the negatives — and think how much time I've often had to spend doing it! For a head that has cost 50 cents up to now, I will have to charge 75 cents."[177] On top of doing the darkroom work herself, Lotte Jacobi had to market the pictures she had brought into exile with her to magazines and newspapers. In New York, there was no point in simply bringing the work into an editorial office and hoping to hit it lucky, as she had been accustomed to doing in Berlin, as most of the market was regulated by agents. "At that time, no one would take my pictures from Berlin. I couldn't have sold them for 25 cents apiece!... People here work different... I don't care what anybody says, I continued to photograph in the same vein."[178] For a short time, Lotte Jacobi tried to work in the fashion branch of commercial photography, but she soon gave up accepting these kinds of commissions. "I was a terrible commercial photographer. If they tell me what to do, it's impossible."[179]

It was difficult for Lotte Jacobi to reconcile the studio work she needed to support herself and her own ideas of artistically demanding portraiture. "To establish a portrait studio in an economically difficult time, it was necessary in this country to develop a clientele within that part of the society which could still afford professional portraits."[180] In Berlin during the 1920s, the leeway allowed by supply and demand was broader in every respect. There, speed, ingenuity and personal contacts decided whether or not a picture was published. On

Plate 74
Central Park by Night
New York, around 1940

Plate 75
View of Manhattan from
the Squibb Building
New York, around 1940

the American media market, however, the predefined guidlines and requirements of different newsrooms set the only standard for success.

Although several press publications and word of mouth had made the Jacobi name familiar with surprising speed in certain circles of New York, the family's financial situation was still difficult. After all, Lotte Jacobi had to support her son, who helped out now and then in the studio until he enlisted in the United States Army when America entered the war in 1941, as well as her mother, who was having a difficult time adjusting to her new surroundings.

Another important source of income for Lotte Jacobi in Berlin: theater and dance photography, did not pan out in New York. Apparently, gaining access to the theaters was so complicated by licenses and contracts that Lotte Jacobi — with the exception of visits to the still successful worker's ensemble known as *Laborstage* — gave up theater photography entirely. Modern dance did not have anywhere near the entertainment value that it did in Berlin in the 1920s, and so the press had little interest in pictures of the genre. Nevertheless, Lotte Jacobi checked out the dance scene in New York. In 1937, she submitted five dance photographs from Berlin to the international exhibit, *The Art of Dance in Photography*, which was held at the Brooklyn museum. She sought contact with American dancers, among them Ted Shawn, Maria Sarita and Kitty Carlisle. And she made sure not to miss the guest appearance of Kurt Joos, who became world famous through his anti-war ballet, *Der grüne Tisch*. Her connection to Hanya Holm, who had studied *Ausdruckstanz* with Mary Wigman and had been directing a branch of the Dresden-based Wigman School in New York since 1931, led to another opportunity for Lotte Jacobi to photograph dance. By the time Wigman won renown with her choreography for the "Olympic Youth" opening celebration at the 1936 Olympic Games in Berlin, Holm had attached her own name to the New York school.

The picture series, made in the practice studios at the school, is impressive in its unity (pl. 80-83). The four images allow the viewer to relive the group dance performance. The position of the photographer, which ranges from high above the group to a nearly flat angle, gives the series a dynamic of its own through the movement of both the eye and the dance. Lotte Jacobi made skillful use of the daylight shining into the room to enhance her dramaturgy, underscoring the motion of the bodies from the shade into the light. In an equation of growth and decay, appearance and disappearance, the dancers perform a group dance that was deceptively unregimented. Lotte Jacobi transposed the idea of a controlled lack of regimentation to her images.

Lotte Jacobi's photographs of Pauline Koner are the product of a meeting between two women who were top representatives of their metier — one of American dance, and the other of dance photography (pl. 76-79, 117). It is difficult to decide if the increased attention to contrast, sharper contours and stricter formalization are indications that Jacobi had begun to range far afield of the shadowy, flowing style of the Berlin years — or if, perhaps, she had come to be influenced by American tastes. Working in the confined space of her studio on a chest that had already been used in Berlin as an improvised stage, Lotte Jacobi photographed excerpts of a dance performed especially for the camera. Using an extremely low angle, she succeeded in capturing the esthetics and dynamics of the art. Her portrait of Korner, who had studied with the Russian ballet dancer Michel Fokine, is an object of lingering fascination (pl. 76). Like Lotte Jacobi's portrait of Koner's Russian colleague, Niura Norskaya, in *Head of a Dancer* (pl. 21), the image is one of nearly abstract beauty, and reminiscent of the geometrical works created by sculptor Constantin Brancusi.

Lotte Jacobi increasingly began to take the initiative to seek out unusual activities for her lens and escape the everyday drudgery of the studio. She managed, for example, to photograph the New York Stock Exchange while it was still in trading, a feat that no woman had

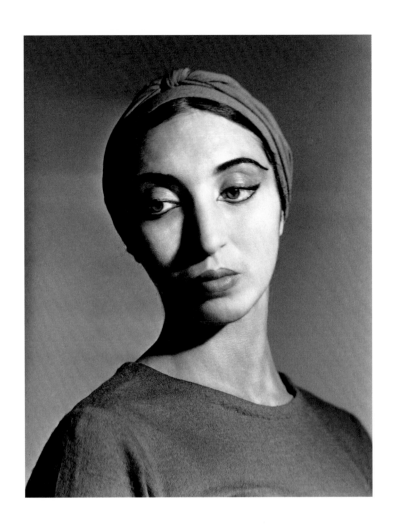

Plates 76 and 77
Pauline Koner
New York, around 1940

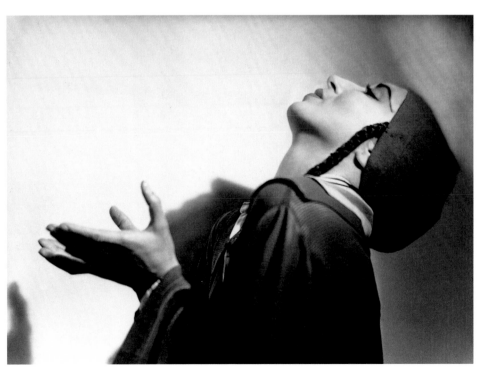

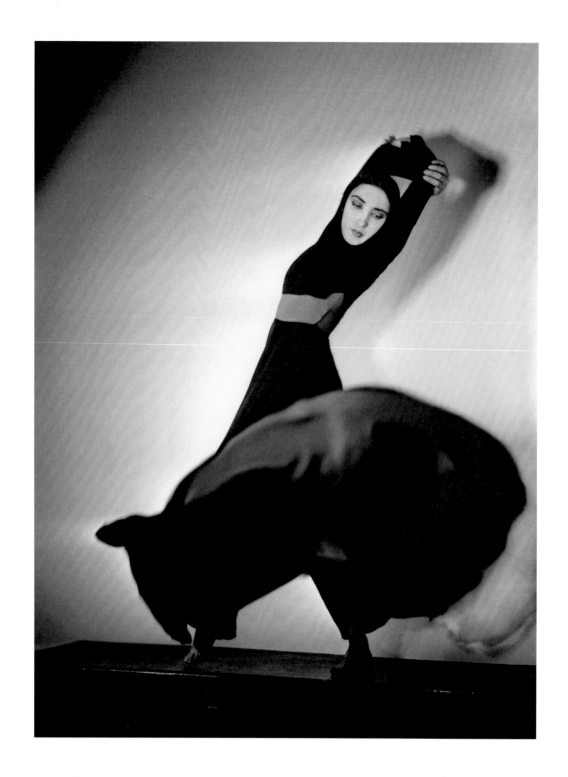

Plate 78
Pauline Koner
New York, around 1940

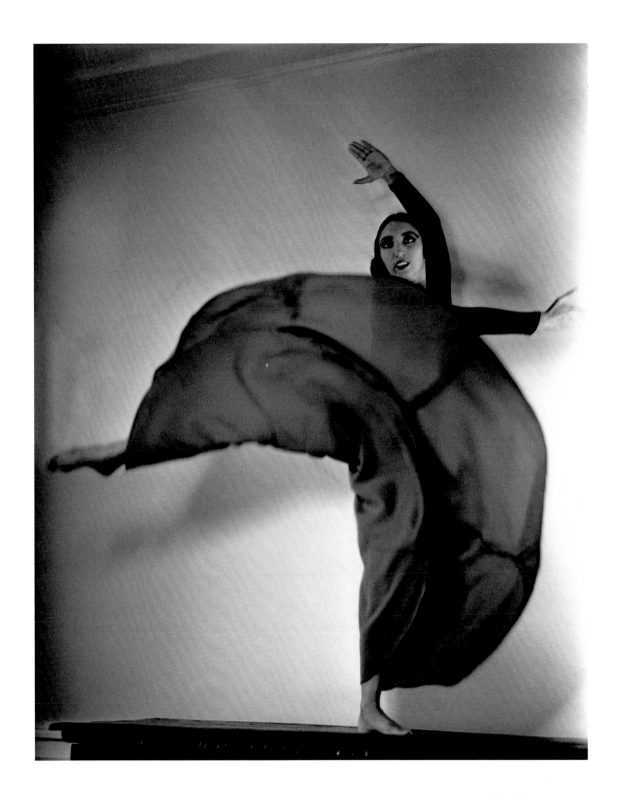

Plate 79
Pauline Koner
New York, around 1940

Plates 80 to 83
Hanya Holm and her Dance Group
New York, 1937

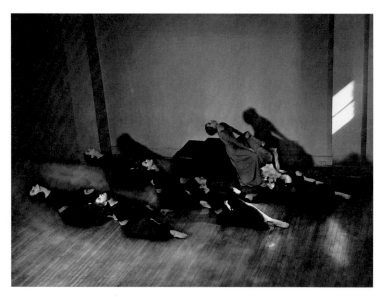 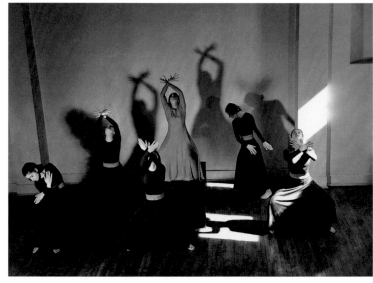

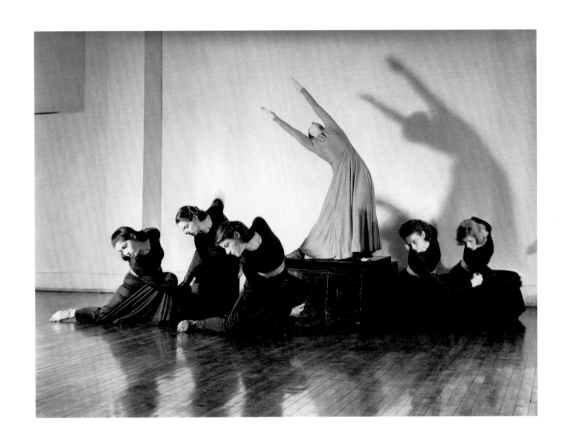

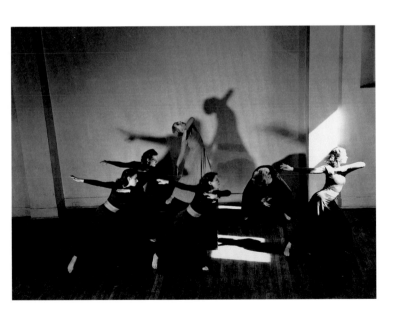

accomplished until then. In the course of several days, she put together a comprehensive report on the various behind-the-scenes activities which kept the market up and running. The *New York Herald Tribune*, however, published only a picture taken from the visitors' gallery. It shows the market empty, the trading floor littered with discarded tickets. The scene gives the viewer a taste of the stockbrokers' frenzied paper chase after the almighty dollar.

Lotte Jacobi rarely reflected on herself in her images, but in the 1937 self-portrait (pl. 84),

she allows us a glimpse of her appearance and character during this period. Not even a decade had passed since the portrait she had made of herself in the Old World — with the studio camera in Berlin (pl. 2) — and that in the New World, a clever "double exposure" outlined in the curve of the bevelled mirror, the index finger of her left hand poised casually on the release of her reporter's

New York Stock Exchange
May, 1938

camera, the Leica. Did she realize at the time that using 35-mm cameras such as the Leica was taboo for photojournalists in the United States, and that not even a magazine like *Life* wanted their photographers using them?[181]

For her, the aim of this portrait was not so much to represent the traditions of her craft, as to present herself in a contemporary manner, with motifs and subjects collected from the street, outside of her private surroundings. Dressed in a man's suit and a fashionable summer hat, she uses the cigarette and her place in the doorframe to show her position between inside and out, between the private sphere and the public places that remained to be discovered. She is fashionably casual and unpretentious, but has nevertheless calculated the effect of her appearance down to a T. By including the mirror itself in the image, the photographer increases the distance between herself and the viewer and introduces another level of observation in which she simultaneously leaves the assessment of her appearance up to a second I who is secretly peering in on the scene.

In America, Lotte Jacobi continued to use her camera as a tool for establishing communication with people whose thoughts and opinions she shared. Among the like-minded emigrés and newly won American friends were Albert Einstein, Ernst Fuhrmann, Ernst Bloch, and, when they were in New York Egon Erwin Kisch, Anton Wohlbrück and Alexander Bender, with whom she continued her discussions from Berlin days; the artist and art teacher Leo Katz, and photographer Berenice Abbott.

Her meeting with Hubertus Prinz zu Löwenstein, of whom she did a portrait for the first time in 1936, was to have far-reaching significance. As a devout Catholic who was at the same time a proponent of a republican Germany, he had been expelled from the country back in 1934. In 1937, he founded the American Guild for German Cultural Freedom in New York. The German-American organization's aim was to support authors who had been persecuted by the Nazis. Alvin Johnson, the founder of the New School for Social Research —

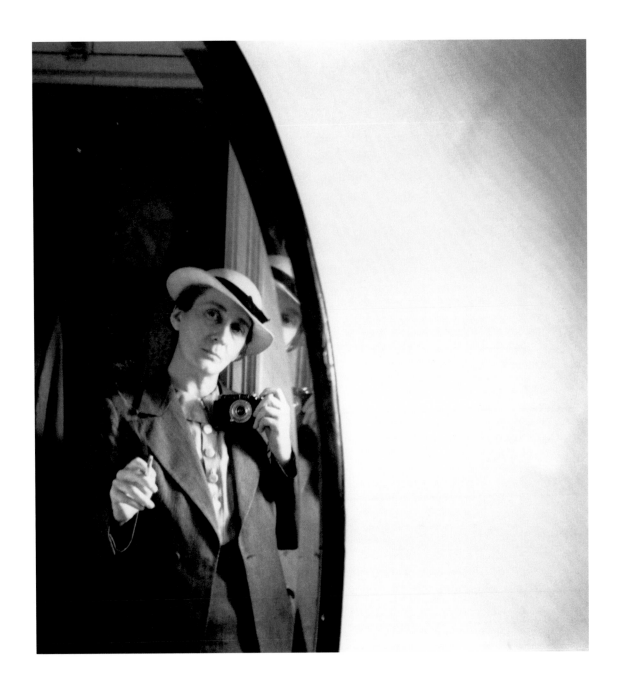

Plate 84
Self Portrait
New York, 1937

which had come to be known as the University of Exile — was responsible for the organization's American side. Thomas Mann represented the Germans. The president of the class of sciences was Sigmund Freud.

Her correspondence with Löwenstein[182] and the only publication to date about the Guild[183] both indicate how close she actually was to this group. For a time, she maintained close contact with the Guild's head office and primarily supported the practical aspects of its activities. This involved obtaining affidavits for the new emigrés and refugees arriving every day and helping them to apply for scholarships to finance their initial period in exile. The fact that, in 1940, Lotte Jacobi herself received fifty dollars from the Guild in "recognition of artistic achievement" rounds out the picture of the photographer's financially desparate situation. Not only was she one of the needy, but one of the notables, as well. This is indicated by her name on an invitation list for a benefit dinner at the Waldorf-Astoria Hotel that was held as a "Tribute Dinner to Honorable Harold L. Ickes" on April 26, 1939. As a guest of honor at the Book Auction Dinner, she had occasion to contribute one of her works to be auctioned off. She selected images taken from a series about Thomas Mann and Albert Einstein (pl. 94, 95).[185]

The Guild broke up in 1941, however: after the signing of the German-Soviet Non-Aggression Treaty, known in the U.S. as the Molotov-von Ribbentrop Pact, tensions grew between those who wanted to see a post-war Germany with limited sovereignty and those who, like Hubertus Prinz zu Löwenstein, believed in the feasibility of a new democratic nation.

Among those with whom Lotte Jacobi was re-united or met through the Guild, aside from the representatives of the organization, were Richard A. Bermann alias Höllriegel, Oskar Maria Graf, Alexander Granach, Thomas Mann, Erika and Klaus Mann, Erwin Piscator, Gustav Regler, Ludwig Renn, Paul Tillich, and many more. She was able to help many of them and took portraits of several, who, in their turn, passed many a commission her way.

Albert Einstein for *Life*

Lotte Jacobi's contact with Albert Einstein was of great importance to her between 1937 and 1939. She already knew him from portrait sittings in Berlin and Caputh. Sigismund Jacobi had also taken portraits of Einstein several times, as had her sister, Ruth. The volume of exposures, and even more so the unusually large number of picture series for Lotte Jacobi's work, are evidence of the personal relationship between the photographer and the "professor": images of Einstein at home with his family, together with colleagues, and several of him out sailing in the summertime. Their experience of emigration, their shared hopes that the U.S.A. would put a stop to the National Socialists' crimes, as well as their similar conceptions of a society guided by humanitarian principles and made up of free and self-determined individuals brought the two even closer in America. They both had a pronounced aversion to empty social conventions and shared a tendency toward self-effacement. They also shared a type of reverence that determined their world view far beyond any institutionalized practice of the Jewish faith. Furthermore, they had a common bond in the hope that, during the administration of President Franklin D. Roosevelt, democracy in America would not remain an empty promise.

When Albert Einstein agreed in principle to a "photo story" in *Life* magazine in 1938, he made it a condition that "Miss Jacobi" take the pictures. He respected her as a photographer and knew that he would not have to play-act or disguise himself for her camera. Instead of

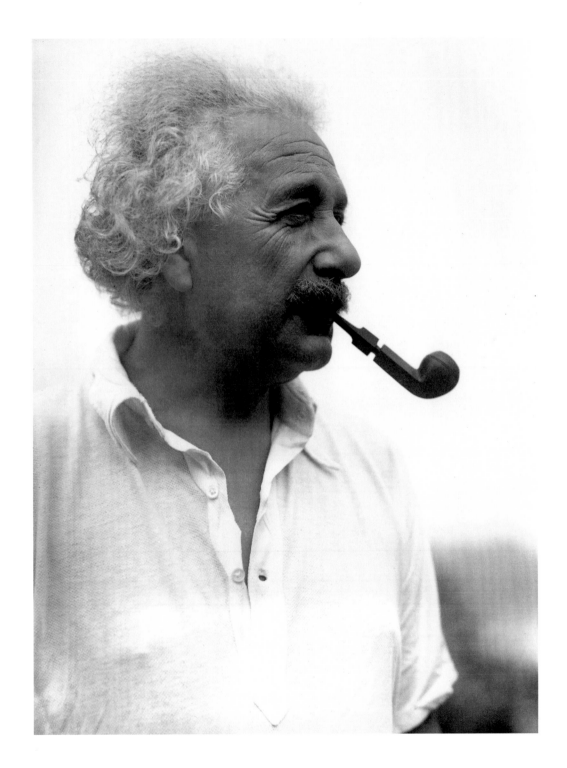

Plate 85
Albert Einstein
Huntington,
Long Island, 1937

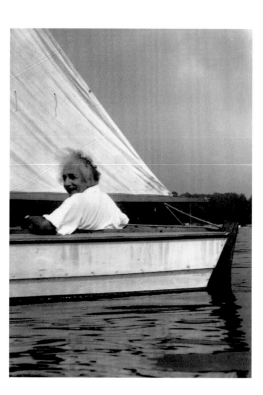

Plates 86 to 90
Albert Einstein Sailing
Huntington, Long Island, 1937

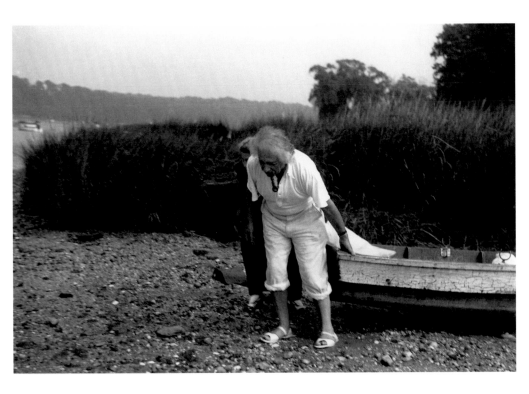

feeling constricted, he was sometimes even amused as she accompanied him with her camera. It was of secondary importance to Einstein that, for Lotte Jacobi, the commission meant a special opportunity to work for one of America's most renowned magazines photographing the man who, perhaps aside from Thomas Mann, was the most prominent in the emigré community.

Since its first appearance in 1936, *Life,* America's first photo magazine, had set the standard for the new American photojournalism. Within an extremely short time, it came to dominate the market for photojournalistic media. It was probably not so much the publisher's ambition to bring the world closer to the readers from an American perspective[186] that made this commission attractive to Lotte Jacobi as the thought that it might lead to long-term access to the country's largest magazine.

Only a year before the *Life* assignment, Lotte Jacobi had photographed the physicist in the New York City suburb of Huntington, Long Island, shortly after the death of his wife, Elsa Einstein. These portraits were made in the presence of Antonia Vallentin, who would later publish Einstein's biography. Outdoors in the bright summer sunshine, Jacobi shot at least fifteen pictures in a series. There are portraits from the front and in three-quarters profile as well as many shots taken with Einstein on the water in his sailboat. All of them are motifs shaped by the free play between the camera and chance (p. 85-90).

When she did the assignment for *Life*, Lotte Jacobi chose to photograph Einstein at his house in Princeton, New Jersey, in the presence of his colleague, Dr. Leopold Infeld, and one of his students. The sequence of shots (pl. 91-93) seems carefully planned, as if it were the product of an imaginary screenplay. The images appear to have been taken unobtrusively from the sideline. They show the physicist in conversation, in a discussion with Infeld and the young student, with the three bent over a manuscript, or just Einstein, wrapped in thought, sitting in a chair smoking his pipe. In each shot, he is tucked into a small section of the room's interior: a bookcase, disordered stacks of papers and files, or a snowy, winter landscape outside of the window. The central picture in the series has come to be one of her most famous portraits: Einstein in the Leather Jacket (p. 91). *Life* never published either the portrait or the series.

In the American media, the image of a person as presented to the public was subject to strict criteria, even if the standard was frequently defined only when the pictures were actually submitted. This meant that portraits of prominent figures, in particular, had to strike the right note between a private atmosphere and a public pose. Lotte Jacobi had not succeeded in meeting that requirement with her picture of Einstein in the leather jacket. "The photographer Lotte Jacobi was too American even for the casual Americans ... Many years would have to pass before a U.S. President could get away with being photographed in casual attire to show a popular preference for the informal and present a 'relaxed' image."[187] In the meantime, however, the Einstein portrait has transcended the American media's standards for photos. It has become one of Lotte Jacobi's most famous picture precisely because it does not meet the fleeting demands of fashion on images. The fact that the picture remained unpublished has thus helped to make it a legendary document over the years. At the time the picture was taken, the photographer was again forced to recognize that her conception of the portrait as the expression of an experience could not be reconciled with the ideas the media had of portraits of a model done up to suit the taste of the times. Faces as they were photographed by Margaret Bourke-White were more in line with these demands. "Margaret had become expert at making poses look natural," was an assessment of the "First Lady" of American photojournalism. "Everything in her pictures looked like it was made out of some kind of polished synthetic, even the skins of the people..."[188]

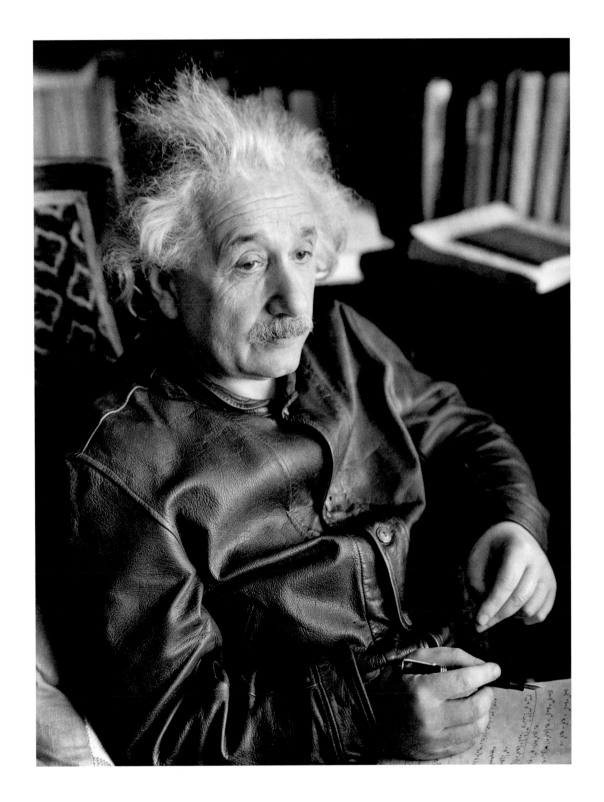

Plate 91
Albert Einstein
in the Leather Jacket
Princeton, New Jersey, 1938

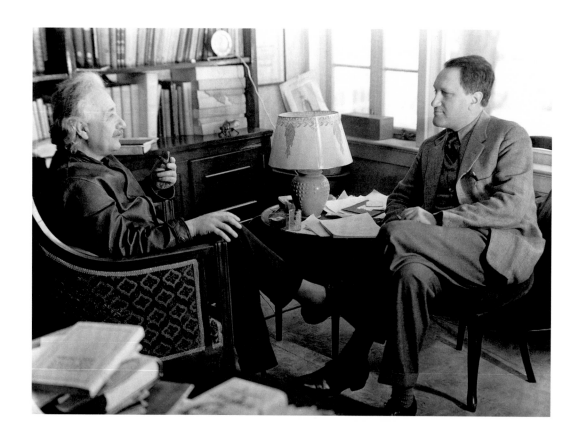

Plate 92
Albert Einstein and his Assistant,
Dr. Leopold Infeld
Princeton, New Jersey, 1938

Plate 93
Albert Einstein, Princeton
New Jersey, 1938

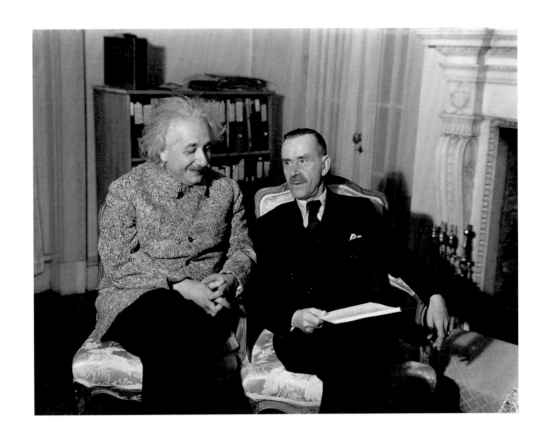

Plates 94 and 95
Albert Einstein and Thomas Mann
Princeton, New Jersey, 1938

Plate 96
Thomas Mann
Princeton, New Jersey, 1936

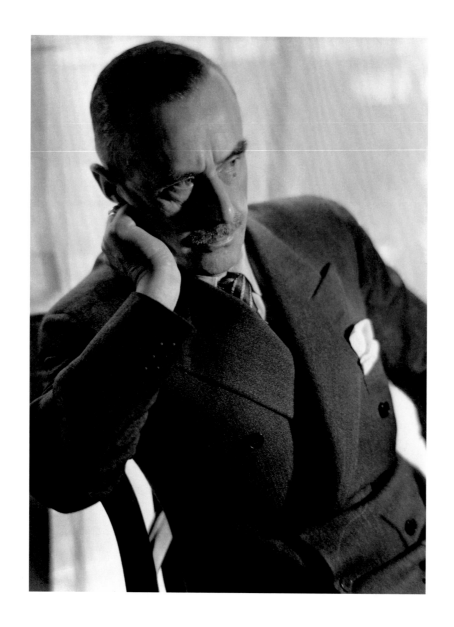

Plate 97
Katja and Thomas Mann
Princeton, New Jersey, 1936

That was a conception of the portrait which Lotte Jacobi did not share and which she never would have wanted to adopt. "I stuck to my conception of photography," she later recollected, convinced that it had been the right thing to do. So it came to be that the portraits she shot in America also express her personal experience of the sitting as it happened, complete with all the coincidences, surprises, and inconsistencies that were a trademark of her work. On the initiative of Edward Steichen, "Einstein in a Leather Jacket" was published for the first time in 1942 in *U.S. Camera,* a periodical somewhat similar to *Deutsches Lichtbild.*

Lotte Jacobi's 1938 portrait series of Thomas Mann at his home in Princeton, New Jersey, is one of her few works which was published by the American press. The circumstances did not make it easier. The portraits had been commissioned by *The New York Times* with the ambition of presenting the author and Albert Einstein to its readers together for the first time. Although the photographs are rather second-rate, they are reminders of the connection between Lotte Jacobi's daily political activities and her career (pl. 94, 95). During the photo session, she gave Einstein a note from an emigré organization expressing opposition to Nazi Germany's participation in the New York World's Fair. It was hoped that Einstein would be able to use his influence, and a representative of the emigré organization, Karl August Wittfogel, came along to present the group's case. The conversation at Thomas Mann's house that day turned into a heated political discussion that touched on such sensitive questions as the difference between Jews of different national origins and on their communist activities. The tense atmosphere led to only four pictures being taken during the meeting.[189]

Despite frequent rejections, Lotte Jacobi did not become discouraged from making repeated offers of her photos to magazines. The series of Einstein in his sailboat was among them, but she had little luck with it. The standards of the American press in regard to subject and presentation were much more commercial and nationally oriented than in Europe:[190] "America's mass media directed the lion's share of the attention on things American … *Time* … and *Life* both tried to ennoble the country and develop a unitary national voice. These widely read magazines influenced the cultivation of a national identity while simultaneously accelerating the Americanization of America."[191] In comparison with the German glossies, *Life* with its "… big budget, relentless optimism and corporate identity represented something completely new and very American."[192]

Seen as such, Lotte Jacobi's experience with the Einstein portrait was more than an isolated bit of bad luck. The few images that actually appeared in the American press show that Jacobi's style and conception of the portrait was not contemporary American. The formulation of a personal experience was not in demand. Each and every image had to conform to American tastes. Lotte Jacobi was not the only photographer who was so rigorously rejected by America's image media. Yet her case reveals the fundamental difference between the American norm of the portrait as the carrier of an image and the aim of the European media to present a private image or a type to the public. *Life* refused to print the pictures by André Kertész on the grounds that he said too much in them.[193] Agencies had sole responsibility for distributing pictures to the publishers and assigning commissions. Gaining direct, personal access to the editorial offices, as Lotte Jacobi had done in Berlin, was out of the question. In general, the commissions were given to photographers, usually of the younger generation, who had already established themselves.[194] Retainer contracts were a rarity, and the number of freelance photographers was continually increasing. Lotte Jacobi would have none of the everyday discrimination faced by women photographers, for example, of working for lower pay or being confined to so-called "women's issues".[195] Her unfailing concept of people as self-determining individuals ruled out any sort of unequal treatment of the sexes by society

Plate 98
Alfred Stieglitz
New York, 1938

Plate 99
Helene Thimig and Max Reinhardt
New York, 1938

164

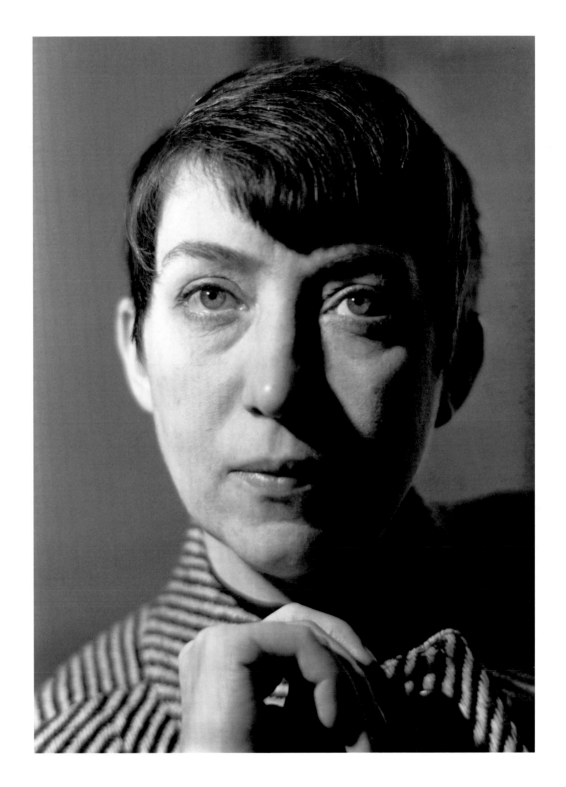

Plate 100
Berenice Abbott
New York, around 1940

Plate 101
Ernst Bloch
New York, 1937

Plate 102
Rudi Lesser
New York, 1953

Plate 103
Karen Horney
New York, 1946

from the very beginning. Even in a mass society that was increasingly coming under the influence of capital and image, she still clung to the belief that all individuals are responsible for themselves, and a lack of success can be traced to a lack of perserverence or some other character flaw. She found her own form of resistance, calling herself "A born rebel", and reached a very American conclusion, "you have to be that way today, or otherwise you are a loser".[196]

The memoirs of Jacobi's American colleague, Berenice Abbott, confirm how difficult the commercial environment was for photographers of both sexes. Abbott had made her reputation working as a portrait photographer in Paris, but she returned to the U.S. at the end of the 1920s and soon gave up portraiture. She wrote that the greatest obstacles to success were the enormous costs of living, discrimination against women and the commercialization of her profession.[197]

Decades later, Lotte Jacobi always referred to Abbott as one of those who helped her to overcome her initial difficulties in New York.[198] A close-up portrait of Abbott reflects the relationship of the two women during these years (pl. 100). As a portrait photographer, Abbott knew exactly how to position herself: in a classical pose — her upper body is tipped forward into the picture, her gaze directed straight into the camera. The line of her shoulders emphasizes the diagonal and the position of her head the vertical. Lotte Jacobi gave her subject more than just a fleeting glimpse. The image is a study of artistically arranged shapes composed of light and dark, rounded and angular surfaces, and parallel, intersecting and perpendicular lines that never lose sight of the open gaze or the relaxed expression of the subject. The portrait was done at the studio and, aside from the photo she made of Minor White (pl. 128), one of the few from the American period in which she resurrects the composition of her modern Berlin images. But the rapport between the two photographers was not only a product of the situation at hand. Both were also convinced that, although a picture could be technically perfect and achieve impressive effects through proper lighting, it could not claim to be an artistic portrait if it did not possess the essential qualities of the expression and bearing, as well as the particular attitude of the subject.[199]

At the end of the 1930s, Berenice Abbott was teaching at the New School for Social Research, a liberal academic institution founded as a reaction to political conditions in Germany. Emigrés from all over Europe had been appointed to the faculty. Erwin Piscator was teaching theater courses at the New School when Lotte Jacobi reestablished her contact with him. It is not certain whether Berenice Abbott had a hand in this, but it can be assumed the two women got acquainted through the Photo-League, an association of photographers who had joined together in 1936 to advocate the cause of the poor, unemployed and disenfranchized through pictures, in much the way that worker-photographers did in Germany in the 1920s.[200] The group's agenda, in addition to distributing its newsletter *Photo News*, included holding exhibits, talks and courses with well-known photographers.[201] In March, 1938, Lotte Jacobi gave a guest lecture on portrait photography for the group, which was exhibiting the works of portrait photographers.[202] The discussions getting underway in America at the time about artistic vs. documentary photography, and the roles of artist, amateur, and professional photographers must have reminded Lotte Jacobi of similar debates in Berlin. It was the first time in literally decades that the dominance of Alfred Stieglitz and his esthetic dogma had been questioned. During the Berlin years, in her work as a professional photographer, she wavered between tradition and "New Seeing". Now she was moving between two poles, on the one hand the new documentarists, represented by Ansel Adams and Dorothea Lange, who were searching for a contemporary esthetic of a new "American Place", and on the other hand by the representatives of photo journalism, whose main thematic and esthetic aim was solely to show "the American way".[203]

New York during the War

The United States' entry into World War II in the early 1940s meant drastic changes in the status of the emigrés. For Lotte Jacobi, this decade marked a retreat from public activity, which the changes in her private life may well have encouraged. Like most exiles, she will have viewed America's joining the struggle as fully justified and cherished new hope for an end to the Nazi terror in Europe. That the war would adversely affect the lives of the emigrés in their host country did not become apparent to many until some years later. The consequences differed according to career, status and political commitment. The change in the media's label for the emigrés alone, from "Hitler's Gift to the USA" to "enemy alien", is sufficient evidence of the shift in the country's political climate.[204] Imagine the paradox faced by families like Lotte Jacobi's: sons and husbands were automatically made American citizens when they enlisted in the U.S. Army, while mothers and older family members who had not been naturalized were declared foreign enemies.

We can only speculate about how Lotte Jacobi spent the war years. The few bits of evidence allow only a fragmentary reconstruction. Restrictions on "enemy aliens" could vary in their severity, but could include a type of ban on practicing one's profession. In several U.S. states, treatment was very repressive, particularly of photographers. Being seen on a New York street with a camera could lead — as it did with André Kertész — to being mistaken for a spy.[205] Publishing house editorial offices began to play it safe politically and hire almost exclusively American photographers.

Lotte Jacobi had no difficulties harmonizing the loyalty she still felt toward her host country with her opposition to fascism. She took part in pro-American activities, such as the "V for Victory" contest sponsored by *U.S. Camera* in 1941 — a sort of populistic action to boost morale — in her spirit of undogmatic anti-fascism. From the official American perspective, her attitudes and close association with communists and socialists like Earl Browder, I.F. Stone (pl. 109), Paul Robeson (Ill. p. 195), William DuBois, and Shirley Graham (Ill. p. 196) were no doubt seen in a different light, not least because the emigré community, who had already taken a public stand against fascism before the persecution, had been labelled as internationalistic and "un-American".

Photographically, Lotte Jacobi's entry in the "V for Victory" contest, sponsored jointly by the bi-annual photo journal *U.S. Camera* and the British-American Ambulance Corps, can be assessed as an isolated event in her work (Ill. p. 170), leaving aside the photomontages John Heartfield did in Berlin using her photos. Her photographic solution, montage of Great Britain's two best-known symbols — the Union Jack and the Tower Bridge — earned Jacobi the one-hundred dollar first prize in the contest. As the winner, she also gained the opportunity to be published in *Life*, which had shifted its reporting almost exclusively to war coverage immediately after America entered the conflict.[206] State institutions also used every opportunity to present the political mission of the country at their events during these years. The Museum of Modern Art held a series of photographic exhibits with titles like "War Comes to the People" (1941) or "Road to Victory" (1942), which were "openly directed at building up national morale".[207]

From a personal standpoint, the 1940s were an extraordinarily happy time for Lotte Jacobi. During the second half of the decade, she exercised her creativity in a very new way. One day in the spring of 1940, Lotte Jacobi's friends Egon Erwin (pl. 104) and Gisl Kisch brought the publisher Erich Reiss (pl. 105) with them to her studio. It was love at first sight. Six months later, Reiss and Jacobi married. Both experienced the marriage, which was characterized by affection and respect, as an unusual kind of love affair. In this decade of increasing

First Prize in the V for Victory Contest was awarded to Lotte Jacobi, New York Photographer

V FOR VICTORY CONTEST

U. S. Camera Collaborates With British-American Ambulance Corps
in Sponsoring Prize Competition

THE photograph on this page is that of the first prize winner in a contest sponsored by *U. S. Camera* in co-operation with the British-American Ambulance Corps. The competition was publicized, through the British-American Ambulance Corps.

Fourteen cash prizes were awarded to the winners who sent in the best pictures dramatizing the victory letter V. The contest was open to anyone and

pictures entered were turned over to the British-American Ambulance Corps, for use in that organization's nationwide victory campaign.

The first prize of $100 was awarded to New York photographer Lotte Jacobi. Second prize of $50 was won by Harold Fried; third prize of $25, N. Field; fourth prize of $25, Robert S. Trowbridge.

"V for Victory" Contest,
in: *U.S. Camera*, Oct. 1941

political polarization, Reiss inspired Jacobi and reaffirmed and supported her work. Through their life together, Reiss, for his part, was able to make a new start after being broken physically at the Oranienburg Concentration Camp north of Berlin. Being a Jew, he had been deported there and his Berlin publishing house destroyed by the Nazis.

By 1933, Reiss had made a uniquely important contribution to expressionist literature through his publishing efforts, which included Maximillian Harden's *Köpfe* and *Die Zukunft* as well as Richard Hülsenbeck's *Dada Almanach*. The names of Reiss's authors reflect his literary preferences: Kasimir Edschmid, the editor and publisher of *Tribüne der Kunst und Zeit*, Theodor Däubler, Henri Barbusse, Ernst Toller, Gottfried Benn, Alfred Wolfenstein, Kurt Hiller, Erna

Pinner, and last but not least, Egon Erwin Kisch, are all representatives of the agitatorial spirit of the period following World War I. In addition to their interest in literature, Reiss and Jacobi shared a great love of the theater. Aside from his publishing activities, Reiss had also worked as a dramaturge for Max Reinhardt in Berlin for many years. Friends and acquaintances described him as an art lover, an esthete and a rugged individualist. One can well imagine that for him as a publisher, the loss of his native language at the age of 53 was a more difficult burden to bear than being forced to give up his possessions.[208]

In October, 1941, Lotte Jacobi and Erich Reiss moved into an apartment with a studio on 52nd Street in the neighborhood between Central Park and West 40th Street. This was the area in the heart of Manhattan where intellectuals and artists had chosen to settle. Galleries, publishing houses, jazz clubs and cafés created an atmosphere that must have reminded Lotte Jacobi of her years in western Berlin. The Austrian photographer Trude Fleischmann had her studio on 56th Street. The Nierendorf Gallery, which Jacobi knew from her Berlin days, had been re-located to 57th Street. And not far away, Otto Kallir was specializing in the works of German expressionists at the Galerie St. Etienne. And Curt Valentin opened up a gallery representing the European classical modernist works. The avant garde gallery of Julien Levy was on Madison Avenue. He was one of the few art dealers who had included photography in his exhibits early on. Lotte Jacobi had sought him out in the first months after she arrived in the city.

Erich Reiss's support for Lotte Jacobi's photographic work extended beyond commissions he sent her way via friends and acquaintences. Reiss also took care of her business correspondence and helped set up the lighting on the more difficult field assignments. In addition, he developed new ideas for advertising postcards and tried to win customers for his wife by making special offers.

The cooperation between these two confirmed individualists gives a very harmonious picture, a rare commodity under the hardships of exile, which were particularly tough on women emigrés.[209] Most of the women had to work in low-level, badly-paid service jobs to support their families, but Lotte Jacobi had been successful in re-starting her career from the very beginning. And Erich Reiss was obviously prepared to help out by taking on tasks that presented him little challenge.

Lotte Jacobi was still dependant on studio sittings for portraits — to go with valentines, or as image builders or roadmaps in the search for identity — to make a living, yet many of these jobs must have put her enthusiasm for the craft to the test. It is hard to decide what was more discouraging — the rejections from the press or the complaints from her customers, who could be absolutely unabashed in their criticism. No matter where they come from, photo assignments remain bound to fashion and subjective tastes. Hubertus Prinz zu Löwenstein, for example, qualified his criticism of the ostensible weatnesses in Lotte Jacobi's portrait of him by saying that the photographer did not yet really know him: "You are seeing me from a side that is neither important nor flattering, one I do not want to have entered in the annals of history."[210] Customers less familiar with her even had the nerve to give technical directions as to the developing process and printing paper she should use to bring out the personality of an old woman in the portrait more sharply, "We thought perhaps sharper contrasts and livelier paper might bring

Plate 104
Egon Erwin Kisch
New York, 1940

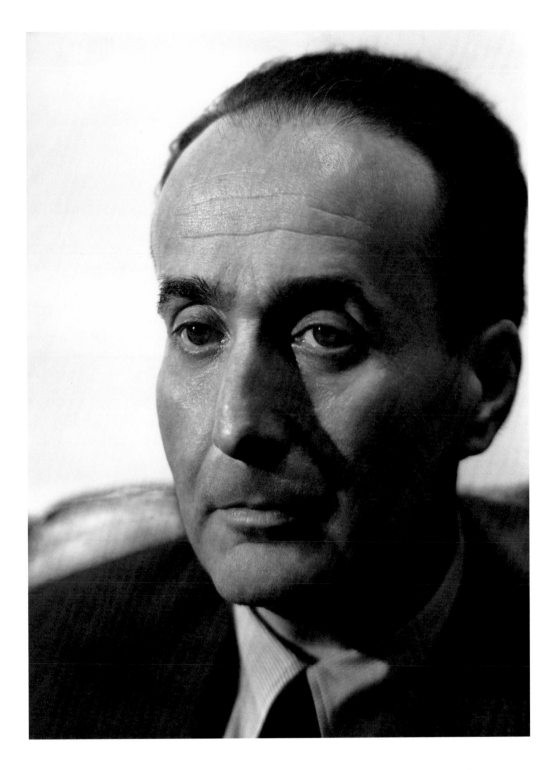

Plate 105
Erich Reiss
New York, 1940

out her enthusiasm for every-
thing from boxed cake mixes
to THE MAGIC MOUNTAIN."[211]
Some clients were encouraging
in their thanks. Marc Chagall,
for one, said he recognized the
artistic dimension of photogra-
phy after he saw the portraits
she had created of him and his
daughter, Ida (pl. 108).[212]

Arnold Kirchheimer's
"counterfeiter's art" was in
demand to satisfy the wishes
her customers had for all the
technical changes to their self-
images. Lotte Jacobi had the
great fortune to find a co-work-
er in Kirchheimer who com-
bined his enthusiasm for her
work with a devotion to his

"These are the Years, The Phillips
Exeter Academy",
New Hampshire, 1946
special edition of the *Academy
Bulletin* with 15 photographs
by Lotte Jacobi

own metier. He had the patience for the most eccentric of requests, and as a master crafts-
man, he did the "cosmetic surgery" needed and probably saved one or two commissions
from rejection.

"I am an artist, not a commercial photographer."

Lotte Jacobi continued to use every opportunity to make a name for herself, and she found
many an occasion to attract the attention of the public to the studio. In 1941, she celebrated
the 90th anniversary of the Atelier Jacobi. It can be assumed that Erich Reiss, who was in
charge of management, played a role in developing the idea for the jubilee. Lotte Jacobi,
who had by then established herself in a modest sort of way, she put on a grand anniversary
celebration. The printed invitation included a testimonial penned by Hubertus Prinz zu
Löwenstein, who was respected in both the emigré and American communities. In an exhi-
bition held at the studio in conjunction with the event, Lotte Jacobi showed "… Nicholas
Murray Butler, Thomas Mann, Alfred Stieglitz and Albert Einstein." In his tribute Hubertus
Prinz zu Löwenstein wrote: "It is certainly a good thing that there is a Jacobi to photograph
the janitors, the presidents, the stage and movie stars, the labor leaders, the forests, the riv-
ers, the animals, the high buildings and the customs of America."[213]

This broad classification of her photographic work sheds some light on how she present-
ed herself. She consistently created an image of her own work as the exclusive product of her
own ideas and interests rather than of the constraints of commissions. The anniversary testi-
monial describes Lotte Jacobi as a photographer who could not be consigned to one area of
specialization. "If you specialize you are lost.",[214] she once declared in regard to professional
photography. She characterized herself with the words, "I am an artist, not a commercial
photographer."[215] The implication here that she had the freedom to pursue artistic endeav-
ors stands in contrast to the reality of her situation as a portrait photographer. But it was less
an intentional exaggeration than the expression of a way of life she had always aspired to.

Even during her years in Berlin, Lotte Jacobi had had to reconcile the demands of the work she did on commission and the projects she undertook on her own initiative. The juggling and maneuvering between the two existences — the photographer and the artist — became even more difficult in New York, even as public interest in photographic works as items to be collected by galleries and museums began to increase in America at the end of the 1930s. This institutionalization of photography as an art as well as the contact with photographers' circles were what Lotte Jacobi needed to feed her self-image as an artist.

The many portraits of photographers she took during these years, including Berenice Abbott (pl. 100), Nancy Newhall (pl. 110), Barbara Morgan (pl. 112), Alfred Stieglitz (pl. 98), Ruth Bernhard, Aaron Siskind and others, are the product of a deliberate focus on the representatives of her profession. At the same time, she focused on the artists as people, not as typical representatives of their profession — or as in her portrait of Alfred Stieglitz, as more the Bohemian (pl. 111). For Lotte Jacobi, on whom authorities in any metier generally made little impression, visiting Stieglitz must have seemed like a ritual act. She had been acquainted with his work ever since she had first viewed some of his photographs in the collection of exemplary work at the Munich school. She visited the doyen of American photography at his residence, *American Place.* During a conversation about her camera — the Stegemann 9 x 12 cm — Lotte Jacobi shot the portrait of Stieglitz, one of the rare pictures of him smiling (pl. 98). With all due respect for his achievements, Lotte Jacobi simply could not comprehend the one-sided interest in his work on the part of many New York gallery owners.[216]

Although the Museum of Modern Art set up its photography department in 1940, Lotte Jacobi was not included in an exhibition there until 1942, as part of a collection of 20th century portraits. Her work was not to appear there again until 1948, in an exhibition titled *In and Out of Focus*, in which the works of contemporary photographers were displayed under the auspices of Edward Steichen. It is likely that she had already been trying since the end of the 1930s to take part in the museum's events and to sell her works there. In the early 1940s, she attempted to establish contact with the museum, as indicated by an exchange of letters with the first curator of the photography department, Beaumont Newhall, in which she enclosed a portrait, certainly not her first, of the photographer and curator, Nancy Newhall (pl. 110).

Plate 106
Abstract
Boston, Mass., 1950

Plate 107
Gardener Museum
Boston, Mass., around 1950

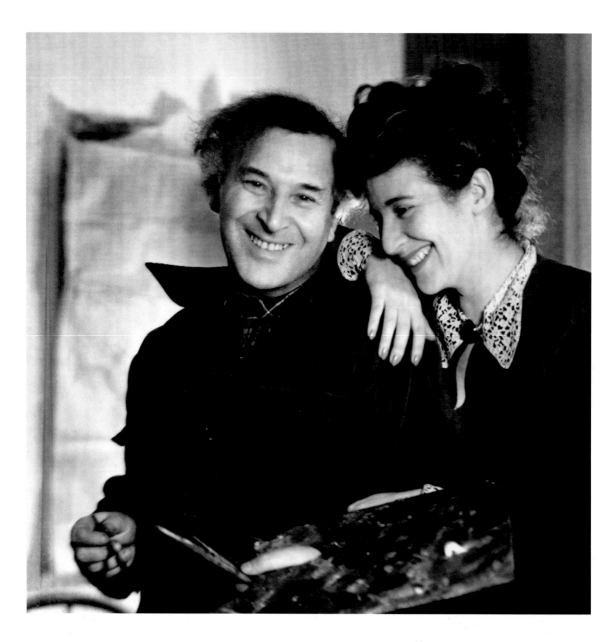

Plate 108
Marc Chagall and his Daughter Ida
New York, 1945

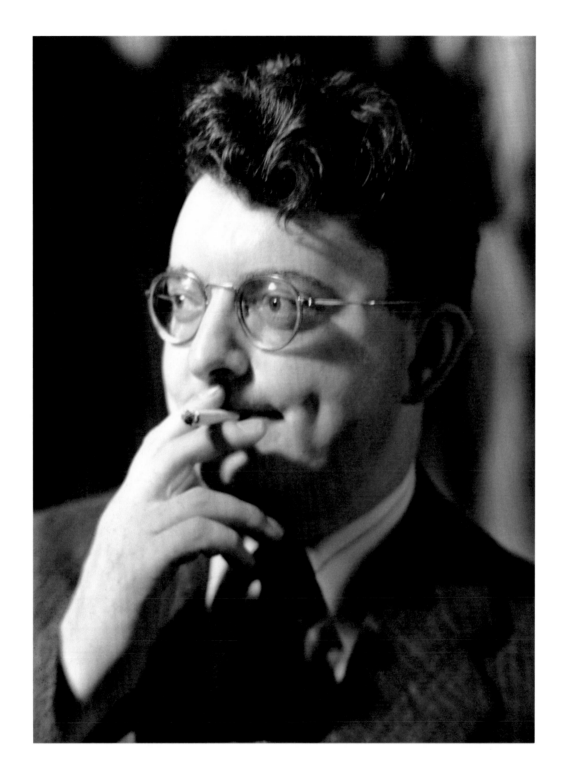

Plate 109
I. F. Stone
New York, 1937

Plate 110
Nancy Newhall
New York, 1943

Plate 111
Alfred Stieglitz
New York, 1938

Plate 112
Barbara Morgan
New York, 1944

Photogenics — Adventures with Light

Appearing unexpectedly in Lotte Jacobi's otherwise homogenous oeuvre, even if they were a typical product of photography in America in the 1940s, are the photogenics: images made in the darkroom without a camera. Starting in 1947, she continued working with varying intensity with these compositions for about a decade. "I started moving around the light source (in the darkroom) as well as the objects I used to make photograms, and from then on, there was nothing I didn't try... If I had time, I went into the darkroom, because my head was so full of ideas. The possibilities are limitless. The only boundary is the personality that's working with them. — There's not much in my life that put me into such an altered state of joyful excitement."[218] There were also very few times Lotte Jacobi expressed herself so emphatically. Otherwise sober, curt, and sparing with her emotions, she generally described her photography and experiences in laconic terms. Erich Reiss's support for her work must have reinforced her own enthusiasm for inventing more and more new images just as much as did the encouragement coming from Edward Steichen. After Stieglitz's death, Steichen became a figure of "unparalleled prestige in American photography",[219] and, in 1947, was appointed the head of the photography department at the Museum of Modern Art. He valued Jacobi's photogenics far more than he did her portraits.[220]

The painter and art historian Leo Katz (pl. 130) had been a friend of Lotte Jacobi's since 1936. One day, he came up with the idea of making photograms as a sort of parlor game together with a group of friends and Erich Reiss, who was sick and could not go outside: "... and we all worked hard, doing everything without a camera. We painted with candles and enlarged the pictures. We made fingerprints and painted with water colors between the glass plates, but at some point I got tired of it."[221]

Lotte soon took leave of the small circle of friends and retired to the darkroom, which, for her, usually stood for the less glamourous aspect of photographic work. When she came out again, she had made a new invention. "I stopped using the objects and drew with light; I used different attachments on flashlights as the light source. I also used the enlarger and glass, paper and celluloid, etc. I often made twenty or thirty attempts, developing each one immediately and then improving on that in the next one... they were adventures in light."[222] Jacobi tried to explore all the possibilites of the dimensions.

Given the abstract art movements as they were then developing in American photography and painting, a parlor game in Lotte Jacobi's home does not seem a sufficient explanation for her experiments in cameraless photography. Much more so than any of the other photographic movements or styles, the art of creating images directly with light, which actually pre-dates the development of conventional photography in history, is the result of exper-

imentation, whether it was guided by rigid theoretical precepts, or by nothing more than the imagination.[223] In the sense that cameraless photography takes its life from experimental ingenuity,[224] Lotte Jacobi's photogenics evidence a playful impulse. But above and beyond this, the artistic qualities of her fantasy images owed more to the artistic trends of the day than to a parlor game. She was particularly fascinated with Barbara Morgan's experiments in light and motion, cameraless luminographs, "One time at her studo, she showed us these wonderful, abstract prints and told us that, every day, she watched the sunlight in her room, and then she finally photographed it."[225] Later on, in a catologue text for an exhibition of Lotte Jacobi's titled, *Light Pictures*, she confessed how crucial Leo Katz' influence had been in her taking the step from photograms to photogenics: "There have been special studies and many experiments behind the pictures of which these are a small selection. I wish to express my gratitude to Leo Katz, who guided my first steps towards understanding in the field which is new to me."[226] Katz was also the person who gave her experiments the name, "photogenics".

Leo Katz must have a kind of Cicero to Lotte Jacobi. As an art historian, painter, author, and a teacher at various educational institutions in New York, Katz carried on discussions with Jacobi about the history of art and contemporary American photography and painting for literally decades.[227] A recurrent theme in their conversations was the visual realization of the idea of "dimensions"[228]. The photographer recalled that Einstein's fellow physicists would frequently debate the same topic at his home, as well.[229]

Katz, like Lotte Jacobi herself, was close to Alfred Stieglitz in his conceptions of art. He was continuously preoccupied by the question of photography as art — a question which had gained new significance during that decade. Katz held that if the camera — or more specifically the world seen through the lens — defined the creative limits of photography, then Lotte Jacobi's experiments in light, freed from a conventional subject as they were, met all the criteria of a work of art.[230] They were not bound to the world of things, they were originals, because "the process of creating an image is an experimental sequence that rules out an exact reproduction of an identical result."[231] And in their abstract visual language, which gave them the power to visualize the world of the subjective and the unconscious, they also became a part of abstract art in America as it began to develop in the 1940s.

"Today, Modern Art presents new worlds of visions, new concepts of form, space and dimensional dynamics. The optical forces of a point, a line, a plane and other dimensional elements are no longer static affairs to us. Composition is adjusting itself to the new dynamic Space-Energy concepts of the Atomic Era," Katz wrote in a text on Lotte Jacobi's *Photogenics*, localizing in his further elaborations the impulse for the abstract art of the day in the revival of a cameraless photography freed from the representation of material objects: "Many artists gradually fled from the world of material objects to explore the forgotten realms of the unconscious mind and its symbolism… Modern Art was shocked by photography out of its objective, descriptive complacency, and now one finds the beginning of a return of the fruits of its labor to photography."[232]

Lotte Jacobi's cameraless images (pl. 113-121) range from simple photograms, through what she called photogenics, to luminograms — visions produced solely using directed light. They develop their degree of esthetic effect by simulating motion, creating associations with sculptures or suggestions of widely diverse materials, or evoking expressionistically graceful spaces. Hair-thin lines of light become sharp-edged objects, concentric circles trace a spinning motion, and a flowing scale of grays creates the illusion of transparency. Well-versed in the principles of esthetic composition, the photographer drew her images from a seemingly inexhaustible repertoire of ideas.

In 1948, art critic Willi Wolfradt had glowing praise for Lotte Jacobi's photogenics: "Luminosity moves in parabolic bows across the paper, and form loses itself in shimmering domes and twists. An oblique beam on the enamelled surface of the paper sets aflame snow white tones that were once the exclusive province of the Chinese masters of pen-and-ink drawings."[233]

While photography is intrinsically bound up with considerations of transience, photogenics — as did other media during this time — elevate the thematics of the temporal dimension into the surreal-fantastic. In the late 1940s, such examples of the *Film noir* as *Out of the Past* or *Till the End of Time,* and, even more so, the painting produced during this decade, as characterized by the monochromatic swirls of abstract expressionist painter Jackson Pollock, were all taking their significance from an insinuation of infinity.[234] From the photographic standpoint, photogenics are closest to the light modulations of László Moholy-Nagy, who had revived his experiments from the Bauhaus Period at the *New Bauhaus* in Chicago.[235]

"He (László Moholy-Nagy) and his colleagues nurtured such artists as Arthur Siegel and Lotte Jacobi. Later, through their prolonged presence in the Chicago milieu, the American-born photographers Aaron Siskind and Harry Callahan adapted and extended the Chicago School — now known as the Institut of Design — into an important part of the American photographic legacy."[236]

Lotte Jacobi's photogenics are the result of her personal investigation and quest to expand the formal language of the art of photography. At the same time, Lotte Jacobi's images are visions of interior worlds, much like the abstract photos made by her contemporaries, who had consciously broken with the esthetics of documentary photography. For the first time, the photographer explored the world of autonomous images, and she had surprising success. Her photogenics were attributed to post-war, avant garde photography in the United States under the heading "Vision in Art" and, a short time later, in Germany under the classification "subjective photography".

In 1948, five *Abstractions* by Lotte Jacobi were displayed for the first time at the Museum of Modern by Edward Steichen in an exhibition he put together called *In and Out of Focus.* A second Museum of Modern Art exhibition, *Abstraction in Photography*, in 1951, reveals something about the context in which her work was seen at that time. Here, Jacobi's works were hung alongside *Equivalents* by Alfred Stieglitz. Only a few years later, Otto Steinert discovered Lotte Jacobi's cameraless images for inclusion in the second exhibit of *subjective fotografie* in Saarbrücken in 1954.

In the photo-historical reception of Jacobi's work today, photogenics are often assigned an inadequate, marginal role, for example by being subsumed under the category "Party Games".[237] This estimation, which is still wide-spread in the United States, is indicated by this entry in the *History of Women Photographers*: "As significant as women's contributions were, credit for moving photography closer to the other visual arts has not been forthcoming for them. In fact, in the United States during and after World War II, the avant-garde was perceived as a masculine phenomenon... but even now their role often remains unacknowledged."[238]

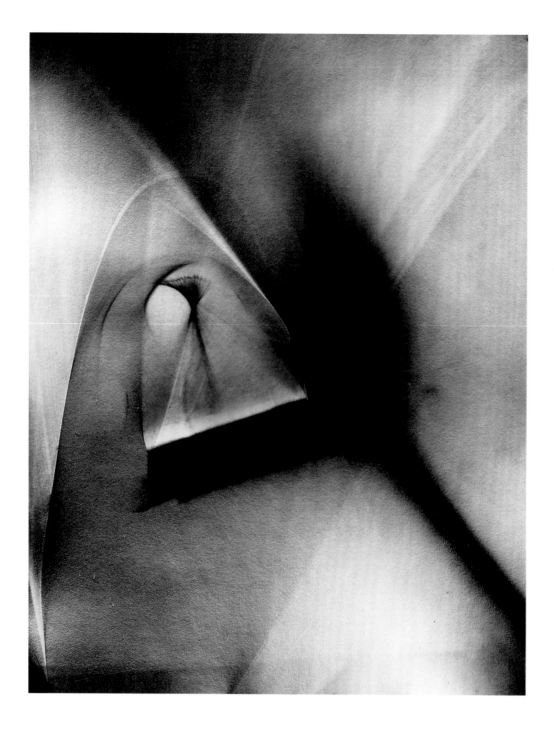

Plate 113
Photogenic
New York, around 1950
Museum Folkwang, Essen

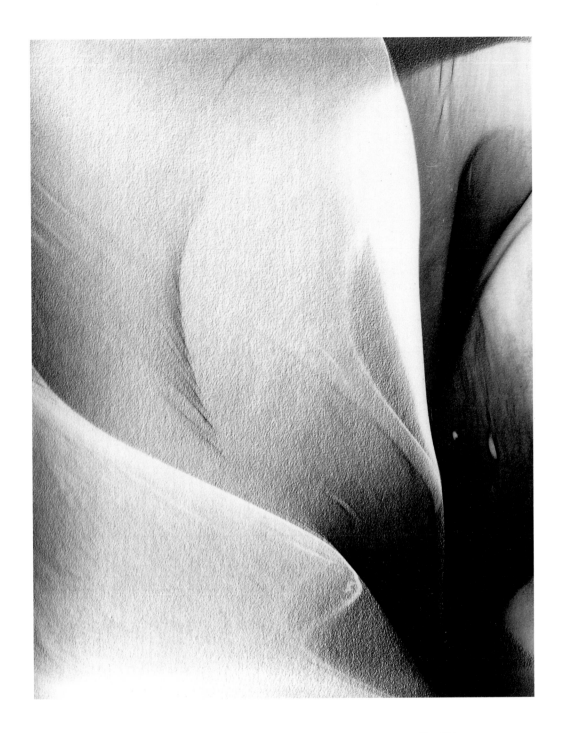

Plate 114
Photogenic
New York
between 1946 and 1955
Museum Folkwang, Essen

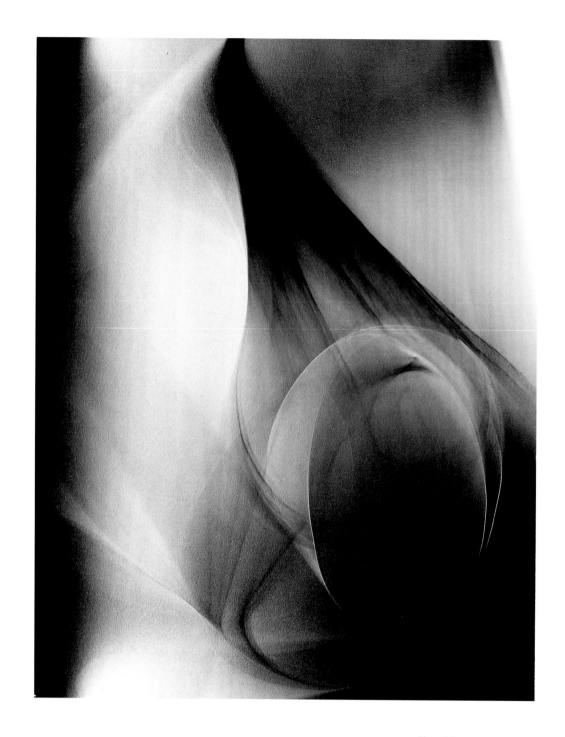

Plate 115
Photogenic
New York, around 1950
Museum Folkwang, Essen

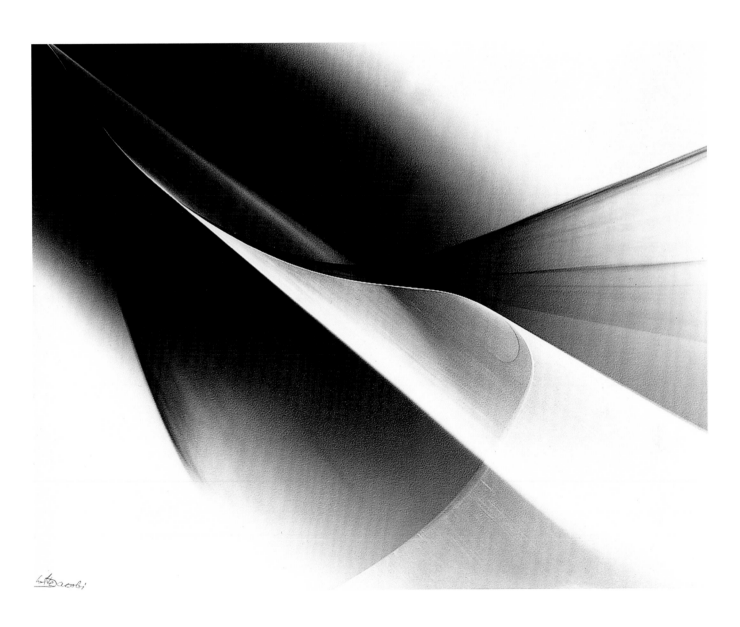

Plate 116
Photogenic
New York, around 1950
Museum Folkwang, Essen

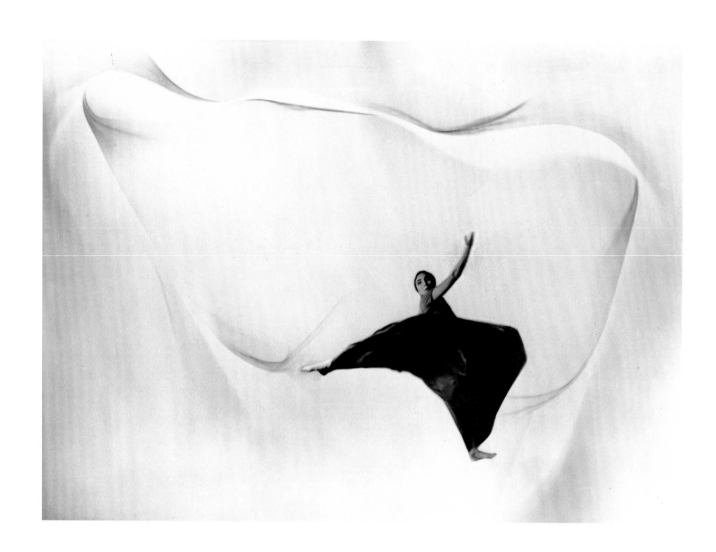

Plate 117
Pauline Koner and Photogenic
New York, around 1950

Plate 118
Photogenic
New York, between
1947 and 1955

Plate 119
Homage to Brancusi
New York, around 1950

191

Plate 120
Photogenic
New York, between
1947 and 1955

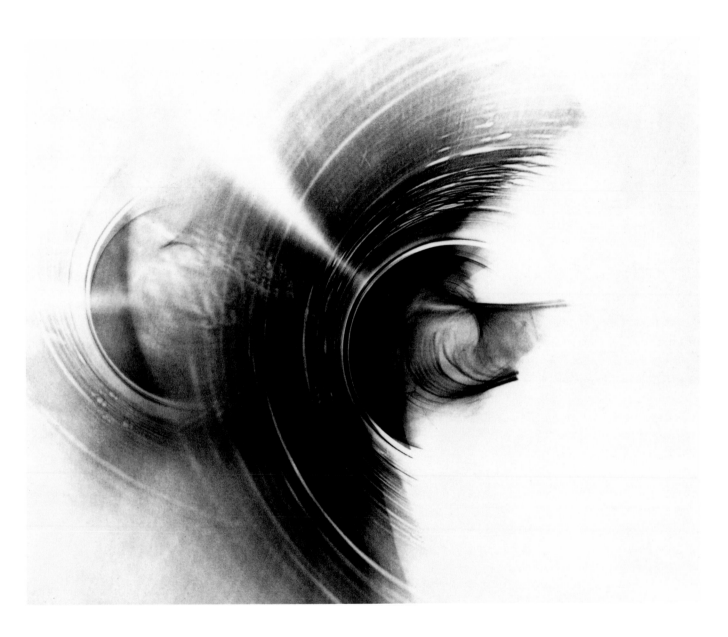

Plate 121
Photogenic
New York, between
1947 and 1955

"A Born Rebel and a Persistent Troublemaker"

"We ask you to do what you can to prevent the passage of the Mundt Bill. This is a bill for fascist countries and has no relation with the American way of life. It also gives one person the power to condemn people without process of law, a power not even granted to the president by the constitiution. This kind of legislation opened the way to Hitler, Mussolini and Franco and their fascistic governments. We think it is your sacred duty to do all you can against this bill."[239]

Eleanor Roosevelt
New York, 1944

This was the text of a telegram Lotte Jacobi and Erich Reiss addressed to Senator Ives in Washington, D.C., with copies sent to the House of Representatives, as well as the "New York Times" and the "New York Herald Tribune". This attempt, in 1948, to establish an official basis for the persecution of communist sympathizers and others denounced as "un-American" by pushing the "Mundt-Nixon Bill" through the senate ultimately failed. But it proved to be only the opening shot of a nationwide witchhunt — instigated by Sen. Joseph R. McCarthy of Wisconsin at the head of his Senate Committee for the Investigation of Un-American Activities.

Lotte Jacobi did well to stay away from active political involvement, even if it went against her deeply ingrained sense of justice. "The sheer accumulation of items — a signature on a peace petition, presence at a demonstration, receipt of left-wing literature... each innocuous in itself, invites the inference that the subject is subversive."[240] Based on criteria like these, even Lotte Jacobi's contacts from her Berlin days with people like Gustav Regler, Egon Erwin Kisch, or Hanns Eisler — whose music had so recently been labeled "un-German" and was now being called "un-American" — could have placed her newly won American citizenship in jeopardy. Just as dangerous was contact with "early anti-fascist behaviour"[241] which basically meant having sympathized with the Communist Party before 1933 — and was seen as fundamentally threatening to the interests of the state.

Albert Einstein had a reputation as a non-conformist and a bull-headed intellectual, and his unwavering vision of human

progress through knowledge was shared by Lotte Jacobi. Einstein himself came under suspicion in the paranoic atmosphere of the Cold War and was eventually denounced as a freethinker of the communist cast. He used his world renown and status as a German exile to encourage those summoned before the Committee to make use of their right to remain silent. Although by doing so they risked going to jail, they had made a public statement against the state's contempt for one of the individual's fundamental democratic rights.[242] Lotte Jacobi could hardly have ignored the grueling years of political harassment to which her American-born colleague, Margaret Bourke-White, was subjected.[243] The daily smear campaigns eventually reached such a point of hysteria that simple loyalty to Roosevelt's policies was enough to make a person suspect of being a communist.[244]

Lotte Jacobi never discussed the inquisatorial policies of America during the McCarthy era, and there are no documents which give a clear picture of her situation at that time, but she probabl experienced it as a bitter disappointment. The photographs of the people she herself sought out with her camera, however, provide eloquent testimony to her personal standpoint. Her fondness for Eleanor Roosevelt, a staunch defender of emigrants' rights in their host country, is manifested in her portrait of her — which, incidentally, she used to advertise her studio work for years afterward. She had spoken the former first lady at a Democratic party function and asked her to come for a studio sitting. One week later, Mrs. Roosevelt turned up at the studio unannounced and declared that she could only stay for twenty minutes. The impression she makes in the portrait is as spontaneous as it is unpretentious. Her candid smile and gesticulating hands are traces of a personal moment shared with the photographer.

Another of Lotte Jacobi's portraits which served at the same time as a political statement is the picture of the world-renowned actor and singer Paul Robeson. It was made at the height of the campaign waged against him by the Senate Committee for Un-American Activities. Robeson had been a leading figure in the fight against racial discrimination, fascism and human rights abuses in Europe and America for decades. For over nine years, Robeson was the victim of systematic persecution that eventually cost him his career as a performer. Lotte Jacobi's portrait expresses a palpable trust and solidarity between the photographer and her model, who would have been welcome in very few of New York's photo studios during those years. The double portrait of husband and wife, William DuBois and Shirley Graham (Ill. p. 196) is to be counted among the politically significant pictures. The couple were among the most influential Afro-American intellectuals. In 1950, Dubois, as president of the Peace Information Center, was one of the most outspoken critics of America's nuclear policy and, like Robeson, an opponent of its Cold War strategies. He was a victim of McCarthy-Era character-assassination tactics for years.

The political climate in the country at the beginning of the 1950s gave scarcely cause for optimism, and the new decade was to bring painful changes to Lotte Jacobi's personal life, as well, and once again put all her survival skills to the test. The death of Erich Reiss on May 8th, 1951, meant the end

Paul Robeson
New York, 1952

of one of the few happy relationships she had ever known. She found consolation in the circles of her artist friends and revived an idea she had dabbled with sporadically over the years: to support artists by making her studio available for public exhibitions of their work, as well as for her own photographs. The "Lotte Jacobi Gallery" developed into a respected venue, not only for such now largely forgotten artists as Rudi Lesser (pl. 102) and Ernest Gutemann, but also for Josef Scharl and Louise Nevelson. Lotte Jacobi had maintained her friendship with Scharl since their days in Munich, and, probably on one of her forays through New York City's galleries, she met Louise Nevelson at Nierendorf, where the sculptress had first presented her works to the public in an individual exhibition in 1940. The "intimate art gallery's"[245] exhibitions were well received in the daily papers and American art journals, and the drawings of Si Lewen even attracted the attention of the German press. Lotte Jacobi helped make a name for the young artist and his anti-war cycle *Parade*, made up of forty black-and-white drawings. She spared no effort to gain as much publicity as possible for the works of these mostly young artists with the help of the press, contacts with other exhibitors and galleries, and invitations with modern typographic design.

In April, 1955, with an exhibition of her *Photogenics*, she took leave of her friends, her gallery and, two months later, of New York itself. Once again, she sensed the time had come to take action before being overtaken by problems already appearing on the horizon. The loss of close friends and family — her mother had died in 1950, Josef Scharl in 1953 — coupled with the growing inhumanity of the city apparently gave her the final impetus to fulfill her long-cherished dream of a life in the countryside. The neighborhood where she had built a new life for herself over the last twenty years was torn down. The Rockefeller Center gouged out a large chunk of Manhattan, and the rents shot through the roof. Trying to earn a livelihood with photography had become even more difficult after the Second World War,

as the next generation came of age and sought new ways and means of photographic expression. The emigrants among the country's photographers began to fall by the wayside. A sense of melancholy accompanies a card with a verse by Karl Kraus sent to her by the lyric poet Mascha Kaleko on the occasion of Lotte Jacobi's farewell to New York:[246]

"Do not ask what I did all the while,
I'll pass you by;
And won't say why.
And the silence will set the Earth to boil.
Not a word did meet;
One speaks only in one's sleep.
And dreams of a sun which laughed.
But nothing remains;
In the end, t'was all the same.
The word passed on, when this world stirred to life."

Lotte Jacobi had no difficulty finding ways to occupy herself in her new living situation. At first, she moved in with her son John F. Hunter (pl. 125) and daughter-in-law Beatrice Trum Hunter, who had bought a house in the small, but spacious town of Deering in the middle of the forests of New Hampshire, and had plans to turn it into a bed-and-breakfast for summer guests. Lotte Jacobi had come here a number of times together with Erich Reiss to escape the summer heat in New York. But it must have taken a radical readjustment to settle permanently in the New England woods, surrounded by nature and only being able to communicate with other people across long distances. In March, 1956, she attended a town meeting for the first time and started down a path which was to give her life a new direction for the coming decades: political activity on a regional level, in particular as a lobbyist for the arts. Apparently, she found acceptance and developed the necessary toughness to defend herself in disputes with even the most hard-headed of opponents. "It wouldn't do to go away while the things that made town meetings unpleasant are not straightened out. And once they are, why go away? So we stay and fight it out."[247]

Left
Frank H. Bauer:
Lotte Jacobi in her studio
New York, 1953

Right
Lotte Jacobi Gallery
New York, 1954

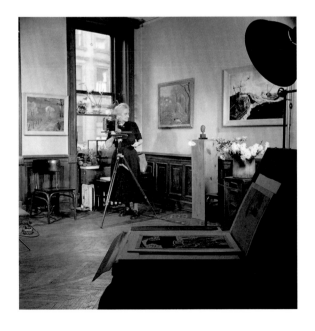

The first major museum exhibition dedicated to her work took place in 1959 at the Currier Gallery in Manchester. For many years afterward, she was to play a key role in shaping the gallery's policies. She now set herself the task of applying in New Hampshire what she had learned at the Museum of Modern Art in New York. Lotte Jacobi had the good fortune to find people who were open to her initiatives in the persons of Charles Buckley, the director during the sixties, and his successor, David S. Brooke. At her suggestion, an exhibition of the photographs of Berenice Abbott was held in 1960, and ten years later, a department of photography was established. She proposed the works of Paul Strand for the opening presenta-

New York, 1955

tion of a continuing series of photographic exhibitions to be held at the Currier Gallery, and in the years to follow, she had a say in collecting and exhibition policies in her capacity as honorary curator.[248] As a respected member of the New Hampshire Art Association, a state organization founded in 1940 to promote the arts, Lotte Jacobi successfully lobbied for the creation of a photography section. As a result, prizes were awarded to photographers for the first time in 1970, and as a member of the jury, she often rendered her verdict on their work.[249]

New England, though in many respects a rather conservative part of the country, also serves as a retreat for many artists and non-conformists fleeing the city. So it wasn't long before Lotte Jacobi found new friends and kindred spirits. Among them were Helen and Scott Nearing (pl. 126), firm believers in an alternative lifestyle who had fled to the countryside of Vermont back in the thirties, because their pacifist views were deemed unacceptable in the civil service.[250] It is easy to imagine Lotte Jacobi becoming friends with this couple with whom she could discuss the pressing issues of the day: war as a means of resolving conflict, the destruction of the environment, and the consumer society. Portrait assignments led to more acquaintances: in 1960, the Norton Publishers sent her to the essayist May Sarton, resulting in the development of a deep friendship and a particular admiration on the part of the author for the photographer. In 1959, Holt Publishers arranged a portrait sitting for

Plate 122
Robert Frost
Ripton, Vermont, 1959

Jacobi with the poet Robert Frost (pl. 122), chosen by John F. Kennedy to bless his term in office with the good graces of the arts. What encounter could have held greater fascination for Lotte Jacobi than one with the man who was said to have had a warm quilt sewn from all the silken caps he had received with his countless honorary doctorates? No doubt Lotte Jacobi primed herself for the meeting by reading the poet's nature verses and animal fables. She was accompanied by Beatrice Trum Hunter who, as a specialist in natural foods, could make interesting conversation with Frost, the farmer. But the photographer was to have a tough time of it with her dialogue, as the several dozen shots resulting from the session attest. Showing little interest in the photographic result, Frost assumed his usual place in an armchair at the window — with the light coming from behind.

Trees
Deering, N.H., no year

"His face is closed to the inquisitive eye. The light appears flat. … Jacobi circled Frost, trying his portrait from a standing position above him, kneeling below him…"[251]

She eventually managed to liven things up; Frost started to respond and smile. He stood up, asked her to accompany him into the garden, and began to hold forth. In addition to being a poet and a farmer, he was also a teacher, as the picture taken in a field on his property effectively demonstrates. Just at the moment when he made a point with finger raised, the photographer captured the harmonious image of a man in nature and, at the same time, the special character of this meeting.

For Lotte Jacobi, the encounter with Robert Frost was at one and the same time the opening shot for the eventful and restless sixties. This included a short interlude at the University of New Hampshire, Durham, from September 1961 to June 1962. She took lessons to brush up her French in preparation for a European tour with an extended stay in France. Inspired by her life in the midst of nature, she took a course in gardening and, convinced of the harmful effects of television on the development of creativity in young people, attended a seminar on the new mass medium, intending to learn about how broadcast schedules were conceived and shows were produced.

Once again, attention was being drawn to the political situation in the country, partly by the growing civil rights movement, but also by the first attacks by the U.S.A. against North Vietnam, still largely ignored in the mainstream press. Soon, demonstrations and sit-ins were being held all across North America and even in Western Europe, loudly protesting against U.S. policies in Southeast Asia. Lotte Jacobi spent half a year touring Europe before resuming her political activism on a regular basis, tirelessly bombarding the New Hampshire congressmen with the issues and problems of the region as well as of the entire country. Once again, the "born rebel and persistent troublemaker"[252], as she called herself, was ready to take on her political adversaries.

She took advantage of an offer by the Cunard Star Line to travel to France on the return ticket which had remained unused since her arrival in New York in 1935. She quite obviously planned an exhaustive itinerary for her six-month tour of Europe: to see her birthplace, Torun, once more, to look up old friends and acquaintances, now scattered all across Europe, to take part in a workshop by Stanley W. Hayter (pl. 123) for the purpose of enhancing her graphic printing skills, and to find a biographer for the life and publishing career of Erich

Reiss. Above all, she was looking for a museum which would exhibit her photographs in Germany. She found staunch allies in this cause in the person of Albert Renger-Patzsch (pl. 131) who especially appreciated Jacobi as a portrait photographer,[253] and Otto Steinert, the initiator of the legendary *subjektive fotografie* exhibition.[254] Even so, another ten years were to pass before she was to see the opening of her first individual exhibition in Germany, proposed by Fritz Kempe, at the Hamburg *Landesbildstelle* in 1972. Taking several weeks to travel through Italy, she at last fulfilled a dream which had gradually taken shape through her long-lasting preoccupation with the arts of the Western world.

Water
Deering, N.H., no year

Once back in New Hampshire, Lotte Jacobi moved into an apartment of her own in a former loggers' quarters on the Old County Road through Deering, which John Hunter had fixed up in her absence. Here, she set up another studio to revive her traditional art exhibitions along the same lines as those in New York. But this time, she placed emphasis squarely on photography. In 1963, she opened the first summer season with portraits and landscape photos Frances Hubbard Flaherty had made during the preparations for Robert J. Flaherty's various ethnographic documentary films. Alongside the younger generation of photographers, she brought in her old friend Minor White for a presentation of his *Three Sequences*; and she made a concerted effort to bring Albert Renger-Patzsch, until then scarcely known in America, to the attention of the public through an exhibition and contacts with various galleries.

Over and above the exhibitions in *Lotte Jacobi Place* and her political work with museums, an essential part of her conception for bringing photography closer to the public comprised her portraits of colleagues in the profession — an idea which she had already initiated during the forties (pls. 98, 100, 110, 111, 112) and which she continued in the sixties (pls. 127, 128, 129, 131). Holding fast to her own photographic style, she found a formulation which expressed something of her personal relationship to the subject for every portrait. Her shot of Edward Steichen, for example, taken in the courtyard of the Museum of Modern Art in New York (pl. 129), which she frequently visited to maintain her contacts with the museums, curators and galleries, is a humorous, tongue-in-cheek commentary on her part. She looks down upon the museum director "from on high" as he, assuming an unaccustomed pose, gazes upward — at Rodin's *Balzac*. Her portrait of Minor White (pl. 128) conveys a quite different relationship, as she moves in with the camera closer than she had ever done even for her early portraits from Berlin days.

The *sine qua non* of her photographic work appears as the expression of the photographer as an artist involved in a dialogue with the scientist. A prime example is her portrait of Erwin Panofsky (pl. 132). This takes on a key significance in Lotte Jacobi's later work, reflecting as it does the person of the photographer in many varied aspects and illustrating — yet again — the dialogue principle in her art of portraiture. Lotte Jacobi and Erwin Panofsky met

each other at his institute in Princeton at the beginning of 1966. The scholar had prepared for the photographer's visit as if for a state occasion. She found a way of putting herself in the picture, albeit indirectly, by placing a magazine with her photographs in Panofsky's hands. This photographic self-reference calls for an elaboration on Siegfried Krakauer's statement, "beneath a person's photograph, his history lies buried as under a blanket of snow",[255] to the effect that, beneath a person's photograph, the history of the person taking the photo also lies "buried". How much of Lotte Jacobi's story is concealed beneath the portrait of Panofsky? It had been her idea to photograph the art historian, who, after being named professor emeritus in 1962, was teaching at New York and Princeton Universities, while on one of her visits to New York City. By including *Foto Magazin* in the shot, she was, in effect, having one of the most prominent art scholars of the century pay tribute to her pictures through his contemplation of them. The magazine had presented Lotte Jacobi in the German-language press for the first time in 1965 with one *Photogenic*, a montage of a *Photogenic* and a dance shot, and a picture of the Rockefeller Center from the series "Romantic New York"[256].

The photo of Erwin Panofsky represents yet another variation, among her portraits of men in seated positions, such as the early one of Josef Scharl (pl. 4), of her father (pl. 1), and of Einstein in his leather jacket (pl. 91). The question of whether she did, in fact, have in mind the classical iconography of the scholarly portrait, which Panofsky had dealt with in his writings, taking Albrecht Dürer's *Erasmus of Rotterdam* as his example, remains an open question.[257] What is certain is that, since her first classes in art history at the academy in Poznan, her interest in the art of the Western world had never waned. Characteristic of her approach, even in absolute compositional stasis, is the "playful touch: Panofsky's right hand does not hold a writing utensil but a cigarette, and, Jacobi suggests, the carefully staged pictorial arrangement may crumble at any moment — when, for instance, the subject leans back, lights his cigarette, turns the page and makes a comment on what he has seen."[258] In a thank-you note, the renowned art historian gave Lotte Jacobi to understand in his own, subtle manner, that he thought she had captured his image of himself as the embodiment of the humanistically educated, old-world scholar; "Of course, one is not the best judge of one's own appearance, and in some cases I feel, probably without any justification, that I look a little more 'pathetic'. But the one where I am reading a magazine seem very excellent to me."[259]

In the mid-sixties, Lotte Jacobi experienced the first comprehensive retrospective of her work with over 300 pictures in the 303 Gallery in New York City. Included with portraits from Berlin, New York and Deering were the photogenics and, scattered here and there as they were in her body of work, a few cityscapes. With fifty prints, she accorded a special place in the exhibit to her journey through the Soviet Union. Photos of the exhibition as it was being set up show that she herself took an active part in the presentation. She arranged her photographs in a style resembling that of the *Family of Man* exhibition,[260] devoid of passe partouts, in formats especially suited to the layout of expansive photo walls. Lotte Jacobi's life's work in photography was finally given definitive recognition and an authoritative appraisal in the art world through the first exhibition to be accompanied by a catalogue,

Above
Rosalyn and Jimmy Carter
Washington, D.C., 1976

Below
Democratic National
Convention, 1976

Menschen von gestern und heute,[261] arranged by Otto Steinert at the Museum Folkwang in Essen in 1973. In 1979, a travelling exhibition, *Recollections: Ten Women of Photography*, a feminist-oriented project based in New York and organized by Margaretta Mitchell, spread the fame of Lotte Jacobi and nine other woman photographers throughout the U.S. The year before, in 1978, the first English-language catalogue was printed for the exhibition *Jacobi Place — Portrait of a Photographer*, including a tribute by the photographic historians Sally Stein and Ute Eskildsen. Lotte Jacobi's success as a photographer continued through the eighties, but she dedicated the greater part of her energy to communal politics. All of her efforts in this respect were driven by one and the same thought, to which she had held fast since her years in Berlin: the protection and exercise of democratic rights. She carried on an unrelenting struggle against America's war in Vietnam and never ceased to protest against the development of atomic energy, both on a regional and a global scale. Next to the front door of her house on the Old County Road, she put up a banner, visible from afar, saying: Deering Resident Supporting Nuclear ARMS FREEZE.

In 1990, deep in the woods of New Hampshire, on the property where Lotte Jacobi lived with John F. Hunter and Beatrice Trum Hunter from 1955 to 1962, she was laid to rest near her mother, Mia Jacobi, her husband, Erich Reiss, and her friend Ernst Fuhrmann.

Above
Frank H. Bauer:
Lotte Jacobi in the 303 Gallery's
exhibition halls, hanging her
photographs
New York, 1964

Below
Exhibition hall at the
303 Gallery
New York, 1964

Plate 123
Stanley W. Hayter
Paris, 1963

Plate 124
Ossip Zadkine,
Paris, 1963

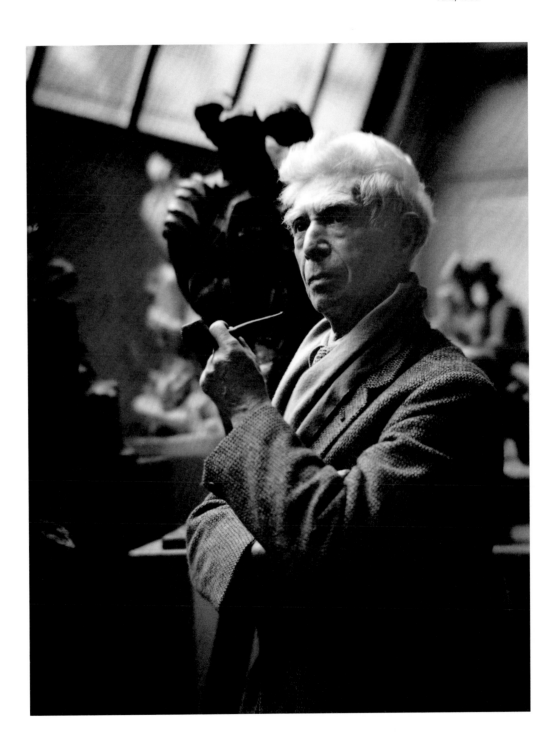

Plate 125
John F. Hunter
Deering, N.H., around 1955

Plate 126
Scott Nearing
Harborside, Maine, 1973

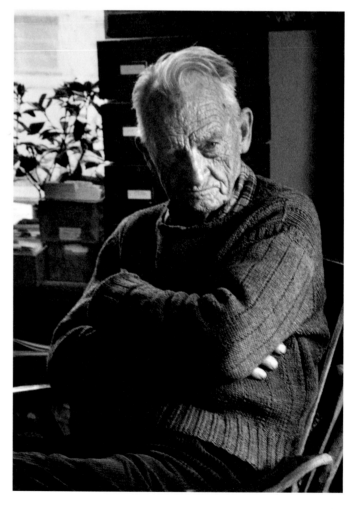

Plate 127
Paul Caponigro
Deering, N.H., around 1965

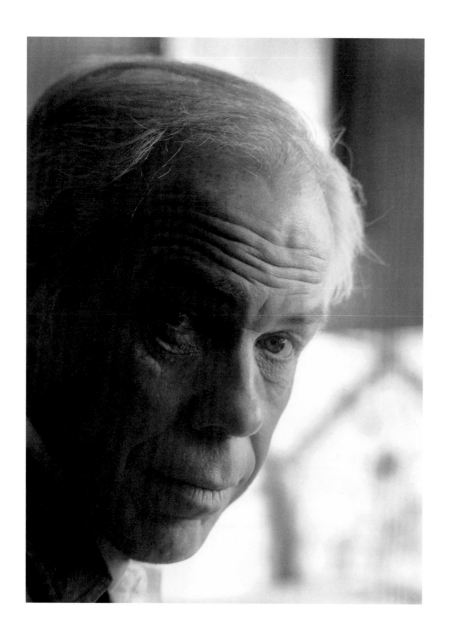

Plate 128
Minor White
Deering, N.H., 1965

Plate 129
Edward Steichen
New York, 1966

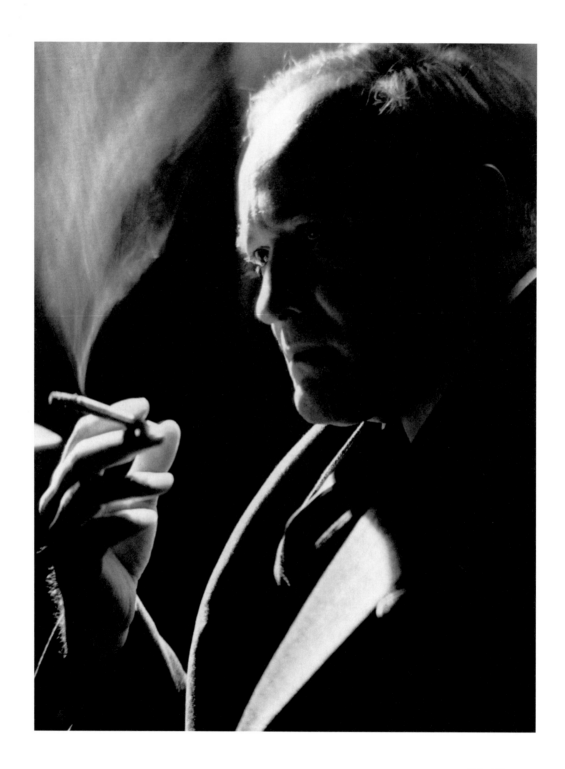

Plate 130
Leo Katz
New York, 1938

Plate 131
Albert Renger-Patzsch
Wamel, 1963

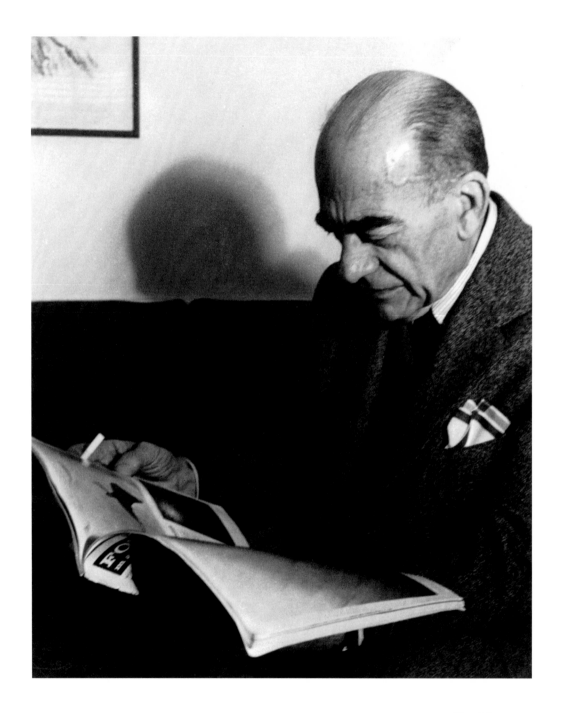

Plate 132
Erwin Panofsky
Princeton,
New Jersey, 1963
Warburg-Archiv,
Hamburg

Plate 133
Robert Frost
Ripton, Vermont, 1959

Notes

Unless indicated otherwise, all quotations are taken from conversations between the authors and Lotte Jacobi, which took place in Deering, NH, U.S.A., in October, 1984. Quotations originally in German have been translated by the translator of the respective chapter.
The abbreviation "LJA" has been adopted for the Lotte Jacobi Archives, Special Collections, a part of her estate; and "UNH" for the University of New Hampshire, Durham, NH, U.S.A.

Four Generations of the Atelier Jacobi

1. Jacobi family tree. Manuscript handwritten by Lotte Jacobi, LJA, UNH.
2. Curriculum vitae written by Lotte Jacobi herself on August 24, 1933, on stationery with the heading "folkwang archiv", LHA, UNH.
 In an 1866 edition of the *Allgemeiner Wohnungs-Anzeiger* in the Torun city archives, Samual Jacobi is mentioned as a master glazier. This information was passend on to the authors by Dr. Tadeusz Zakrzewski, Torun in a letter of April 19, 1966.
3. The Torun city address books mention the Atelier Alexander Jacobi for the first time in 1866 at Auf der Bache 48; starting in 1869 at Mauerstr. 371; in 1872, A. Jacobi bought the property at Mauerstr. 368/369; when a new address system was introduced in 1888, it was given the numbers 50/52; Lotte Jacobi was born in apartment house No. 50; the glass-roofed studio was located in No. 52. An Atelier Julius Jacobi is entered for Elisabethstr. 16 in 1912 (owned by Willi Gordon, a brother-in-law of Julius Jacobi; a studio in Thorn-Podgórz, Magistratstr. 95c is entered under Julius Jacobi in 1919; the information is taken from a conversation between the authors and Dr. Tadeusz Zakrzewski, Torun, Feb. 18, 1996.
4. Cf., Tadeusz Zakrzewski, 'Pionierzy Torunskiej Fotografii 1843-1868' (Pioneers of Photography in Torun), in *Torunski 21/1992* (Torun yearbook No. 21/1992); 'Pioneers of Photography in Torun (1869-1899)' in *Torunski 23/1996*.
5. Marian Arszynski and Tadeusz Zakrzewski, 'Torun — Miasto i Ludzie na dawnej Fotografii (do 1939 roku), (Torun — the town and people in old photographs (to 1939), in Polish, Engl., Germ., Torun, 1995. The Atelier Alexander Jacobi made the photos on pp. 27, 48, 49, 51 (Willi Gordon), 53.
6. Cf., Timm Starl, 'Die Rückseite' in *Fotogeschichte*, No. 2, 1981, p. 23.
7. The locations of the Atelier Sigismund Jacobi in Poznan were: 1895, At. Winetka; 1898-1905, Friedrichstr. 25; 1905-1917, Berlinerstr. 4; 1917-1921, Victoriastr. 19. Information given to the authors by Magdalena Mrugalska-Banaszak, Director of the Poznan City Historical Museum, 1992.
8. Op. cit., note 6, p. 25.
9. See note 6, p. 18.
10. Tilla Durieux, 'Meine ersten neunzig Jahre, Reinbek bei Hamburg. 1974, p. 16.
11. Cf. Margaretta Mitchell, 'Lotte Jacobi' in, *Recollections: Ten Women of Photography*, New York, 1980, p.140. An uncle of Lotte Jacobi's worked as a photographer in London. In addition to photography, Lotte Jacobi intended to learn by English.
12. This wedding photo is by Sigismund Jacobi; from

l. to r.: Mia Jacobi, Sigismund Jacobi, Josef Honig, Mrs. Honig, Willi Gordon, Hannchen Gordon, Hertha Fromholz (in front), Irma Honig, unknown, Ruth Baruch, Ruth Jacobi (in front), Helene Honig (behind), Pauli Schwalbe, Claire Schwalbe, Ludwig Honig, Alfred Schwalbe, Lotte Jacobi, children with Bemchen, Siegbert Fritz Honig, Josef Lublinski, Alexander Jacobi, Mr. Honig, Adolph Baruch, Meta Baruch, child Gordon.

"Forget the idea you can already do something"

13. The school was founded and chartered in 1900 by the royal Bavarian state government as the teaching and research facility of the Southern German Photographers' Association in Munich. The school was transferred to state control on July 1, 1921, and renamed the Staatliche Höhere Fachschule für Phototechnik. On May 1, 1922, its cinematography department was attached to the German Film School. In 1928, it was once again renamed the Bayerische Staatslehranstalt für Lichtbildwesen. In 1935, the cinematography department was dissolved by order of the Ministry of People's Education and Propaganda. Today, the school is called the Bayerische Staatslehranstalt für Photographie.
14. Ute Eskildsen, 'Die Kamera als Instrument der Selbstbestimmung', *Fotografieren hieß teilnehmen. Fotografinnen der Weimarer Republik*, exhibition catalogue, ed. Ute Eskildsen, Düsseldorf, 1994, p. 17.
15. Atina Gossmann, 'Berufswahl — ein Privileg der bürgerlichen Frauen', *Fotografieren hieß teilnehmen. Fotografinnen der Weimarer Republik*, exhibition catalogue, ed. Ute Eskildsen, Düsseldorf, 1994, p. 11.
16. Cf. Dr. Lilly Hauff, *Der Lette-Verein in der Geschichte der Frauenbewegung*, Berlin, 1928.
 Doris Obschernitzki, 'Der Frau ihre Arbeit!', *Lette-Verein 1866-1986*, Berlin 1987.
17. Dieter Hinrichs, 'Die Geschichte der Photoschule 1', *Lichtblick 2 — Informationsblatt der Freunde und Förderer der Bayerischen Staatslehranstalt für Photographie München*, Feb. 1985, o.p.
18. Dieter Hinrichs, 'Die Geschichte der Photoschule 2', *Lichtblick 3 — Informationsblatt der Freunde und Förderer der Bayerischen Staatslehranstalt für Photographie München*, Feb. 1986, o.p.
19. Op. cit., note 17.
20. Dieter Hinrichs, 'Die Geschichte der Photoschule 4', *Lichtblick 5 — Informationsblatt der Freunde und Förderer der Bayerischen Staatslehranstalt für Photographie München*, Feb. 1988, o.p.
21. Op. cit., note 20.
22. Op. cit., note 20.
23. Viktor Inglstedt, 'Geeigneten-Auslese im Lichtbildberuf', *Der Photograph*, vol. 1926, No. 81, p. 321.
24. Op. cit., note 20.
25. Cf., Rudolf Müller-Schönhausen, 'Stuttgarter Betrachtungen mit Streiflichtern an die Münchener Schule, *Der Photograph*, vol. 39, 1929, No. 53, pp. 209-10.
 Rudolf Müller-Schönhausen, 'Auf der Suche', *Der Photograph*, vol. 39, 1929, No. 60, p. 237.
 Hanna Seewald, 'Sachlichkeit in der Porträtphotographie', *Der Photograph*, vol. 39, 1929, No. 66, pp. 261-2.
 Rudolf Müller-Schönhausen, 'Über Portraitaufnahmen', *Der Photograph*, vol. 39, 1929, No. 71, pp. 281-2.
 Hanna Seewald, 'Gestern und Heute', *Der Photograph*, vol. 39, 1929, No. 88, p. 349.
26. Willi Warstatt, 'Wo stehen wir?' *Der Photograph*, vol. 39, 1929, No. 72, p. 285.
27. Cf. Susanne Meyer-Büser, 'Die Krise des Porträts in der Weimarer Republik', *Bubikopf und Gretchenzopf — Die Frau der 20er Jahre*, Heidelberg 1995, pp. 62ff.
 Cf. Hans Jürgen Buderer and Manfred Fath, 'Das Bild des Menschen', *Neue Sachlichkeit*, exhibition catalogue, Mannheim, 1995, pp. 149ff.
28. Cf. Enno Kaufhold, *Bilder des Übergangs — Zur Mediengeschichte von Fotografie und Malerei in Deutschland um 1900*, Marburg, 1986, pp. 65ff.
29. Graphikus, 'Zur Frage der weich-unscharfen Abbildung', *Der Photograph*, vol. 1927, No. 43, p. 169.
30. Cf. Ute Eskildsen and Jan-Christopher Horak, *Film und Foto der zwanziger Jahre*, exhibition catalogue, Stuttgart, 1979. The development of photography

as represented in the exhibitions of the twenties is dealt with in the essay, 'Fotokunst statt Kunstphotographie', by Ute Eskildsen, pp. 8-25.
31. Cf. Dieter Hinrichs, 'Hanna Seewald — Photographin und Pädagogin', *Hanna Seewald*, exhibition catalogue, Bayerische Staatslehranstalt für Photographie, Munich, 1989.
32. Susanne Baumann, 'Der Weg über Schulen', *Fotografieren hieß teilnehmen, Fotografinnen der Weimarer Republik*, exhibition catalogue, ed. Ute Eskildsen, Düsseldorf, 1994, p. 36.
33. James A. Fasanelli, 'Lotte Jacobi: Photographer', *Lotte Jacobi*, Danbury, NH, U.S.A., 1978, p. 14.
34. Cf. Ulrich Pohlmann, 'Schönheit ist Seele', *Frank Eugene — The Dream of Beauty*, Munich, 1995, p. 68.
35. Cf. Paul Strand, 'Rebecca, 1912', *Lichtbildnisse — Das Porträt in der Fotografie*, ed. Klaus Honnef, Cologne, 1982, p. 165.
36. Klaus Honnef, 'Das Porträt im Zeitalter der Umbrüche', *Lichtbildnisse — Das Porträt in der Fotografie*, ed. Klaus Honnef, Cologne, 1982, p. 583.
37. Cf. 'Deutsche Filmschule in München', *Die Kinotechnik*, vol. 4, 1922, No. 17, pp. 653-60.
 cf. Dr. Rolle, 'Staatliche Höhere Fachschule für Phototechnik in München, Jahrbuch 1925', *Die Kinotechnik*, vol. 8, 1926, No. 4, pp. 108-9.
 The integration of the German Film School's cinematography department into the State Higher Academy for Photo-technology was a decision taken by the government in an effort to cut costs by re-locating the training of the technical personnel for the film industry to a facility which already included the basics — photography — in its curriculum. Trained photographers were allowed to start in the cinematography department in their third semester.
38. See note 11, p. 141.
39. Cf. Lotte Jacobi's terms' report from the Staatliche Höhere Fachschule für Phototechnik, LJA, UNH. Subjects covered in the photography course were: shooting technique, positive and negative retouching, enlarging, drawing, photochemistry and optics, electronics and accounting; in the cinematography department: cine-technology, photo-technology, photochemistry, photo-optics, electronics, commercial law, cinematography, film processing and treatment, film projection, photographic shooting technique, photographic printing techniques and drawing.
40. Cf. 'Etwas, das herausfordert... wie ein Negativ', interview with Lotte Jacobi conducted in 1977 by Ute Eskildsen and Sally Stein, in *Lotte Jacobi 1896-1990 Berlin — New York — Deering*, exhibition catalogue, Museum Folkwang Essen 1990, pp. 6-7.

Atelier Berlin

41. Karl-Heinz Metzger and Ulrich Dunker, *Der Kurfürstendamm*, Berlin, 1986, p. 114.
42. See note 14, p. 21.
43. Lotte Jacobi in a conversation with Eckhart Gillen and Elisabeth Moortgat in Berlin on September 18, 1983 (video recording, care of Museumspädagogischer Dienst, Berlin)
44. After studying photography at the Lette Association 1920-1922, Ruth Jacobi (1899-1996) passed her journeyman's examination in the Berlin Chamber of Trade, worked for a short time for a studio in Hoerde, Westphalia in a managerial capacity, then came to work in her father's studio in Berlin. She started taking photos with a Leica in 1927. The same year, she married and emigrated to the U.S., returning to her father's studio in 1931. Ruth Jacobi left Germany together with her second husband, Szolt Morris Roth, in 1935. For one year, she ran a studio together with Lotte Jacobi in New York. From 1950 on, she took lessons in painting from Zoltan Hecht and Hans Hofmann before taking up photography again in 1973. This information comes from a curriculum vitae writen by Ruth Jacobi herself, now in the photographic collection of the Museum Folkwang, Essen.
45. See note 40, p. 7.
46. The photographer Elisabeth Röttgers in a conversation with the authors in Wiesbaden, Sept. 1, 1985, and May 6, 1988.
47. See note 40, p. 7.

48. Cf. *Unsere Flimmerköpfe — ein Bildwerk vom deutschen Film*, ed. Leopold Freund, 2nd edition, Apr., 1929, Berlin, 1929. More than a quarter of the approx. 450 photos came from the Atelier Jacobi.

49. *Porza*, vol. 1, No. 2-3, 1929.
Kunst der Zeit — Organ der Künstler-Selbsthilfe, vol. II, Nos. 7 and 10, 1928.

50. Cf. Hans Spörl, 'Ist eine Kundenwerbung in jetziger Zeit zweckmäßig und durchführbar?', *Der Photograph*, vol. 37, 1927, No. 89, p. 353.
Cf. 'Über Kundenwerbung in der Photographie', *Der Photograph*, vol. 37, 1927, No. 97, p. 385.

51. The photographer Ilse Siebert in a conversation with the authors in Berlin-Nikolassee, Jan., 1989. After studying at the Lette school, 1927-1930, Ilse Siebert was an assistant at the studio of photographer Steffi Brandl, Kurfürstendamm 211.

52. From about 1925 on, the photos from the Atelier Jacobi are stamped on the reverse "Atelier Jacobi". The earliest photograph taken in Berlin known to us, with the credit "Atelier Jacobi" handwritten on the reverse, is a protzrait in two different typographical versions. The earliest photo taken in Berlin known to us, with the credit "Atelier Jacobi" handwritten on the reverse, is a portrait of Albert Einstein (1921), now in the Ullstein picture archive, Berlin. After 1927, Sigismund Jacobi apparently seldom took photographs himself. From 1925 to 1927, Lotte Jacobi was in Munich, and from 1923 to 1927, her sister, Ruth Jacobi, worked with their father, but was not in Berlin from late 1927 to late 1930. Only when Lotte Jacobi was away on her trip through the U.S.S.R. did she return to manage the business from 1932 to February, 1933. Ruth Jacobi specialized mainly in fashion photos and still lifes. From 1929 to 1931, Elisabeth Röttgers took care of marketing and archiving, served as Lotte Jacobi's assistant, took on the odd portrait sitting and photographic work in the studio. The photographer Willi Gordon, an uncle of Lotte Jacobi's, was sent on some of the field assignments, to ambassadors and diplomats, for example. Other employees were responsible for the positive and negative refinishing and the work in the darkroom. It is therefore not possible to trace the authorship with absolute certainty by the studio stamp. By process of elimination, considering times of absence and presence, Lotte Jacobi's authorship can only be surmised. The great majority of the photos from late 1927 to late 1930 were taken by Lotte Jacobi herself. Photos hand-signed "Jacobi" directly on the negative are by Lotte Jacobi and originated in the period up to 1935. As far as is known, those hand-signed "Lotte Jacobi" date from her time in the U.S.A.

53. Kurt Korff, 'Die Berliner Illustrirte', *50 Jahre Ullstein 1877-1927*, ed. Max Osborn, Berlin, 1929, pp. 291-92.

54. See note 40, p. 8.

55. The actress Steffie Spira in a conversation with the authors in Berlin-Mitte, 1990.

56. Eckhardt Köhn, *Sasha Stone, Fotografien 1925-31*, exhibition catalogue, Berlin, 1990, p. 13.
In 1927-28, Erwin Piscator worked with the theater photographer, Sasha Stone, who not only documented his productions, but also got involved in scene design and photo-montage work with Piscator's theatre team. Piscator had given Lotte Jacobi permission to take pictures freely in his theaters. She remembered receiving permission from the director after she had given him several of her photos; but she was not bound to any agreement.

57. *Die Fackel*, vol. XXXII, Nos. 838-844, Sept. 1930, p.48.

58. Ernst Fuhrmann, *Neue Wege*, second collected edition, 10 vols., Hamburg 1954-1983.

59. See note 46.

60. In September, 1983, Lotte Jacobi told Janos Frecot, director of the Berlinische Galerie's photographic collection, that she had taken these photos of rocks now in the archive of *Volk und Welt*.

61. Letter to Lotte Jacobi from Ernst Fuhrmann, dated Mar. 31, 1932, LJA, UNH.

62. Cf. Ernst Fuhrmann, *Neue Wege*, vol. 10, Hamburg 1983, p. VI. Albert Renger-Patzsch worked from about 1920-23 with and for Ernst Fuhrmann. Fuhrmann introduced him to the world of nature, in particular that of plants. Renger-Patzsch later said that Fuhrmann had tought him how to see.

63. Cf. Marion Beckers, *Else Thalemann. Industrie- und Pflanzenphotographien der 20er und 30er Jahre*, exhibition catalogue, Das Verborgene Museum, Berlin, 1993.

64. Eberhard Roters, 'Künstlerfreunde', *Hannah Höch, Eine Lebenskollage 1921-1945*, vol. II, Ostfildern-Ruit, 1995, p. 247.

65. Cf. Christiane Barckhausen, *Auf den Spuren von Tina Modotti*, Cologne, 1988, pp. 266ff.

66. See note 33, p. 15.

67. Susan Butler, 'So how do I look' as quoted in: Monika Faber "Selbstfoto", Fotografieren hieß teilnehmen... p. 282.

68. Gary Samson, unpublished manuscript, Lotte Jacobi Archives, Photographic Services, University of New Hampshire,o.p.

69. Cf., *Fotografieren hieß teilnehmen, Fotografinnen der Weimarer Republik*, exhibition catalogue, ed. Ute Eskildsen, Düsseldorf, 1994, pp. 217/318.

70. Cf. the list of periodicals with photo prints from the Atelier Jacobi compiled and reviewed for the purposes of this publication.

71. See note 46.

72. See note 41, p. 141.

73. Letter to Lotte Jacobi from Margarete Kaiser, dated July 15, 1964, LJA, UNH.

74. See note 46.

75. *Die Funkwoche* was published by the Szaro Verlag in Berlin-Schöneberg from 1926-1941.

76. *Die schaffende Frau — Zeitschrift für Modernes Frauentum*, ed. Margarete Kaiser, Verlag Joachim Kaiser, Berlin, bibliographical listings from No. 1, Oct. 1929 to No. 3, vol. 3, June, 1932. until Apr. 1931, all cover portraits were made by the Atelier Jacobi; the Nos. from Apr. 1931 to Mar. 1932 could not be traced (ceased publication may have); the covers for Apr. 1932, No.1, vol. 3, and June, 1932, were again provided by the Atelier Jacobi.

77. *Der Künstlerische Tanz*, paste-in picture album for 312 dance photos, Eckstein-Halpaus GmbH, Dresden, no year (1933).

78. *Berliner Illustrierte Woche*, vol. 13, No. 49, rear cover.

79. Cf. Marion Beckers and Elisabeth Moortgat, 'Neue Lebensqualität oder unpersönliches Zweckdesign — Zu einer Photo-Serie aus dem "Atelier Jacobi"', *Photo-Sequenzen, Reportagen, Bildgeschichten, Serien aus dem Ullstein Bilderdienst von 1925 bis 1944*, exhibition catalogue, Haus am Waldsee, Berlin, 1992, pp. 45-51, 86/7.

80. 'Das Heim Piscators', text by Hildegard Piscator, photos by Lotte Jacobi (2) and Sasha Stone (6), *Die Dame*, vol. 55, No. 14, Apr. 1928, pp. 10-12.

81. Cf. Rolf Sachsse, *Lucia Moholy*, Düsseldorf, 1986, p. 30.

82. 'Haus Lewin', series of seven photos, unpublished, Ullstein picture archive, Berlin.

83. So far, no study of the still photo in the German and American photo journals of the twenties to the forties has been made. For an evaluation of photo journals from the standpoint of photographic and media history, please refer to: Ute Eskildsen, *Fotografie in deutschen Zeitschriften 1924-1933*, Institut für Auslandsbeziehungen, Stuttgart, 1982. *Die Gleichschaltung der Bilder — Zur Geschichte der Pressefotografie 1930-36*, ed. Diethart Kerbs, Walter Uka, Brigitte Walz-Richter, Berlin, 1983. Bernd Weise, 'Pressefotografie Teil I-V', *Fotogeschichte*, vol. 9, 31/1989; vol. 9, 33/1989; vol. 10, 37/1990; vol. 14, 52/1994; vol. 16, 59/1996. Marianne Fulton, *Eyes of Time, Photojournalism in America*, Boston, Toronto, London, 1988.

84. 'Zeitgestalten (II): Der Funker', Phot. Ullstein, *BIZ*, vol. 38, No. 4, Jan. 2, 1929, title page. 'Zeitgestalten (III): Der Sportler', Phot. Riebicke, *BIZ*, vol. 38, No. 10, Mar. 10, 1929, title page.

85. Rudolf Arnheim, *Kritiken und Aufsätze zum Film*, Munich/Vienna, 1977, p. 289.

86. Ute Eskildsen, *Fotografie in deutschen Zeitschriften*, Institut für Auslandsbeziehungen, Stuttgart, 1982, p. 13.

87. 'Das fesselnde Männergesicht', *UHU*, vol. 7, No. 6, Mar. 1931, pp. 9-16.

88. *Unsere Zeit in 77 Frauenbildnissen*, Niels Kampmann Verlag, no year, (approx. 1930) o.p.; Atelier Jacobi: Elsa Wagner and Paula von Rezniczek.

"My Style Is the Style of the People I Photograph"

89. Marilyn Myers Slade, 'Lotte Jacobi', *New Hampshire Profiles*, vol. 36, No. 1, Jan. 1987, p. 38.

90. Vicki Goldberg, 'Lotte Jacobi', *American Photographer*, Mar. 1979, p. 24f.

91. Cf. Hellmuth Karasek, 'Lotte Jacobi oder die kritische Unschuld', *Menschen von gestern und heute. Fotografische Portraits, Skizzen und Dokumentationen von Lotte Jacobi*, exhibtion catalogue, Museum Folkwang Essen, 1973, p. 6f.

92. Thomas Medicus, 'Die Krise des Subjekts', *Der Tagesspiegel*, July 30, 1995, p. 21.

93. Enno Kaufhold, 'Hugo Erfurth — Am Anfang der Karriere. Die Professionalisierung der künstlerischen Bildnisphotographie', *Hugo Erfurth (1874-1948), Photograph zwischen Tradition und Moderne*, catalogue, Cologne, 1992, p. 35.

94. Peter Gay, *Die Republik der Außenseiter*, Frankfurt am Main, 1987, p. 171.

95. See note 36, p. 572.

96. Ernst von Niebelschütz, 'Verfall der Porträtkunst', *Deutsche Kunst und Dekoration*, vol. 59, 1927, March. No. as quoted in: Susanne Meyer-Büser, 'Die Krise des Porträts in der Weimarer Republik', *Bubikopf und Gretchenzopf — Die Frau der 20er Jahre*, Heidelberg 1995, p. 64.

97. See note 36, p. 582.

98. 'Einstein mit seiner Segeljacht am Wannsee', *Berliner Illustrirte Zeitung*, vol. 1929, No. 32, p. 1446.

99. Ulrich Keller, 'Die deutsche Portraitfotografie von 1918 bis 1933', *Kritische Berichte*, vol. 5, No. 2/3, Marburg, 1977, pp. 41ff.

100. Ibid., p. 42.

101. Cf. Hubertus Gassner, *Rodcenko Fotografien*, Munich 1982, p. 61.

102. Cf. Herbert Molderings, *Umbo — Otto Umbehr 1902-1980*, Düsseldorf, 1995, pp. 63ff.

103. Cf. note 36, p. 585.

104. See note 35.

105. Cf., *Gisèle Freund, Photographer*, New York, 1985.

106. Ute Eskildsen and Sally Stein, 'The German Years of Lotte Jacobi', *Jacobi Place, Portrait of a Photographer*, exhibition catalogue, Manchester, NH, U.S.A. 1977, o.p.

107. Georg Simmel, 'Die ästhetische Bedeutung des Gesichts', ders., *Das Individuum und die Freiheit*, Stuttgart, 1984, p. 142.

108. Cf. note 102, p. 54 and pl. 3.

109. See note 46.

110. Peter Panter (i.e. Kurt Tucholsky), 'Neues Licht' (1930), *Das Deutsche Lichtbild Jahresschau 1930*, Berlin, 1929, o.p.

111. Cf. letter to Lotte Jacobi from Lotte Lenya dated Sept. 19, 1979, LJA, UNH.

112. Cf. note 102, p. 62. Moldering's supposition that Lotte Jacobi may have had in mind Umbo's likeness of Ruth Landshoff, printed in *Querschnitt*, when she made her portrait of Lotte Lenya runs counter to the interaction of the photographer with her models, especially under the circumstances of an official photo session, in which the photographer would scarcely have the opportunity to ask her subjects to assume a certain position. Instead, this frequently reccuring pose in portraits of women could be seen as characteristic of the so-called New Woman in its contrasting of alacrity and distance.

113. A., 'Das gemeinsame Gesicht', *Berliner Illustrirte Zeitung*, Feb. 9, 1930, vol. 39, No. 6, p. 205.

114. Quoted from Uwe Naumann, *Klaus Mann*, Reinbek bei Hamburg, 1984, p. 41.

The Camera as an Admission Ticket — Theater Photographs

115. Several photos are to be found in the archives — hitherto only partially catalogued — of university theater department collections: Theaterwissenschaftliche Sammlung, University of Cologne, Theaterwissenschaftliche Sammlung of Berlin University, Stiftung Archiv der Akademie der Künste Berlin, Theatersammlung of the Berlin City Museum Foundation, etc.

116. Cf. Claudia Balk, *Theaterfotografie*, Munich, 1989. *'Auf Wiedersehn hier u. dort'* — Bühnenkünstler auf frühen Photographien (Carsten Niemann and Ludwig Hoerner), exhibition catalogue, Prinzenstraße, No. 3, Hannover, 1994.

117. Cf. note 56.
118. Claudia Balk, *Theaterphotographie*, Munich, 1989, pp. 78ff.
119. The collections of Carl Niessen (Cologne), Walther Unruh (Berlin) and Dr. Robert Steinfeld (Cologne) have been integrated into the local theater department collections.
120. See note 40, p. 7.
121. Gisèle Freund, *Photographie und Gesellschaft*, Munich, 1986, p. 126.
122. Till, 'Momentphotographie im Theater', *Das Theater*, vol. VI, No. 1, Jan., 1925, pp. 17-18.
123. Fritz Hansen, 'M.M.', (Muster-Messe Leipzig), *Der Photograph*, 1925, No. 19, p. 73.
124. Dr. Hans Böhm, 'Neue Wege der Photographie auf der Bühne', *Photographische Korrespondenz*, 1926, vol. 62, No. 4, pp. 198/199.
125. Dr. Hans Böhm, 'Ein Spezialapparat für die Theaterphotographie während des Spiels', *Photographische Korrespondenz*, 1927, vol. 63, No. 12, pp. 379ff. Hans Böhm writes of his experiences with the Ermanox 9 x 12 cm.
126. Trude Fuld, 'Noch ein Paar Worte über Theaterreportage', *Gebrauchsphotographie*, No. 9, 1933, p. 77.
127. See note 124, p. 199.
128. Erwin Piscator, *Das politische Theater*, revised version of the 1929 edition, Reinbek bei Hamburg, 1979. p. 235.
129. Klaus Völker, 'Klaus Richter portraitiert Schauspieler', in; Marcus Bier, *Schauspielerportraits*, Berlin, 1989, p. 6. The uncredited photo of Max Reinhardt on the cover is by Lotte Jacobi and was taken in New York in 1936.

Dance — Photography — Motion

130. Cf. on dance photography: William A. Ewing, *The Fugitive Gesture*, London, 1987. *Tanz: Foto, Annäherungen und Experimente 1880-1940*, ed. Monika Faber, exhibition catalogue, Vienna, 1990. Gisela Barche and Claudia Jeschke, 'Bewegungsrausch und Formbestreben', *Ausdruckstanz*, Wilhelmshaven, 1992, pp. 317 — 346. Hedwig Müller and Patricia Stöckemann, '… jeder Mensch ist ein Tänzer…', *Ausdruckstanz in Deutschland zwischen 1900 und 1945*, exhibition catalogue, Giessen, 1993. Claudia Rosiny, 'Tanz und Fotografie. Berührungspunkte von Bewegung und Bild', *Tanzdrama*, No. 20, 1994.
131. Cf. Siegfried Krakauer, 'Die Jupiterlampen brennen weiter', (1926), ders: *Der Verbotene Blick*, Leipzig, 1992, p. 288ff. Cf. René Clair, *Vom Stummfilm zum Tonfilm*, Munich, 1952, p. 27.
132. Ann Parson, 'Lotte Jacobi, Camera Artist', *Boston Sunday Globe*, New England, Oct. 16, 1977, p. 64.
133. Janos Frecot, 'Einführung', *Sprung in die Zeit*, exhibition catalogue, Berlinische Galerie, Berlin, 1993, p. 13.
134. Arnold Genthe, *The Book of the Dance*, incl. the essay 'On with the Dance', by Shaemas O'Sheel (first edition: Boston, 1916), Boston, 1920.
135. Cf. Frank-Manuel Peter, 'Das tänzerische Lichtbild', *Hugo Erfurth (1874-1948), Photograph zwischen Tradition und Moderne*, ed. Bodo von Dewitz and Karin Schuller-Procopovici, Cologne, 1992, pp. 45-62.
136. Cf. Charlotte Rudolph, 'Tanzphotographie', *Schrifttanz*, vol. 2, 1929, p. 28f. 'Das tänzerische Lichtbild', *Tanzgemeinschaft*, 1930, pp. 4-6. 'Tanz-Photographie', *Photographik*, Jan. 1937, No. 14, p. 1ff.
137. Ibid., Charlotte Rudolph, 'Tanzphotographie', 1929, pp. 28-9.
138. Ibid., p. 29.
139. Cf. Marion Beckers, 'Virtuosität des Augenblicks — Photographinnen sehen Tänzerinnen', *Frauen Kunst Wissenschaft*, No. 14, Oct. 1992, pp. 43-53.
140. Kelly Wise, 'Lotte Jacobi', *Portrait: Theory*, New York City, 1981, p. 94.
141. Ibid.
142. László Moholy-Nagy, *Malerei Fotografie Film*, Bauhausbücher No. 8, Munich, 1925, Reprint, Berlin, Mainz, 1967, pp. 52-3.
143. Jo Hanns Rösler, '"Artisten" in Wien', *Das Theater*, vol. X, No. 8, Apr., 1929, p. 185.
144. 'Louis Douglas', *UHU*, vol. 5, No. 3, Dec., 1928, p. 44.
145. 'Vera Skoronel', *Tempo*, vol. 3, June 18, 1930.

Seeing the Soviet Union with One's Own Eyes

146. This poster is filed in the German Federal Archives under: Plak 2/16/78. Other versions were also printed with Jacobi's photos.
147. Cf. note 40, p. 8.
148. Cf. *Lotte Jacobi — Rußland 1932/33. Moskau, Tadschikistan, Usbekistan*, ed. Marion Beckers and Elisabeth Moortgat, Berlin, 1988.
149. The Society of Friends of the New Russia was founded in 1921 and published a quarterly review, *Das Neue Rußland*, from 1923 to 1932, with travel reports, news and editorials by such writers as Alfred Döblin, Egon Erwin Kisch, Berta Lask, Ernst May, Anna Seghers and Bruno Taut, etc. It also dealt — from a critical perspective — with the economic situation in the Soviet Union, the construction of mass housing, cultural policy, nationality issues, the first five-year-plan, etc.
150. Cf. the correspondence between Lotte Jacobi and Max Hoelz while he was staying in Moscow and during the time before and after Mia Jacobi's trip to Moscow in Feb. 1931. Max Hoelz Archiv, Stiftung Archiv der Parteien und Massenorganisationen der DDR in the German Federal Archives (the former Institut für Marxismus und Leninismus IML), Berlin. Hoelz took care of the organization for Mia Jacobi's trip, and she took him, among other things, a movie camera from Berlin. Lotte Jacobi had already sent him a Leica, film stocks, stationery, toiletries and clothing.
151. *Deutschland, Deutschland über alles. Ein Bilderbuch von Kurt Tucholsky und vielen Fotografen*. Mounted by John Heartfield, Berlin, 1929. Heartfield put together montages of text and images and, as with other of his works, he turned to Lotte Jacobi's photos in his search for motifs. According to the photographer (and Lotte Jacobi's former assistant) Elisabeth Röttgers, in *Deutschland, Deutschland…* the motifs on pp. 54, 55, 137 and 185 come from the Atelier Jacobi. Harry Liedtke complained to Mia Jacobi about the publication of his doorbell button. Ruth Jacobi remembered that Hearfield had used some of her photos for the cover of a short story by Michael Gold.
152. Letter to Max Hoelz from Lotte Jacobi dated Apr. 25, 1931. Page three of this four-page letter was singled out by the Institut für Marxismus und Leninismus (IML) presumably because it named members of the KPD by name. Max Hoelz Archiv, Stiftung Archiv der Parteien und Massenorganisationen der DDR in the German Federal Archives, Berlin.
153. Ibid.
154. Ibid.
155. Cf. Gabriele Saure, 'Eine neue Künstlergilde', *Photo-Sequenzen — Reportagen, Bildergeschichten. Serien aus dem Ullstein Bilderdienst von 1925 bis 1944*, exhibition catalogue, Haus am Waldsee, Berlin, 1992, pp. 29-31.
156. Ellen S. Goldberg, 'Lotte Jacobi: Photographer', unpublished dissertation for Skidmore College, University Without Walls, Saratoga Springs, NY, 1982, p. 5, LJA, UNH.
157. Cf. Katharina Sykora, 'Außer Kurs — Zu den Reisefotografien von Marianne Breslauer, Annemarie Schwarzenbach und Ella Maillart', *Fotogeschichte*, No. 48, 1993, pp. 27-43. Cf. Dorothee Wiethoff, 'Die moderne "Amazone"', *Fotografieren hieß teilnehmen, Fotografinnen der Weimarer Republik*, exhibition catalogue, ed. Ute Eskildsen, Düsseldorf, 1994, pp. 254-261.
158. Ella Maillart, *Ausser Kurs* (original edition, 1932, *Parmi la jeunesse Russe: De Moscou Au Caucase*), Munich, 1990.
159. Margaret Bourke-White was in Germany in 1931 on assignment from the magazine *Fortune*, to photograph industrial installations. Once in Germany, she obtained a visa and permission to photograph in the Soviet Union.
160. On Aug. 8, 1932, Lotte Jacobi concluded an 8-point contract for photos from the Soviet Union with Union-Bild, a photo agency which had been incorporated into Münzenberg's Neuer Deutscher Verlag in 1930. LJA, UNH.
161. Lotte Jacobi, 'Notizen zur Reise in die Sowjetunion', LJA, UNH.

"Warning! Photographer Banned"

162. Cf. note 40, p. 9.
163. Cf. the correspondence between Ernst Fuhrmann and Lotte Jacobi 1932-1935, LJA, UNH. In 1932, Ernst Fuhrmann was planning to relocate his Auriga-Verlag and Photo-Archiv Folkwang to Berlin. He proposed setting up a common photo archive to be able to work more efficiently. Lotte Jacobi could not agree to Fuhrmann's practice of not crediting the authors of the pictures by name; besides, the planned pay scale seemed to her to be too high. They were unable to reach an agreement. In mid-1933, when the studio had to use an Arian name to allow it to continue working for the press, she accepted the offer to publish under the name "folkwang-archiv". Fuhrmann may well have been hoping to revive the idea of a common archive, but because of Jacobi's autocratic methods, withdrew the offer to use this alias nine months later.
164. Janos Frecot, 'Die Kontinuität der Behaglichkeit. Eine Polemik' The continuity of the comfortable. A polemic, *Leitbilder für Volk und Welt, Nationalsozialismus und Photographie* Models for the world and the people to follow, National Socialism and Photography (German and English), gegenwart museum, ed. by the Berlinische Galerie and the Museumspädagogischer Dienst, Berlin, 1995, pp. 10-11.
165. *Atlantis*, vol. VI, No. 1, Jan. 1934, p. 17.
166. Communication from the Reich Association of German Correspondence and News Bureaus, assoc., Berlin, Trade Association of the Reich Chamber of the Press in the Reich Chamber of Culture, June 6, 1935, to the company Bender & Jacobi, Kurfürstendamm 35, concerning re-staffing, LJA, UNH.

Atelier New York

167. Letter (early 1972) from Lotte Jacobi to Grace Mayer, curator at the Museum of Modern Art in New York, LJA, UNH.
168. *New York Herald Tribune*, Sun., Dec. 29, 1935.
169. *New York Herald Tribune*, Jan. 8, 1936.
170. Bruce Blixen, 'Thank you, Hitler', *The New Republic*, Nov. 10, 1937. Lotte Jacobi's name was mentioned alongside such immigrants as Albert Einstein, Thomas Mann, Ernst Toller, Max Reinhardt, Kurt Weill, Erwin Panofsky, Vicki Baum and others, who were described as "Hitler's gift" to the U.S.A. because they enriched the culture of the nation.
171. Dorothy Thompson, *I saw Hitler*, New York, 1932. In 1934, Dorothy Thompson became the first American to be deported from Germany by the Nazis.
172. Cf. Erika and Klaus Mann, *Escape to Life, Deutsche Kultur im Exil* (first edition: Boston, April, 1939), Munich, 1991, pp. 368ff. *Exil in den USA, Kunst und Literatur im Antifaschistischen Exil 1933-1945*, vol. 3, Frankfurt am Main, 1980, pp. 64-66.
173. Cf. Richard M. Bacon, 'Lotte Jacobi', *Yankee*, August 1976, pp. 89-90. Lotte Jacobi's maternal grandfather lived in western Massachusetts for a few years where he ran a notions shop, but he eventually returned to West Prussia because his bride did not want to come to America.
174. Anthony Heilbut, *Kultur ohne Heimat, Deutsche Emigranten in den USA nach 1930*, Weinheim and Berlin, 1987, p. 40.
175. Op. cit., note 156, p. 6.
176. Cf. note 40, p.10. Her addresses in New York: Studio with Ruth Jacobi Oct. 1936 – Sept. 1937: 6th Ave. & 57th Str.; Sept. 19, 1936 – Aug. 1938: 24 Central Park South (near the Hotel Ritz); Sept. 1938 – Sept. 1939: 35 W. 57th Str.; Oct. 1939 – Sept. 1941: 127 W. 54th Str.; Oct. 1941 – June 1955: 46 W. 52nd Str.
177. Letter to Lotte Jacobi from Arnold Kirchheimer dated Nov. 4, 1937, LJA, UNH.
178. Op. cit., note 156, p. 7.
179. Op. cit., note 90, p. 25.
180. Op. cit., note 106, o.p.
181. Cf., note 121, p. 134.
182. Letters from Hubertus Prinz zu Löwenstein, 1937-1953, LJA, UNH.
183. Cf. *Deutsche Intellektuelle im Exil, Ihre Akademie und die "American Guild for German Cultural*

Freedom", exhibition catalogue, Deutsche Bibliothek, Munich, London, New York, Paris, 1993.

184. Letter from the American Guild for German Cultural Freedom, Inc. dated March 12, 1940, LJA, UNH.

185. Op. cit., note 183, p. 266, and an invitation sent to Lotte Jacobi to a Book Auction Dinner dated Dec. 6, 1938, LJA, UNH.

186. Vicki Goldberg, *Margaret Bourke-White — A Biography*, New York, 1987, p. 187.

187. Op. cit., note 174, p. 184.

188. Op. cit., note 186, p. 188 and p. 185.

189. Unpublished manuscript by Lottet Jacobi, LJA, UNH.

190. "The editors of that time were inclined to regard the photographer's work as a finished product, not as the raw material to be used in developing a story. Basic editing was done by the photographer himself, who would deliver those photographs which seemed to him to tell the story. On the average, Kertész recalls, if ten pictures were submitted, eight would be used." John Szarkowski, *André Kertész, Photographer*, New York, 1964, p. 6, here quoted from *André Kertész — Of Paris and New York*, London, 1985, p. 122, Note 18.

191. Sidra Stich, *Made in USA — The Americanization in Modern Art, the 50th & 60th*, Berkeley, Los Angeles, London, 1987, p. 111.

192. Luc Sante, 'Eine Nation in Bildern', *Amerikanische Photographie 1890-1965*, exhibition catalogue, Munich, 1995, p. 51.

193. Weston J. Naef, 'André Kertész: The Making of an American Photographer', *André Kertész — Of Paris and New York*, London, 1985, p. 104.

194. Hank O'Neal, *Berenice Abbott, Sixty Years of Photography*, London, 1982, p. 23.

195. Naomi Rosenblum, *A History of Women Photographers*, New York, 1994, p. 188.

196. Op. cit., note 11, p. 141.

197. Op. cit., note 194, p. 5.

198. Sandra S. Phillips, 'An Interview with Lotte Jacobi', *Center Quarterly*, vol. 3, No. 1, The Catskill Center of Photography, Woodstock, NY, 1981, o.p.

199. Op. cit., note 195, p. 13.

200. Anne Tucker, 'A History of the Photo League — The Members Speak', *History of Photography*, vol. 18, No. 2, Summer, 1994, pp. 174-184.

201. Naomi Rosenblum, 'Die Fotografie im sozialen Geschehen', The Camera Image in Social Action, *Walter Rosenblum*, Dresden, 1990, german and english, pp. 192ff.

202. Naomi Rosenblum in a letter of June 11, 1996 to the authors: Lotte Jacobi's lecture of March 21, 1938, is printed in *Photo Notes*, the journal of the Photo League. No other dates are documented.

203. Cf. Margaret Bourke-White, 'At the time of the Louisville Flood', 1937, Afro-Americans stand in line for food rations in front of a billboard with the slogan, "There's no way like the American Way", Marianne Fulton, *Eyes of Time, Photojournalism in America*, Boston, Toronto, London, 1988, p. 106.

204. Cf., note 174, pp. 263ff.

205. Op. cit., note 193, pp. 111-12.

206. Op. cit., note 186, p. 252ff.

207. Peter Galassi, 'Zwei Geschichten', *Amerikanische Photographie 1890-1965*, exhibition catalogue, Munich, 1995, p. 32.

208. Cf. Hans Adolf Halbey, *Der Erich Reiss Verlag 1908-1936. Versuch eines Porträts*, Frankfurt am Main, 1981. Obituary by Kurt Pinthus, *Aufbau*, New York, May 18, 1951.

209. Cf. Christine Backhaus-Lautenschläger, *...Und standen ihre Frau, Das Schicksal deutschsprachiger Emigrantinnen in den USA nach 1933*, Pfaffenweiler, 1991.

210. Hubertus Prinz zu Löwenstein in a letter to Lotte Jacobi dated July 11, 1937, LJA, UNH.

211. Mrs. George Bartley Schroyer in a letter to Lotte Jacobi dated May 28, 1953, LJA, UNH.

212. Martha Carlson, 'Lotte Jacobi: Still unpredictable at 89', *Business NH*, Nov. 1985, p. 78.

213. Invitation card to the *Exhibition of Portraits* at the Jacobi Studio of Photography for March 1, 1941, LJA, UNH.

214. Op. cit., note 90, p. 26.

215. Op. cit., note 173, p. 64.

216. Op. cit., note 40, p. 11.

217. Beaumont Newhall in a letter to Lotte Jacobi dated February 13, 1944, LJA, UNH.

Photogenics — Adventures with Light

218. Lotte Jacobi, unpublished handwritten notes with the title 'über Photogenics', o.p., LJA, UNH.

219. Op. cit., note 207, p. 34.

220. Kelly Wise, 'Gentle Persuasions and a Benign Predator's Eye', (Forewood***), *Lotte Jacobi*, Danbury, NH, 1978, p. 12.

221. Op. cit., note 40, p. 15.

222. Op. cit., note 218.

223. Cf. Floris M. Neusüss, *Das Fotogramm in der Kunst des 20. Jahrhunderts*, Cologne, 1990.

224. Cf. J. A. Schmoll aka Eisenwerth and Gottfried Jäger, *Das Autonome Bild*, exhibition catalogue, Kunsthalle Bielefeld, Stuttgart, 1989, p. 9.

225. Op. cit., note 40, p. 12.

226. Lotte Jacobi, 'Light Pictures', one-page, type-written manuscript, LJA, UNH.

227. Cf. concerning Leo Katz: Adolph Rosenberg, 'Leo Katz', *The Southern Israelite*, vol. XXXIV, No. 47, Nov. 27, 1959. We should like to thank Anne Hoy for drawing our attention to this essay on Leo Katz. Anne How ist the curator of the Lotte Jacobi exhibition in the ICP, New York, 1994. Leo Katz, Biographical Data, 1959, LJA, UNH. Lotte Jacobi, *Leo Katz — Twenty-three Prints 1932-1965*, four-page information brochure on the Leo Katz exhibition at Lotte Jacobi Place, Deering, NH, Aug. 14 to Sept. 4, 1965, LJA, UNH.

228. Leo Katz, 'Dimensions', *Encyclopedia of photography*, National Education Alliance, New York, 1942.

229. 'Lotte Jacobi', *Light Abstractions*, exhibition catalogue, University of Missouri, St. Louis, 1980.

230. Leo Katz, 'Photogenics and Lotte Jacobi', type-written manuscript as an introduction to an exhibition of works by Lotte Jacobi, Norlyst Gallery, New York, 1948, LJA, UNH.

231. Jutta Hülseweg-Johnen, 'Bildautonomie, Fotos aus neuen Welten', *Das Autonome Bild*, ed. J. A. Schmoll aka Eisenwerth and Gottfried Jäger, *Das Autonome Bild*, exhibition catalogue, Kunsthalle Bielefeld, Stuttgart, 1989, p. 15.

232. Op. cit., note 230.

233. Willi Wolfradt, quoted by Fritz Kempe, 'Lotte Jacobi und ihre "Photogenics"', *MFM Fototechnik*, December, 1973, p. 638.

234. Cf. David Anfam, 'Die Extreme des Abstrakten Expressionismus', *Amerikanische Kunst im 20. Jahrhundert*, exhibition catalogue, Munich, 1993, p. 102.

235. Jeannine Fiedler, 'Fotografie- und Lichtwerkstatt', *50 Jahre New Bauhaus. Bauhaus-Nachfolge in Chicago*, exhibition catalogue, Berlin, 1987, pp. 153-56.

236. Jane Livingston, *The New York School. Photographs 1936-1963*, New York, 1992, p. 261.

237. Op. cit., note 223, p. 154.

238. Op. cit., note 195, p. 244.

"A Born Rebel and a Persistent Troublemaker"

239. Western Union Telegram, probably a carbon copy, LJA, UNH.

240. Frank J. Donner, *The Age of Surveillance*, (New York, 1981, pp. 170-71) quoted by Robert E. Snyder, 'Margaret Bourke-White and the Communist Witch Hunt', *Journal of American Studies*, vol. 19, No. 1, 1985, p. 24.

241. Op. cit., note 174, p. 291.

242. Op. cit., note 174, p. 312.

243. Robert E. Snyder, 'Margaret Bourke-White and the Communist Witch Hunt', *Journal of American Studies*, vol. 19, No. 1, 1985, pp. 5-25.

244. Op. cit., note 174, p. 293.

245. *Frankfurter Allgemeine Zeitung*, Oct. 8, 1953, p. 7.

246. Karl Kraus, *Die Fackel*, No. 888, Oct. 1933, vol. XXXV, p. 4. Mascha Kaleko jotted down the poem on a card to Lotte Jacobi dated May 11, 1955, LJA, UNH.

247. Lotte Jacobi in a letter to Helen and Scott Nearing dated April 1, 1959, LJA, UNH.

248. Charles Buckley in a conversation with the authors in Manchester, NH, U.S.A. on June 30, 1990.

249. Grace Casey in a conversation with the authors in NH, U.S.A. on June 24, 1990. From 1966 to 1983, Casey was the director of the Art Association of New Hampshire. The photographer Richard Merrit in a conversation with the authors in Durham, NH, U.S.A. in June, 1990. The first photographs to be shown at the Art Association of New Hampshire were by Lotte Jacobi and Richard Merrit.

250. Scott Nearing, *The Making of a Radical: A Political Autobiography*, New York, Evanston, San Fransisco, London, 1972.

251. Op. cit., note 212, p. 80.

252. Op. cit., note 173, p. 63.

253. Albert Renger-Patzsch in letters written to Lotte Jacobi between 1957 and 1966, LJA, UNH. Excerpt from a letter dated July 15, 1959: "First of all, thank you for the letter and the magnificent portraits (by Lotte Jacobi). Now, they are what I call models! And that's just what I like about these portraits — that they're not overdone. Carsh, you can keep yourself — I can't stand him. You always get the impression from his portraits that he's trying to say through them, 'Look what a great guy I am, how wonderfully I've pulled it off, once again, etc.' But you want to find out something about the subject from a portrait, and not about the photographer. No wonder he did such a grand job on Thomas Mann — Mann's writing has a certain resemblance; he's always peeking out from behind his witty diatribes, saying, 'Look what a clever man I am, how much I know about everything: modern music, history, psychology, philosophy, etc.! And entire passages of his later novels, like *Zauberberg* and *Dr. Faustus* are long strings of brilliantly written essays about the most fantastic things, but if I want to know something about modern music, then I'd much rather read the original text by Adorno, and I'd rather read the *Minima Moralia* than the philosophical expectorations of some novelist, unless they're his very own, homegrown produce, and unless they're very much suited to the form of a novel. Just compare Mann's *Zauberberg* with Melville's *Moby Dick*. So much for that Canadian warlock, Carsh. I've only made a few portraits — I'm just not any good at it. I'm very interested in people, but not necessarily from the optical standpoint. Often, it says too little — you might say, it conceals too much. But you're quite good at it, as the portraits show, and there simply aren't any good portrait photographers any more. I seriously think you should get into it even more. The Steinert School and their free compositions are a little fringe area of photography, and I prophesy to you that, in the course of your lifetime, even the art will return to the subject. But I don't want to write an essay here, and the topic is vast. You can't cover it all in a letter."

254. Cf. *subjektive fotografie 2* by Otto Steinert, exhibition catalogue, Saarbrücken, 1954; '*subjektive fotografie*' — *Der deutsche Beitrag 1948-1963*, J. A. Schmoll aka Eisenwerth, exhibition catalogue, Stuttgart, 1989. *Subjektive Fotografie, Bilder der 50er Jahre*, ed. Ute Eskildsen, exhibition catalogue, Museum Folkwang, Essen, 1984/85.

255. Siegfried Krakauer, *Das Ornament der Masse*, Frankfurt am Main, 1977, p. 26.

256. On Lotte Jacobi's photographic series, 'Romantic New York', cf. Richard F. Crandell, 'U.S. Camera 1947', *New York Herald Tribune*: "Included too are some of the finest examples of the camera art, creations that are masterpieces of design, with a depth that gives an almost third dimensional effect... Lotte Jacobi's 'Moonlight on Radio City' have (has) qualities about them that give a new dignity to an art sometimes dismissed as lucky button pushing."

257. Karen Michels, 'Versprengte Europäer. Lotte Jacobi photographiert Erwin Panofsky', *IDEA X* (1991), pp. 8-13.

258. Ibid., p. 12.

259. Erwin Panofsky in a letter to Lotte Jacobi dated May 5, 1966, LJA, UNH.

260. Cf. Ezra Stoller's documentary photos in the *Family of Man* exhibition in *Shift, Zeitgenössische künstlerische Konzepte*, exhibition catalogue, Neue Gesellschaft für bildende Kunst, Berlin, 1996, pp. 18-24.

261. *Menschen von Gestern und Heute. Fotografische Portraits, Skizzen und Dokumentationen von Lotte Jacobi*, collected by Otto Steinert, exhibition catalogue, Museum Folkwang, Essen, 1973.

Biography

1896 Johanna Alexandra, nicknamed Lotte, is born on August 17th, in Thorn/Thoruń, West Prussia, the eldest daughter of Sigismund Jacobi (1860-1935), a third generation photographer, and his wife, Maria, nicknamed Mia, née Lublinski (1872-1950). She will have one sister, Ruth (1899-1996), and one brother, Alexander (1902-1922).

1898 The family moves to Posen/Poznań, Friedrich-str. 25, where Sigismund Jacobi had a branch of his studio. In 1905, the family moves to Berliner Str. 4.

1902-1913 Lotte Jacobi attends the Königin-Luise-Schule and, from 1910 on, the Higher School for Girls in Posen-Wilda.

1908-1909 Lotte Jacobi experiments with a camera obscura she built herself and takes her first photos with a 9 x 12 cm Ernemann.

1914-1916 Attends courses in art history and literature at the Academy in Posen.

1916 May 18, marries the wood merchant, Siegbert Fritz Honig.

1917 March 26th, her son, Jochen is born. After emigrating to the U.S.A., he re-names himself John F. Hunter. Her parents move to Victoriastr. 19.

1920 Lotte Jacobi moves to Berlin with her husband and son.

1921 Sigismund and Mia Jacobi move to Berlin and establish a photo studio at Joachimstaler Str. 5 in Berlin's Charlottenburg district. Lotte Jacobi is separated from her husband (divorced in 1926) and starts working in her father's studio. Lotte Jacobi's brother is killed in an accident by bathing.

1925-1927 She attends the Staatliche Höhere Fachschule für Phototechnik in Munich to train as a photographer. The first year, she studies phototechnology and practice; during the third and fourth semester, she is enrolled in the department of cinematography and purchases a movie camera. She is befriended by the painter Josef Scharl, who introduces her to artists' circles in Munich.

1927-1935 Returns to Berlin in September, 1927, and commences independent work in her father's studio, in particular for magazine publications.

1928 Purchases a 9 x 12 cm Ermanox with an anastigmat Ernostar 1:1.8, 16,5 cm focal length lens. Encounters Max Hoelz for the first time in Sonnenburg Prison.

1929 Buys her first Leica. The photographer Elisabeth Röttgers works as the director of marketing and the archive and as Lotte Jacobi's assistant for two years. Jacobi meets John Heartfield with whom she collaborates on individual projects until 1932.

1930 Works for the Soviet photo agency Press Clichee Moskau until spring, 1931.

1931 Officially renounces the Jewish faith in March. Meets the photographer Tina Modotti and allows her to use the darkroom in the Atelier Jacobi during her half-year stay in Berlin. Receives the silver medallion from the Royal Photography Salon in Tokyo.

1932-1933 Considers establishing a joint photo archive with Ernst Fuhrmann to be run in Berlin. From August, 1932 to February, 1933, she travels to Moscow and through the Central Asian Republics, Tajikistan and Uzbekistan. Shoots approx. 6,000 photos during the journey. In October, 1932, the studio is moved to Kurfürstendamm 216. The Jacobis sell the 18 x 24 cm studio camera and acquire a 9 x 12 cm Stegemann.

1933-1935 With the transfer of power to the National Socialist Party, working conditions for Jews, and thus the Atelier Jacobi, are made increasingly difficult. In October, 1933, the Atelier Jacobi is moved to Kurfürstendamm 35. From the fall of 1933 to mid-1934, photographs are published in magazines under the name "folkwang archiv", for about two months following, under the name "Behm's Bilderdienst", thereafter until Lotte Jacobi's emigration, the studio's stamp bears the name "Bender u. Jacobi". Individual photos are printed under the name "Lloyd". Lotte Jacobi obtains a master's certificate from the Chamber of Trade.
In early September, Lotte Jacobi leaves Berlin, stopping off for three weeks in London, then travels on to New York on a tourist visa, arriving on Sept. 29th. On October 30th, 1935, together with her sister, she opens a studio at 57th Str. and 6th Ave. On December 29th, the first of her photos are printed in the photogravure supplement of the *New York Herald Tribune*.

1936 On January 20th, Lotte Jacobi officially immigrates from Toronto, Canada, with the aid of an affidavit from her American relatives. On Feb. 20th, Mia Jacobi arrives in New York with the household goods from Berlin. On Sept. 4th, Lotte Jacobi's son, Jochen, immigrates to New York with a guarantee from the journalist Curt Riess.
On Sept. 19th, Lotte Jacobi opens the first studio of her own at 24 Central Park South. She meets the painter and teacher Leo Katz and the journalist Dorothy Thompson. Devotes energy to helping other emigrants.

1938 On March 21st, holds a lecture in the Photo League. In June, meets photographer Berenice Abbott. On Sept. 2nd, moves to 35 W. 57th Str. The "Albert Einstein" photo series is rejected by *Life* as too unconventional.

1939 In October, moves to 127 W. 54th. Str.

1940 Buys a Rolleiflex. Through Egon Erwin Kisch, who arrives in New York on Dec. 29th, 1939 for six months before going on to Mexico, she is introduced to the Berlin publisher and fellow emigrant, Erich Reiss. On Oct. 7th, Lotte Jacobi and Erich Reiss marry.

1941 Exhibition on the 90th anniversary of the Atelier Jacobi in Lotte Jacobi's own studio. Wins first prize for her entry in the "V for Victory" contest held by *U.S. Camera* and the British American Ambulance Corps. In October, she moves to 46 W. 52nd Str.

1944 She is granted U.S. citizenship.

1947-1955 Works with cameraless photography; produces what she calls photogenics. On Dec. 31st, 1950, Mia Jacobi passes away.

1951 On May 8th, Erich Reiss passes away.

1955 On June 22nd, after an exhibition of her photogenics in her studio, Lotte Jacobi leaves New York and moves into the house of her son, John F. Hunter, and daughter-in-law, Beatrice Trum Hunter, in Deering, New Hampshire.

1956 On March 13th, takes part for the first time in a town meeting in Deering, NH.

1958 Buys an old, abandoned logger's house on the Old County Road in Deering, NH.

1960 Obtains a driver's license and purchases a car. First meeting with the author and poet May Sarton. Becomes active in cultural politics, including lobbies for the establishment of a department of photography at the Currier Gallery in Manchester, NH.

1961-1963 Buys a Speed Graphic 2 1/2 x 3 1/4". From September 1961 to June 1962, attends courses at Durham University, NH, in French, printing graphics, art history, gardening and "television". Buys a printing press. In Sept. 1962,
leaves on first return trip to Europe with stops in Thoruń and Wrocław in Poland, and in Berlin and other places in Germany; travels through Italy for three weeks; visits Paul Strand in Orgéval, France, and takes part in workshops at Stanley William Hayter's Atelier 17 in Paris. After returning from Europe, Lotte Jacobi moves into the cabin in Deering, NH, which John F. Hunter has meanwhile renovated. Begins holding exhibitions again in her new studio, "Lotte Jacobi Place".

1964 Initiative to have a stamp issued to honor the 100th birthday of Alfred Stieglitz.

1969 The Klingspor Museum in Offenbach holds an exhibition entitled *Der Erich Reiss Verlag 1908-1938* ("The Erich Reiss Publishers 1908-1938"). The publication of the same title appears in 1981.

1970 Receives first prize of the annual arts prizes awarded by the Arts Association of New Hampshire.

1970-1971 Department of photography established at the Currier Gallery in Manchester, NH on the initiative and with the participation of Lotte Jacobi; from 1972 to 1979 active at museum as honorary curator.

1972 Fritz Kempe organizes first individual exhibition for Lotte Jacobi in Germany at the Landesbildstelle in Hamburg, Germany.

1973 Otto Steinert organizes Lotte Jacobi's first major retroperspective with a catalogue at the Museum Folkwang, Essen, Germany.

1974 Receives an "Honorary Doctor of Fine Arts Degree" from the Durham University, NH. Awarded further honorary doctorates throughout the seventies and eighties.

1976 As delegate to the Democratic National Convention, meets future U.S. president Jimmy Carter.

1977 Receives a grant from the National Endowment for the Arts for a project involving making portraits of contemporary photographers. Travels to Peru with a group of students from Durham University, NH. Exhibition at the Institute of Arts and Science, Manchester, NH, with the first catalogue in English (Text by Ute Eskildsen and Sally Stein).

1978 First monograph on Lotte Jacobi's life and work published by Kelly Wise and James A. Fasanelli.

1980 New Hampshire Governor's Award for the Arts.

1981 Lotte Jacobi arranges for the University of New Hampshire, Durham, to take on her entire collection of negatives, as well as her letters and documents for its archives.

1983 In Philadelphia, Lotte Jacobi receives an Honors Award for Outstanding Artistic Achievement from the Women's Caucus for Art Conference. In Berlin, she shares with Tim N. Gidal the Erich Salomon Prize awarded by the Deutsche Gesellschaft für Photographie (German Society of Photography).

1985 Lotte Jacobi moves to the retiring home "Havenwood" in Concord, NH.
Her son, John F. Hunter, passes away.

1986 All photographic prints still in her possession are sold to the galerist Stephen White in Beverly Hills, Ca.

1990 In February, Stephen White sells his entire photographic collection to the Tokyo Fuji Museum.
On May 6th, Lotte Jacobi passes away in Concord, NH.

Appendix

Individual exhibitions

All exhibitions entitled "Lotte Jacobi" are listed according to location only.

1937
- Lotte Jacobi Studio, New York (24 Central Park South)

1941
- *Zum 90sten Jahrestag des Ateliers Jacobi* Lotte Jacobi Studio, New York (127 West 54th Street)
- *Photo-Portraits and Compositions* Direction Gallery, New York

1948
- Norlyst Gallery, New York

1952
- Ohio University, Athens, Ohio

1953
- University College of Education, New Paltz, N.Y.

1955
- Lotte Jacobi Gallery, New York (46 West 52the Street)

1957
- Sharon Arts Center, Peterboro, N.H.
- Boston Camera Club, Boston, Mass.

1959
- *Lotte Jacobi: A Retrospective Exhibition of Photographs 1927-1959,* Currier Gallery of Art, Manchester, N.H.
 Exhibition shown by:
- Brandeis University, Waltham, Mass.,
- University of New Hampshire, Durham, N.H.,
- University of Ohio, Athens, Ohio

1962
- *Lotte Jacobi: A Retrospective,* Sawyer Art Center, Colby Jr. College, New London, N.H.

1964
- *Lotte Jacobi: A Retrospective Exhibition of Photographs 1927-1963,* 303 Gallery, New York
- Lotte Jacobi — photogenics and portraits Egbert Starr Library, Middlebury, Vermont
- Institut of Arts and Sciences, Manchester, N.H.
- *Two from Hillsboro — Lotte Jacobi and William H. Manahan,* Phillips Academy, Andover, Mass.
- Templehof Art Gallery, Temple, N.H.

1965
- College Library, Middlebury, Vermont
- Lexington Studio Gallery, University of Chicago, Chicago, Ill.
- New England College, Henniker, N.H.

1966
- *Lotte Jacobi — Photographer,* Roger McCollester House, Irvington-on-Hudson,N
- *Lotte Jacobi and Marie Cosindas* Gropper Galleries, Cambridge, Mass.

1967
- *Lotte Jacobi Photograph Exhibit* Community Church-Art Gallery, New York
- Gropper Galleries, Cambridge, Mass.

1968
- New England College, Henniker, N.H.

1969
- Concord Public Library, Concord, N.H.

1971
- *90 prints,* New England Center, Durham, N.H.
- New England College Library, Henniker, N.H.

1972
- Belknap College, Center Harbor, N.H.
- *Lotte Jacobi, Berlin — USA, Retrospective 1927/1972,* Staatliche Landesbildstelle Hamburg

1973
- *Menschen von Gestern und Heute — Fotografische Porträts, Skizzen und Dokumentationen* (Katalog), Museum Folkwang, Essen
 Exhibition shown by:
- Stadtmuseum München

1974
- Carter Gallery, Paul Arts Center UNH, Durham, N.H.
- Light Gallery, New York
- Sharon Arts Center, Peterboro, H.H.
- Washington Gallery of Photography, Washington, D.C.

1975
- *Lotte Jacobi: Personalities from Yesterday and Today,* Paul Creative Arts Center, UNH, Durham, N.H.
- *50 Photographs by Lotte Jacobi* Fine Arts Festival, New England College, Henniker, N.H.
- *The Photography of Lotte Jacobi* GalleRYspace, YM/YWHA, Philadelphia, Pa.

1976
- *Lotte Jacobi — photographs and prints* Arts and Science Center, Nashua, N.H.
- Photo-Graphics Workshop, New Canaan, Conn.
- *Lotte Jacobi und Horst Janssen,* William Benton Museum of Art, Storrs, Conn.
 Exhibition shown by:
- Danforth Museum, Framingham, Mass.

1977
- Kimmel-Cohn Gallery, New York
- Kiva Gallery, Boston, Mass.
- *Photographs and Photogenics* Allan Frumkin Gallery, Chicago, Ill.
- Jacobi Place — Portrait of a Photographer (Catalogue), Manchester Institute of Arts and Sciences, Manchester, N.H. travelling exhibition:
- Beaumont-May Gallery, Hanover, N.H.;
- Library Arts Center, Newport, N.H.

1978
- *portraits and photogenics* (Katalog) University of Maryland, Baltimore, Md.
- New Hampshire Art Association, Manchester, N.H.
- *Major Retrospective of the Work of Lotte Jacobi* Kiva Gallery, Boston, Mass.

1979
- Galerie Taube, Berlin (Katalog)
- Studio 139, Portsmouth, N.H.
- Addison Gallery of American Art, Phillips Academy, Andover, Mass.
- Scudder Gallery, Durham, N.H.

1980
- Theater on the sea, Portsmouth, N.H.
- *Retrospective Lotte Jacobi* (Katalog) Alfred University, Alfred, N.Y.

1981
- Stadtmuseum München
- Gutenberg Museum, Mainz
- *The Art of Lotte Jacobi,* Alexander Hall Gallery, Westbrook College, Portland, Maine
- The Catskill Center For Photography, Woodstock, N.Y.

1982
- Lamont Gallery, Exeter, N.H.
- The Plus Company, Nashua, N.H.

1983
- New Hampshire Art Association, Manchester, N.H.
- Dryden Galleries, Providence, Rhode Island
- Galerie Taube, Berlin
- AVA-Gallery, Hanover, N.H.
- Associated Artists Gallery, Philadelphia, Pa.
- *Faces of Women — Photographs by Lotte Jacobi* The Bryn Mawr College Library, Philadelphia, Pa.

1984
- Currier Gallery of Art, Manchester, N.H.
- Ledel Gallery, New York
- Carl Solway Gallery, Cincinatti, Ohio

1989
- *Lotte Jacobi — Photographien einer Reise durch die Sowjetunion 1932/33* (Photo-Taschen-Buch) Das Verborgene Museum, Berlin

1990
- The Paul Creative Art Center, UNH, Durham, N.H.
- *Lotte Jacobi (1896-1990) — Berlin · New York · Deering* (exhibition catalogue) Museum Folkwang, Essen

1993
- Galerie Bodo Niemann, Berlin

1994
- *Lotte Jacobi: Old and New Worlds* (leaflet) International Center of Photography, New York

1997
- *Atelier Lotte Jacobi · Berlin – New York* (Monographie) Das Verborgene Museum, Berlin
 Exhibition shown by:
- Suermondt Ludwig Museum, Aachen;
- Museum Ostdeutsche Galerie, Regensburg

Participation in exhibitions (selection)

1930
- *Das Lichtbild,* Münchner Bund und Ausstellungspark e.V., München, travelling exhibition:
- Essen, Düsseldorf, Dessau, Breslau

1933
- *La Danse et Le Mouvement* Les Archives International de la Danse, Paris

1936
- *U.S. Camera Salon,* Mezzanino Gallery, Rockefeller Plaza, New York
- *Third International Leica Exhibit* Radio City, New York

1937
- *The Art of the Dance in Photography* Brooklyn Museum, New York

1939
- *Pictorial Photographers of America (6. Int. Salon of Photogr.)* American Museum of Natural History, New York (on the occasion of the World Exhibition)

1941
- *Affilated Arts Associates* Penthouse Studio Greenich Village, New York

1942
- *Twentieth Century Portraits* Museum of Modern Art, New York

1947
- *First Women's Invitation Exhibition* Camera Club, 121 West 68th. St., New York

1948
- *In and Out Of Focus* The Museum of Modern Art, New York
- *Pioneer Photographers* Addison Gallery of American Art, Phillips Academy, Andover, Mass.

1950
- *Photography — Mid Century* Los Angeles County Museum, Ca.

1951
- *51 American Photographers — Then And Now* The Museum of Modern Art, New York
- *Abstraction in Photography* The Museum of Modern Art, New York

1953
- *Women in Art,* Contemporary Arts Association of Houston, Texas

1954
- *subjective fotografie 2,* Staatliche Schule für Kunst und Handwerk, Saarbrücken

1960
- *The Sense of Abstraction* The Museum of Modern Art, New York

1961
- *Professional Photographers of America Inc.* New York City

1962
- *International Photography Fair,* 71st Regiment Armory on Park Ave./34th St., New York
- *70 Photographers* Lincoln, Mass.
- *April Festival of Arts* Mount Saint Mary College, Hooksett, N.H.
- *Robin Bookshop on the Green* Fitz William, N.H.

1963
- *4 Photographers* Manchester Institut of Arts and Science, N.H.

1964
- *4e salon national d'Art photographic de l'Amicale Photo-Ciné du Blaisois,* Paris
- *Three Artists* Art Group Headquarter, Manchester, N.H.

1965
- *New York's Worlds Fair* New York
- *Photographic Exhibition* Lexington Studio Gallery, Chicago, Ill

1967
- *The Art Association of Newport* Bellevue Ave., Newport, Rhode Island

1968
- *Light 7,* Hayden Gallery, Massachusetts Institute of Technology, Cambridge, Mass.

1970
- *Fotografinnen* Museum Folkwang, Essen

1971
- *Art in New Hampshire* Plymouth State College, Plymouth, N.H.

1972
- *New England Women Photographers* Wellesly College Museum, Wellesly, Mass.
- *Women of Photography* Jewetts Arts Center, Wellesly, Mass.
- *The New England Experience* De Cordova Museum, Lincoln, Mass.
- *Photo-Vision '72* Boston Center for the Arts, Boston, Mass.
- Travelling exhibition: 12 locations

1975
- *Women of Photography,* San Francisco Museum of Modern Art, Exhibition shown by:
- Museum of New Mexico, Santa Fe;
- Art Historiy Galleries, University of Wisconsin, Milwaukee;
- Wellesley College Museum, Wellesly, Mass.
- *women in photography* Friends of crafts Inc., Seattle, Wash.
- *International invitational photography exhibition* Union Carbide Exhibition Gallery, New York

1976
- *Women in the Arts* Chapel Art's Center, Manchester, N.H.
- *A Camera in Common* Wheelock College Gallery, Boston, Mass.
- *Women in Art* Colby Sawyer College, New London, Mass.

1977
- *Künstlerinnen international 1877-1977* Schloß Charlottenburg, Berlin
- *Group Show: featuring Lotte Jacobi* Brattle Street Gallery, South Berwick, Maine
- *Lotte Jacobi · Arman · John Stuart Curry* Ulrich Museum of Art, Wichita, Kansas
- *Subjective Photography* Kimmel/Cohn Gallery, New York

1978
- *14 New England Photographers* Museum of Fine Arts, Boston, Mass.
- *Photographie* Moderna Museet Fotografiska, Stockholm
- *Fleeting Gestures: Treasures of Dance Photography* International Center of Photography, New York

1979
- *Photography: Lotte Jacobi, Gerda Peterich, Martha MacEmerson, William H. Manahan Jr.* Currier Gallery, Manchester, N.H.
- *Recollections: Ten Women of Photography* International Center of Photography, New York

- Travelling exhibition: 14 locations
- *Self as Subject. Photographs* und
- *Focus on older Artists at Work* Scudder Gallery, Durham, N.H.
- *Fleeting Gestures: Treasures of Dance Photography,* Venedig
- *Abstract Photography in America 1935-1950* Lubin House, Syracuse University, New York

1980
- *Light Abstractions* University of Missouri, St. Louis
- *Avant-Garde Photography in Germany 1919-1939* San Francisco Museum of Modern Art, Ca., Exhibition shown by:
- Akron Art Institut, Ohio;
- Walker Art Center, Minneapolis, Minnesota;
- The Baltimore Museum of Art, Maryland;
- The Chicago Center for Contemporary Photography, Ill.;
- International Center of Photography, New York;
- Portland Art Museum, Oregon
- *Photography of the Fifties,* International Center of Photography, New York Exhibition shown by:
- Tucson, Arizona;
- Minneapolis, Minnesota;
- Long Beach, Ca.;
- Wilmington, Delaware

1982
- *Sixteen Photographers* Montserrat Gallery, Beverly, Ma.
- *Figura della Danza,* Reggio Emilia
- *Lichtbildnisse — Das Porträt in der Photographie* Rheinisches Landesmuseum Bonn

1983
- *Dance photography exhibition* Il Theatro Municipale, New York
- *Women's Caucus for Art — 5th Annual Exhibition* The Port of History Museum of Penn's Landing, Philadelphia, Pa.
- *22 Photographinnen* GEDOK Hamburg
- *Fotogramme — Die lichtreichen Schatten* Fotomuseum im Stadtmuseum, München
- *Erich-Salomon-Preisträger 1983* Berlinische Galerie, Berlin
- *Lensless Photography* The Franklin Institut, Philadelphia, Pa.

1984
- *Twentieth-Century Photographs from Hawaii Collections,* Honolulu Academy of Art, Hawaii
- *Ullstein Bilderdienst Berlin,* Museum Folkwang, Essen

1985
- *Künstler und Politiker der Weimarer Zeit. Pressezeichnung und Portraitfotografie — B. F. Dolbin. Emil Stumpp. Lotte Jacobi* Museum für Kunst und Kulturgeschichte, Dortmund, travelling exhibition:
- Haus am Lützowplatz, Berlin
- *Das Selbstporträt,* Musée cantonal des Beaux-Arts Lausanne, travelling exhibition:
- Württembergischer Kunstverein Stuttgart;
- Akademie der Künste, Berlin

1987
- *Photography and Art 1946-86* Los Angeles County Museum of Art, Ca.
- *Deutsche Lichtbildner* Museum Ludwig, Köln
- *Nine Masters* Photographic Resource Center, Boston, Mass.

1988
- *Bilder von Frauen* Museum Folkwang, Essen

1989
- *Fotografie als Fotografie — 10 Jahre Photographische Sammlung Berlinische Galerie,* Berlinische Galerie, Berlin
- *art express* Orangerie, Schloß Charlottenburg, Berlin

1991
- *From Germany to America — Lotte Jacobi. Gerda Peterich. Ursula Wolff Schneider* The Art Gallery, University of New Hampshire, Durham, N.H.

1992
- *Sprung in die Zeit* Berlinische Galerie, Berlin
- *Photo-Sequenzen* Haus am Waldsee, Berlin

1993
- *Women on the Edge,* J. Paul Getty Museum, Malibu, exhibition shown by:
- Solomon R. Guggenheim Museum, New York

1994
- *Photographische Perspektiven aus den Zwanziger Jahren,* Museum für Kunst und Gewerbe, Hamburg
- *Fotografieren hieß teilnehmen — Fotografinnen der Weimarer Republik,* Museum Folkwang, Essen Exhibition shown by:
- Fundació "La Caixa", Barcelona;
- The Jewish Museum, New York City;
- Fotomuseum, Winterthur

1995
- *Moskau-Berlin · Berlin-Moskau* Martin-Gropius-Bau, Berlin Exhibition shown by:
- Staatliches Puschkin-Museum, Moskau
- *Portraits in Modernism* Metropolitan Museum of Photography, Tokio

1996
- *Fields of Vision: Women in Photography* Albin O. Kuhn Library and Gallery; University of Maryland, Baltimore, Md.
- *Ansichten der Natur* raum 1 (Ausstellungsforum des August Sander Archivs), Cologne, Exhibition shown by:
- Berlinische Galerie, Berlin
- *A History of Women Photographers* The New York Public Library, New York Travelling exhibition

Bibliography

Negative and Document Archives
- Lotte Jacobi Archives, Photographic Services and
- Lotte Jacobi Archives, Special Collections of the University of New Hampshire, Durham, N.H.

Unpublished Sources
- Lotte Jacobi: "Tagebuch der Reise in die UdSSR", 1932/33, LJA, UNH
- Lotte Jacobi: Appointment books from 1936-1955, LJA, UNH
- May Sarton: A Portrait of Lotte Jacobi, Nelson 1972, LJA, UNH
- Ellen S. Goldberg: "Lotte Jacobi · Photographer", unpublished dissertation, Skidmore College, University Without Walls, Saratoga Springs, New York November 1982, LJA, UNH

Exhibition catalogues and books on Lotte Jacobi (selection)
- Menschen von Gestern und Heute, Fotografische Porträts, Skizzen und Dokumentationen von Lotte Jacobi, with text by Hellmuth Karasek, exhibition catalogue, Museum Folkwang, Essen 1973
- Jacobi Place — Portrait of a Photographer, with texts by Ute Eskildsen, Sally Stein, Peter A. Moriaty, exhibition catalogue, Manchester Institute of Arts and Sciences, Manchester, 1977
- Kelly Wise, James A. Fasanelli: Lotte Jacobi, Danbury, N.H. 1978
- Lotte Jacobi — portraits and photogenics, text by Tom Beck, exhibition catalogue, University of Maryland, Baltimore, 1978
- Theater and Dance, Deering, N.H. 1979
- Lotte Jacobi, exhibition catalogue, Galerie Taube, Berlin, 1979
- Lotte Jacobi Retrospective, ed. David Barry Lash exhibition catalogue, Hidden Spring Press, Alfred, N.Y., 1981
- Berlin — New York. Schriftsteller in den 30er Jahren, text: Ludwig Greve, Marbach am Neckar: Deutsches Literaturarchiv 1982
- Lotte Jacobi, gallery catalogue, Beverly Hills, Stephan White Gallery, 1986
- Lotte Jacobi. Rußland 1932/33 — Moskau, Tadschikistan, Usbekistan, ed. Marion Beckers and Elisabeth Moortgat, Berlin, 1988
- Lotte Jacobi 1896-1990. Berlin — New York — Deering, ed. Ute Eskildsen, Sally Stein, exhibition and collection catalogue, Museum Folkwang, Essen, 1990

Essays, Articles and Interviews on Lotte Jacobi (selection)
- New York Herald Tribune, Sunday, December 29, 1935
- New York Herald Tribune, November 1, 1937; Emma Bugbee: "New York Enchanting To Artist With Camera, Says Lotte Jacobi — Central Park Skyline and Thunderstorm Over City Make Her Grow Lyrical"
- The New Republic, Vol. CXXXXIII, No. 1197. Nov. 10, 1937, Bruce Bliven: "Thank you Hitler", pp. 11/12

- The Christian Science Monitor, July 13, 1938
- Boston Sunday Advertiser, Green Magazine, July 17, 1938
- The Boston Sunday Post, July 17, 1938
- Direction (New York), Suppement: "Exiled German Writers", December 1938
- The New York Post, August 3, 1943, Dexter Teed: "Camera: The Fourth Generation"
- The New York Herald Tribune ? 1947, Richard F. Crandell: "U.S. CAMERA 1947"
- The New York Times, April 17, 1955 Jacob Deschin: "Substance And Form — Reportage and Abstracts In Four New Shows"
- Art News, April 1955
- Art Digest, May 1955
- Infinity, April 1960
- Aperture, 10, no. 1, 1962, "Lotte Jacobi, Photogenics" (Portfolio) pp. 4-16
- New Hampshire Profiles, October 1963, Phyllis K. Warnock: "Home of the Month" — Portrait Lotte Jacobi
- The New York Times, June 28, 1964, Jacob Deschin: "Career in Review — Work of Lotte Jacobi"
- The New Hampshire Sunday News, November 29, 1964
- Idea, International Advertising, No. 68 (Japan), 1964
- New Hampshire Profiles, May 1965
- New Hampshire Profiles, April 1965
- Rangefinder, August 1965
- The Boston Sunday Globe, September 5, 1965 Edgar J. Driscoll jr.: "Galleries Flourish in Unlikely Places"
- Foto Magazin (Munich), October 1965, p. 42f, Fritz Neugass: "Lotte Jacobi — schöpferische Fotografin"
- Christian Science Monitor, April 27, 1966
- The New York Times, March 26, 1967
- The New York Post, April 4, 1967
- The New York Times, April 16, 1967, Jacob Deschin: "Camera Collection to be Auctioned"
- The New York Post, April 27, 1967
- The New York Sunday News, July 9, 1967
- Popular Photography, July 1970, Jacob Deschin: "Viewpoint: Lotte Jacobi Photographic Psychedelics"
- U.S. Camera Annual, 1971, p. 279, Lotte Jacobi: "Light Studies. Studios in Light"
- New Hampshire Profiles, April 1972, Alexander Karanikas: "Lotte Jacobi's Place"
- MFM — Moderne Fototechnik, December 1973, Fritz Kempe: "Lotte Jacobi und ihre Photogenics"
- Neue Ruhr Zeitung NRZ, December 15, 1973, Ludwig Wintzenburg: "Prominenz auf Fotos"
- Frankfurter Allgemeine Zeitung, January 1974, Friedrich A. Wagner: "Porträts aus fünf Jahrzehnten"
- Die Welt, January 5, 1973, R.F.: "Besuch der alten Dame"
- National-Zeitung Basel, June 14, 1974, Georg Ramseger: "Menschen von gestern und heute"
- New Hampshire Times, May 15, 1974
- Camera, No. 35. August/September 1975. p. 36-42, Margery Mann: "Women of Photography"
- Yankee. August 1976 (pp. 60-67, 83-93), Richard M. Bacon: "Lotte Jacobi"
- New Hampshire Democrat, Aug.-Oct. 1976, Stephanie v. Henkel: "Profile of a Party-Stalwart: Lotte Jacobi"
- Boston Sunday Globe. October 18, 1977, pp. 62-66, Ann Parson: "Lotte Jacobi: Camera Artist"
- The Keene Sentinal. October 26, 1978, Lynn Smith: "New Hampshire's Lotte Jacobi — on camera's eye"
- The Messenger. October 26, 1977, Stephanie v. Henkel: "Manchester Institute of the Arts and Sciences features photographic work of Lotte Jacobi"
- Decade, Jan. 1979, Alan Lamer: "Lotte Jacobi 'The soul perceived'"
- Valley News, February 28, 1979, Mary Ellen Donovan: "Lotte Jacobi was destined to become a photographer"
- American Photographer, March 1979, pp. 22-31 Vicki Goldberg: "Lotte Jacobi"
- Maryland Magazine, Spring 1979, pp. 6-11 Tom Beck: "I remember Einstein"

- Der Abend. June 20, 1979, Angelika Stepken: "Epoche in Portraits"
- Die Welt, July 28, 1979 A.B.: "Spezifisches Talent aus den zwanziger Jahren"
- Horizon, September 1979, Photographic Recollections
- New York Times Magazine, September 16, 1979 Gaylen Moore: "Lotte Jacobi: Born with a Photographer's Eye"
- WAN, December 1979 — January 1980, Susan B. Laufer & Cindy Lyle: "Photography's Grandes Dames"
- University free press, March 17, 1980, "women in art Lotte Jacobi"
- Women for Women Weekly, April 8, 1980, Charlotte Fardelmann: "An Eye for the Image"
- Broadcaster 1590, August 6, 1980, Lori L. Salomon: "A Picture of perfect Art"
- Art news, October 1980, Richard Whelan: "Are Women Better Photographers Than Men"
- Boston Sunday Globe, December 28, 1980, Richard W. O'Donnell: "A photographer loves N.H."
- Review, January 25, 1981, Thomas Albricht: "Avant-Garde Photography in Germany 1919-1939"
- The Union Leader Manchester, N.H., January 29,1981, "Famous Photographer Lotte Jacobi Focuses on New Job"
- Maine Sunday Telegram, February 8,1981, "Photographing the Famous, by Lynn Franklin"
- The Christian Science Monitor, February 24, 1981, Maria Lenhart: "Lotte Jacobi absorbed in a career of extraordinary images"
- Helicon Nine, A Journal of Women's Art & Letters, Spring 1981, No. 4, pp. 72/73. Margaretta Mitchell: "Lotte Jacobi"
- Süddeutsche Zeitung, April 18/20, 1981, "Menschen keine Masken — Lotte Jacobi im Gespräch mit Michael Köhler"
- Center Quarterly (The Catskill Center For Photography), Vol. 3, No. 4, Fall 1981, Sandra S. Phillips: "An Interview with Lotte Jacobi"
- Plus, December 1981, Margaretta Mitchell: "The Women's eye"
- A Pioneer Press Newspaper, February 18, 1982 Suzanne Weiss: "Pioneers active up to the photo finish"
- Views, Spring 1982 (Vol. 3, No 3), "Lotte Jacobi with Polaroid"
- Leica Fotografie, April 1982, Fritz Kempe: "Lotte Jacobi"
- Fotografie, No. 20/1982, Georg Steiner: "Lotte Jacobi (no indication is given whether this text is a translation of the english Original by James A. Fasanelli "Lotte Jacobi: Photographer", in: Lotte Jacobi, Danbury, N.H. 1978)
- The Evening Sun, November 22, 1982 Bonnie J. Schupp: "'Break the rules', advises veteran photographer, 87"
- Noyola World, December 1982, Suzanne M. Harding: "A chronicle of early women photographers: Lotte Jacobi and Barbara Morgan"
- Jewish Exponent, February 25, 1983, Michael Elkin: "Lotte Jacobi and the scrapbook in her mind"
- New Hampshire Times, supplement, March 28, 1983, Gail Smuda: "Lotte Jacobi and the art of teaching"
- Sunday Inquirer, September 18, 1983, Maralyn Lois Polak: "Lotte Jacobi 'She shot the giants'"
- DCPh Intern, IV/1983, Ute Eskildsen: "Laudatio Dr. Lotte Jacobi"
- Courage, vol. 8. December 1983, pp. 22-25 Inge Lutz: "Künstlerin: Lotte Jacobi"
- Journal for Constructive Change, Spring 1984, vol. 5, No 2. Joy Clough: "Don't retire!"
- Business N.H., November 1985. Martha Carlson: "Lotte Jacobi: still unpredictable at 89"
- New Hampshire Profiles, January 1987, pp. 38-45 Marilyn Myers Slade: "Lotte Jacobi — An Internationally known photographer leaves a legacy to New Hampshire"
- Frankfurter Allgemeine Zeitung, Saturday supplement, May 17, 1986. Sigrid Bauschinger: "Bilder unseres Jahrhunderts"
- Aufbau, August 15, 1986, hm: "Lotte Jacobi begeht ihren 90. Geburtstag"

- *Die Tageszeitung,* August 16, 1986, Marion Beckers, Elisabeth Moortgat: "Gesichtszüge — Kopfneigungen"
- *Süddeutsche Zeitung,* Aug. 16/17, 1986. Claus Heinrich Meyer: "Das persönlichkeitsdeutende Bild"
- *New Hampshire Profiles,* January 1987, vol. 36, No. 1 Marilyn Myers Slade: "Lotte Jacobi 'The most famous woman photographer in the world'"
- *The Germanic Review,* vol. LXII, No. 3, Summer 1987, pp. 109-117, Helmut Pfanner, Gary Samson: "Lotte Jacobi: German Photographer and Portraitist in Exile "
- *Women Artists News.* April 20, 1988, Joanne Savio: "A Visit with Lotte Jacobi"
- *Die Tageszeitung,* March 10, 1989. Katrin Bettina Müller: "Die Wirklichkeit des Fremden"
- *Die Wahrheit,* April 1, 1989, Iris Billaudelle: "Sprunghafte Veränderung eingefangen"
- *Manchester Union Leader N.H.,* May 8, 1990, "Artist and Activist Photography Great Lotte Jacobi Dies"
- *New York Times,* May 9, 1990, C. Gerald Fraser: "Lotte Jacobi, 93; Photographer made Portraits of Artists"
- *Washington Post,* May 9, 1990, "News Services, Photographer dies at 93"
- *Frankfurter Allgemeine Zeitung,* May 9, 1990, W.W.: "Lotte Jacobis Kunst des unsichtbaren Stils"
- *The Independent* (London), May 11, 1990, Val Wiliams: "Lotte Jacobi"
- *The Times* (London), May 12, 1990. "Lotte Jacobi"
- *Boston Globe,* May 12, 1990, Kelly Wise: "Lotte Jacobi saw clearly"
- *Concord Monitor,* May 14, 1990, Susan Orenstein "From her 'Theater & Dance' Photographs"
- *Aufbau,* May 25, 1990, Thema: "Zum Tode Lotte Jacobis"
- Anne Hoy: *Lotte Jacobi — Old and New Worlds,* brochure for an exhibition at the International Center of Photography, New York, 1994
- *Przeglad Artystyczno-Literacki* (Toruń), vol. 5, No. 6, 1996, pp. 36/37. Tadeusz Zakrzewski: "Lotte Jacobi's 100th Birthday"

Exhibition catalogues and books carrying photographs by Lotte Jacobi or mentioning the photographer (selection)

- Julius Bab: *Schauspieler und Schauspielkunst,* Berlin, 1928
- *Deutschland, Deutschland über alles. Ein Bilderbuch von Kurt Tucholsky und vielen Fotografen,* Montages by John Heartfield, Berlin, 1929
- *Unsere Flimmerköpfe. Ein Bildwerk vom deutschen Film.* ed. Leopold Freund, Berlin, 1929
- *Fotografinnen,* with texts by: Otto Steinert, Helene Schreiber, Heinz Winfried Sabais, exhibition catalogue, Museum Folkwang, Essen, 1970
- *Women on Photography,* with texts by Margery Mann and Anne Noggle, exhibition catalogue, San Francisco Museum of Modern Art, San Francisco, 1975
- *Künstlerinnen International 1877-1977,* exhibition catalogue, Neue Gesellschaft für Bildende Kunst, Berlin, 1977
- *Light Abstractions* by Jean S. Tucker, exhibition catalogue, University of Missouri, St. Louis, 1979
- Jörg Krichbaum, Rein A. Zondergeld: *Künstlerinnen* (reference work), Cologne, 1979
- *La Fotografia. Venezia 1979 (Photography. Venezia '79),* exhibition catalogue, Venice, 1979
- *Die Sammlung Josef Breitenbach zur Geschichte der Photographie,* Collection catalogue, Münchner Stadtmuseum, 1979
- *Recollections -Ten Women of Photography,* ed. Margaretta Mitchell, New York, 1980
- *Avant-Garde Photography in Germany 1919-1939,* texts by Van Deren Coke, Ute Eskildsen, Bernd Lohse, exhibition catalogue, San Francisco Museum of Modern Art, San Francisco, 1980 (Germ. ed. Munich, 1982, only with text by Van Deren Coke)
- Kelly Wise: *Portrait — Theory,* New York: Lustrum Press, 1981
- *Lexikon der Fotografen,* ed. Jörg Krichbaum, Fischer-Handbuch, Frankfurt/M 1981

- *Biographisches Handbuch der deutschsprachigen Emigranten nach 1933. International Biographical Dictionary of Central European Emigrés 1933-1945,* vol. II, Munich, London, Paris, New York, 1982
- *Lichtbildnisse. Das Porträt in der Fotografie,* ed. Klaus Honnef, Handbuch, Rheinisches Landesmuseum Bonn, Cologne, 1982
- *Berlin fotografisch — Fotografie in Berlin 1860-1982,* collection catalogue, Berlinische Galerie, 1982
- Aloys Greither and Armin Zweite: *Josef Scharl 1896-1954,* exhibition catalogue, Munich, 1982
- *Dictionnaire des photographes,* Edition du Seuil, Paris, 1982
- *Encyclopedia of Photographic Artists and Innovators,* Macmillan, New York, 1983
- *Figure della danza/Visions of the Dance,* exhibition catalogue, Reggio Emilia (Italy), 1983
- *Museum Folkwang. Die Fotografische Sammlung,* Collection catalogue, Museum Folkwang, Essen, 1983
- *Die Gleichschaltung der Bilder — Zur Geschichte der Pressefotografie 1930-36,* ed.: Diethart Kerbs, Walter Uka, Brigitte Walz-Richter, exhibition catalogue, Berlin, 1983
- *Grande Temi Della Fotografia. La Foto D'Arte (parte seconda),* Milan, 1983
- *Fotogramme — die lichtreichen Schatten,* ed. Floris M. Neusüss, exhibition catalogue, Fotoforum, Kassel, 1983
- *Encyclopedia of Photography,* Crown Publishers, New York, 1984
- *Encyclopédie Internationale Des Photographes,* Editions Camera Obscura, Geneva, 1985
- *Sammlung Otto Steinert. Fotografische Sammlung Museum Folkwang Essen,* Collection catalogue, Essen, 1985
- *Das Selbstportrait im Zeitalter der Photographie,* ed. Erika Billeter, exhibition catalogue, Lausanne 1985
- *Deutsche Lichtbildner,* exhibition catalogue, Museum Ludwig, Cologne 1986
- Anthony Heilbut: *Kultur ohne Heimat, Deutsche Emigranten in den USA nach 1930* (original edition: *Exiled in Paradise,* New York, 1983), Weinheim and Berlin, 1987
- *Nine Masters,* exhibition catalogue, Photographic Resource Center, Boston 1987
- William A. Ewing: *The Fugitive Gesture,* London, 1987
- *Berlin, Berlin,* ed. Gottfried Korff, Reinhard Rürup, exhibition catalogue, Berliner Festspiele GmbH, Berlin, 1987
- *Berliner Begegnungen. Ausländische Künstler in Berlin 1918 bis 1933,* ed.: Klaus Kändler, Helga Karolewski, Ilse Siebert, Berlin, 1987
- *Contemporary Photographers,* St. James Press, Chicago, 1988
- Christiane Barckhausen: *Auf den Spuren von Tina Modotti,* Cologne, 1988
- *Das Autonome Bild,* exhibition catalogue, Kunsthalle Bielefeld 1989
- *Photographie als Photographie, Zehn Jahre Photographische Sammlung 1979-1989,* Berlinische Galerie 1989
- Floris M. Neusüss with Renate Heyne: *Das Fotogramm in der Kunst des 20. Jahrhunderts,* Cologne, 1990
- Michael Grüning: *Ein Haus für Albert Einstein,* Berlin, 1990
- Erika and Klaus Mann: *Escape To Life. Deutsche Kultur im Exil,* (first edition: 1939, Boston), Munich, 1991
- Jane Livingston: *The New York School Photographs 1936-1963,* New York, 1992
- *Photo-Sequenzen. Reportagen. Bildgeschichten. Serien aus dem Ullstein Bilderdienst von 1925 bis 1944,* exhibition catalogue, Haus am Waldsee, Berlin, 1992
- *Jüdische Frauen im 19. und 20. Jahrhundert, Lexikon zu Leben und Werk,* ed. Jutta Dick, Marina Sassenberg, Reinbek bei Hamburg, 1993
- *Deutsche Intellektuelle im Exil. Ihre Akademie und die "American Guild for German Cultural Freedom",* exhibition catalogue, Die Deutsche Bibliothek, Frankfurt/Main, 1993
- *Berlin en vogue. Berliner Mode in der Photographie,*

ed. F. C. Gundlach, Uli Richter, exhibition catalogue, Tübingen, Berlin, 1993
- *Photographische Perspektiven aus den Zwanziger Jahren,* exhibition catalogue, Museum für Kunst und Gewerbe, Hamburg, 1994
- Naomi Rosenblum: *A History of Women Photographers,* New York, 1994
- *History of Photography,* Vol. 18, No. 3, fall 1994, London, Washington, D.C.; supplement: "Women in Photography"
- *Fotografieren hieß teilnehmen. Fotografinnen der Weimarer Republik,* ed. Ute Eskildsen, exhibition catalogue, Düsseldorf, 1994
- *Neue Frauen zwischen den Zeiten,* ed. Petra Bock, Katja Koblitz, Berlin, 1995

Illustrated periodicals which published photographs from the Atelier Jacobi between 1927 and 1935 in Germany (selection)

- *Berliner Illustrirte Zeitung (BIZ)*
- *Die Dame*
- *Der Querschnitt*
- *UHU — Das neue Magazin*
- *Berliner Morgenpost*
- *B. Z. am Mittag*
- *Tempo*
- *Die grüne Post*
- *Montagspost*
- *Zeitbilder,* Supplement of the *Vossische Zeitung*
- *Sieben Tage*
- *Der Bazar*
- *Der Brummbär*
- *B.A.Z., Berliner Allgemeine Zeitung*
- *Der fröhliche Fridolin*
- *Das Blatt der Hausfrau*
- *Die Koralle*
- *Blatt Wien*
- *Die Funkwoche*
- *Der Tanz*
- *Das Theater*
- *Arbeiter-Illustrierte-Zeitung (AIZ)*
- *Magazin für alle*
- *Die schaffende Frau*
- *Das neue Russland*
- *Scherl's Magazin*
- *Die Woche*
- *Berliner Illustrierte Woche*
- *Die Wochenschau,* Supplement of the *Düsseldorfer Nachrichten*
- *Blatt der Frau,* Supplement of the *Frankfurter Zeitung*
- *Münchner Illustrierte Presse (MIR)*
- *Leipziger Illustrierte Zeitung*
- *Der Weltspiegel,* Supplement of the *Berliner Tageblatt*
- *Farbe und Form — Monatsschrift für Kunst und Kunstgewerbe*
- *Velhagen & Klasings Monatshefte*
- *Westermanns Monatshefte*
- *Das Magazin*
- *Die Fackel*
- *Skizze — Illustrierte Monatsschrift für Kunst, Musik, Tanz, Sport, Mode, Haus*
- *Omnibus — Almanach für das Jahr*
- *Atlantis*
- *Die Umschau*
- *Volk und Welt*

In England, 1935 (selection)
- *Kodak Magazine*

In the U.S.A. after 1935 (selection)
- *New York Herald Tribune,* New York
- *The New York Times Magazine*
- *U. S. Camera annual*
- *Time*
- *Life*
- *Wisdom Magazine*
- *Scientific American*
- *Harpers*
- *Aperture*
- *American Photographer*
- *Decode*
- *The Print Collector's Newsletter*
- *New Hampshire Profiles*

Exhibitions in the Jacobi Gallery in New York and Lotte Jacobi Place in Deering, N.H.

Jacobi Gallery, New York

1937
- Louis Lionel Stern:
 Landscapes, Portraits, Studies

1953
- Gustav Wolf:
 Oil paintings, Engravings, Lithographs
- F. G. Kuttner:
 Paintings, Water colors, Drawings
- Six Artists: Benjamin Benno, Si Lewen,
 Jeason Seley, Josef Scharl, Robert E. Mueller,
 Johannes Molzahn
- Four Artists: Benjamin Benno, Josef Scharl,
 Gustav Scholz, Robert E. Mueller
- Si Lewen:
 The Parade, Drawings
- Gustav Wolf:
 Paintings and Graphics
- Josef Scharl:
 Drawings and Guaches
- Robert E. Mueller, Kiyoshi Saito, Rudi Lesser
 Print Show: Engravings, Etchings,
 Lithographs
- Coulton Waugh:
 Paintings

1954
- Louise Nevelson:
 Etchings
- Benjamin Benno:
 Drawings
- Ernest Guteman:
 Sculptures
- Benjamin Benno:
 Paintings
- Ernest Guteman:
 Sculptures, Drawings
- Etchings by artists from the *Atelier 17:*
 Hecht, Stanley W. Hayter, Vieillard, Courtin,
 Leo Katz, Peterdi, Klett (Jacobi Collection)

1955
- Robert Emmet Mueller: Ten Non-representative
 Pictures
- Ruth Jacoby:
 "dynastats" — The shaped canvas
- Paintings
 Hansegger, Leo Katz, Roy Newell
 Lotte Jacobi Place, Deering, N.H.

Lotte Jacobi Place, Deering, N.H.

1963
- Frances Hubbard Flaherty:
 Photographs
- William H. Manahan jr.:
 Photographs

1964
- John Herrick:
 Crafts
- L. M. A. Roy:
 Photographs
- Gustav Wolf:
 "New York City"
- Robert J. Flaherty:
 Studies of the Hudson Bay Region —
 Photographs
- Christopher Cook:
 Paintings, Drawings, Sculptures

1965
- Albert Renger-Patzsch:
 Photographs
- Louise Nevelson:
 Lithographs
- Leo Katz:
 Print Graphics 1932-1964
- Gustav Wolf:
 Compositions with Flowers

1966
- Minor White:
 Three Sequences

- Robert Emmett Mueller:
 Encaustics, Woodcuts, Schema
- Gret Mohrhardt and Inge Richter:
 Tapestries
 Hans Schmidt:
 Print graphics

1968
- Frances H. Flaherty and Robert J. Flaherty:
 Photographs "The Magic Portraits"
- Luther Thompson:
 Photograms and Photographs

Museums and public collections containing Photographs by Lotte Jacobi (selection)
- Andover, Mass., Addison Gallery of American Art,
 Phillips Academy
- Baltimore, Md., University of Maryland
- Berlin, Foundation Archive of the Akademie der
 Künste
- Berlin, Berlinische Galerie
- Berlin, Kunstbibliothek SMBPK
- Berlin, Theater Department Collection of the Freie
 Universität
- Berlin, Ullstein Bilderdienst
- Boston, Mass., Museum of Fine Arts
- Bryn Mawr, Pa., Bryn Mawr College Library
- Cambridge, Mass., Massachusetts Institute of
 Technology
- Essen, Museum Folkwang
- Hamburg, Museum für Kunst und Gewerbe
- Houston, Texas, Museum of Fine Arts
- Cologne, Deutsches Tanzarchiv
- Cologne-Porz, Theater Department Collection of
 the University of Cologne
- Manchester, N.H., Currier Gallery of Art
- Marbach, Schiller National Museum
- Munich, Photography museum in the Stadt-
 museum
- New York, N.Y., The Museum of Modem Art
- New York, N.Y., The Metropolitan Museum
- Paris, Centre Pompidou
- Rochester, N.Y., International Museum of Photo-
 graphy at G. Eastman House
- Richmond, Virginia, Virginia Museum of Fine Arts
- San Francisco, Ca., San Francisco Museum of
 Modern Art
- St. Petersburg, Pa., Museum of Fine Arts
- Stockholm, Fotografiska Museet
- Tokio, Tokyo Fuji Art Museum
- Tucson, Arizona, Center for Creative Photography
- Washington, D.C., Smithsonian Institute
- Wellesley, Mass., Wellesley College Museum

Index